T0386634

TAKING TIME

TAKING TIME

AZZEDINE ALAÏA

WITH DONATIEN GRAU

Rizzoli
ex libris

CONTENTS

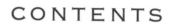

I met Papa when I was sixteen. It was my first day working in Paris. Afterward, I would stay with Azzedine every time I was in Paris. He really became like a father to me. Spending time together, I learned about architecture, furniture, and artists. We used to go look at collections of designers from the 1920s and 1930s. He was passionate about literature and the arts.

Papa used to have gatherings where he would host and honor artists and writers. He had deeply personal relationships with creative people: they were his friends, and he wouldn't have thrown such big dinners if he hadn't felt a personal kinship with those he invited. It was as important to him that I attend these dinners as it was to attend his fashion shows. Papa liked to mix people from different cultures. He was respectful to everyone and appreciated all the arts. He was fascinated by other people's workmanship, whether writing, painting, designing furniture, or architecture. He had an amazing eye and was sure of what he wanted the artists and craftspeople to do when they worked with him. Some people close to Papa knew that about him, but not everyone did.

When Papa moved to rue de Moussy, it wasn't just for Alaïa—the store, the fashion shows—to be in one place. He wanted a place where he could show other people's work. He wanted to offer a space of creativity, which is what it became. He wanted to place the people he gathered "at the right level."

Azzedine had always done things at his own pace. When he decided to show only at the moment he felt ready, it was a big revolution; everybody else followed the dictates of the fashion calendar. It made sense because his approach to designing was unique. Unlike other designers, he didn't have a huge atelier. He would draw and cut his own patterns: it was a one-man show. He did things on his own and he would check everything on his own. That was his work ethic, and it's why we would do fittings until four or five in the morning. He liked that quiet time when the phone stopped ringing. People came over to visit at all hours because they knew he was up working. I don't think I know any designers who work that way. They all have a team. He did not, but he liked it that way.

When Papa took the decision to show when he wanted to show, it wasn't to make a statement to say "I'm different." It really was about creativity and doing things properly. He was someone who finished his work from A to Z. He was a perfectionist

in every sense of the word. If something wasn't cut right, it would have to be redone until it was. I can't tell you how many times I stood up fitting a dress—but I understood, and it was an honor to watch and be part of his creativity. He would not be rushed: if he wasn't ready to show, he wasn't rushing to show. In the beginning, it was difficult for some models to come back, but they did because there was nobody like him. No one cut like him, no one designed like him—he really stood up on his own. So it worked. It wasn't related to his ego; it was related to his creative views, his views of art. He wanted things to be finished properly.

He was intuitive, able to sense people's talents, and he educated us about their work. When people say to me that Papa wasn't literary, I say, "Yes, he was, very much so." He was observant, he looked at everything. He had an incredible eye, an incredible sense of being. It didn't have to be from the fashion world. He connected to craftspeople in other fields, and they connected, too. They shared a common denominator. The range of people he knew was extraordinary: they came from all walks of life. He was loved by so many because of that. When there are gatherings for Papa now, even though he's no longer with us, you can see the wide variety of people there. Whether you were dressing a shopwindow or writing poetry, he appreciated you for what you did. He never judged anyone. He was always encouraging. If you ever had a moment of indecision, that's when he would be there the most.

I don't know if he knew, but Papa was ahead of his time in so many things. You would expect him to show one design and he would show something else; he would change the shape entirely, and it wouldn't make sense until you saw somebody else trying to do it. The workmanship that went into everything he did stands the test of time. The Alaïa clothing I have had since 1986 still looks vibrant, as if it had been made today. The stretch in the fabric, the stitching, the cut: it stands out on its own, as a piece of art.

When you see the people Azzedine has collected in this book, you will understand how expansive his mind was. He had a vision beyond clothing. So many collaborations happened in Papa's kitchen: people gathering and meeting each other, finding a way to work together. Not forced—it just happened that way. He still is, now more than ever, an inspiration.

Naomi Campbell, Paris, September 2019

PREFACE

The following conversations started with an impetus that Azzedine Alaïa felt in 2013—one that he had been feeling for a long time. He wanted to make people aware of how limited our use of time is, how constrained we are by it, how figures from the creative sphere are unable to properly create, invent new things, or break new ground when experiencing these limitations. Through interviews and in his own oeuvre, he had been a vocal proponent of the necessity to take one's time, to do things when they feel right, and not yield to the pressure of an industry, whatever it might be.

Azzedine was a couturier, he was himself; but that did not prevent him from being open to others. Quite the opposite. He was the greatest example of how consistently demanding and relevant one can be when knowing exactly where to locate people's expectations—when being at the service of individuals, famous or anonymous, and shaping new ways to dress meant that you could not accept the demands that were forced upon you.

Azzedine's world brought together the greatest figures of our time. Whether they had been icons in the 1950s or were icons of the 2010s, whether they were models, pop stars, writers, poets, artists, designers, architects, actors and actresses, gallerists, curators, film directors, opera singers, or ballet dancers, they were all his friends and they gathered around him at his kitchen table in the awareness that this was not a shallow scene. It was the moment when creative talents were able to speak to one another, to converse, to share the issues they were experiencing with people who were dealing with similar problems. Azzedine would listen, and often guide them, with the same generosity and exacting precision that he upheld in his designs.

In 2014, Azzedine decided to invite creative figures, all from among his friends, to participate in an open discussion on time: they were to take their time, and to take on time. Between that year and his passing in 2017, we held thirteen such conversations. One of his friends would be invited to choose another friend, someone whom Azzedine knew or, sometimes, he did not know personally but whose work he deeply admired, such as the *nouveau roman* writer Michel Butor. He would moderate these conversations himself, and I was fortunate that he chose me to be his steering partner in this project.

What he did was singular in the history of fashion. No couturier, no designer, had ever opened a stage for friends to come and share their lives, their visions, in an intimate setting, with other friends present and with a grand prospect: taking time, taking on

time, being completely self-aware of one's stance in the world, which is what couture is all about. Being unique, and belonging to humanity.

This blending of personalities, of lives, of time periods, has not been recorded in any other contemporary instance. Both Claude Parent and Bettina were in their nineties when the interviews took place; several other participants were only in their thirties. One of the greatest creative forces of our time was inviting his peers to present their views to the public, to spread awareness of how much we need to take our time to be creative. It became a manifesto set by examples, rather than defined by one person's individual, and perhaps monotonous, vision. The approach shifted constantly; major themes elicited personal and often intimate accounts, from Azzedine as well as from each participant.

Reading these texts again, after Azzedine left us on November 18, 2017, feels like an adventure left open. The interviews had been proofread by several participants at the time, and all had been reviewed by Azzedine. And yet they haven't changed much since the conversations took place, and the whole project seems to be the trace of a miracle that could have kept on going. So many conversations were meant to be held, by so many more friends. They also feel like his testament: Azzedine's voice comes across here like nowhere else.

A true couturier, Azzedine did not state his vision. He manifested it with the people he loved and for them as well—for these people and for all, for the experienced and for the young. He may not have been the "last couturier"; he hated being qualified in those terms. But with this book he definitely proved himself to be the utmost couturier: one for whom a love of others is the most potent manifestation of oneself and one's own work. A person for whom spiritual life, intellectual life, and physical life are not disconnected.

Each of these interviews is like a couture dress made of words. They are to be looked upon with admiration and veneration, for they already belong fully to the history of couture, of fashion, and of culture as well as of their own field, whether theater, film, art, design, poetry, or music. They should also be regarded with aspiration, for they truly are a call to be aware of, to be at ease in, and perhaps to change time. Because the three are tied, the ones within the others, in our lives.

Azzedine took time for us. Now let's take time with him.

Donatien Grau, Paris, May 2019

I first met Donatien Grau in September of 2016 for breakfast at Sant Ambroeus
in New York's West Village. We sat at an outdoor table as it was a cloudless late-
summer day. Donatien was working with Azzedine Alaïa organizing several
exhibitions for the Galerie Azzedine Alaïa, and he wanted to speak to me about
publishing a book. He explained that over the past couple of years Azzedine had
hosted conversations on the subject of time. Friends of the couturier were invited
to bring a guest to the Maison Alaïa to discuss what time meant to them and how
it affected their work and lives; the book would be called *Prendre le temps*, or *Taking
Time* in English. It would serve as a manifesto of sorts—a document conveying
Azzedine's thoughts on the state of fashion and creativity as a whole. Our conver-
sation ended with Donatien rubbing his hands together enthusiastically, excited at
the prospect of introducing me to Azzedine and taking steps toward making the
book you now hold.

Five months later I arrived in Paris. Donatien greeted me and gave me a tour
of the gallery and buildings that make up the House of Alaïa. Chairs by Prouvé,
Bertoia, and Newson filled the many rooms lit by Bouroullec and Mouille lamps,
some featuring paintings by Schnabel and von Weyhe (Azzedine's partner). We
then made our way to the kitchen to meet Azzedine. Just as Donatien opened the
door he whispered, "OK, you must speak up now, you must take the stage, because
Azzedine doesn't speak much, and if you both don't speak it will be very awkward."
We entered the room. Azzedine was standing all in black, in a pair of cotton Chinese
pajamas and sneakers. We said hello and he invited me to sit down for lunch,
offering a thick vegetable soup as a starter, followed by a choice of smoked salmon
or Tunisian chicken. Donatien encouraged me to have the chicken, as it was
cooked by Azzedine. Azzedine quipped that Donatien had only said this because
he preferred the salmon.

This was the beginning of the first of many meals and conversations I was fortunate to share with Azzedine and Donatien over the following two years. Time and time again, Azzedine returned to a persistent concern: that people were being forced to produce at an ever-faster rate to the detriment of creativity and humanity. That's not to say he advocated a life of leisure. On the contrary, he would spend most of his time in his atelier and worked into the early hours of the morning. He believed in quality over quantity and, above all, in self-fulfillment. Life and work were intertwined and inseparable. Only very rarely did he leave his home, which was also his place of work (and which continues to be the House of Alaïa). Rather, he would let the world in and share his life generously with others. He brought up age one evening, saying that when people asked him how old he was he would respond, "As old as the pharaohs." A person's age meant nothing to him and indeed when we last met he seemed to defy the concept, dancing the running man to Adriano Celentano's "Prisencolinensinainciusol" at 1 a.m. in his kitchen surrounded by friends. He retired to his atelier to continue working after everyone had left.

Donatien Grau, who was often by Azzedine's side, was a beacon and a driving force in the couturier's world, bringing people together and then mediating conversations, helping facilitate new ideas and often riotous discussion. At our most recent meeting in New York in the summer of 2019, once more for breakfast at Sant Ambroeus, we reviewed the mock-up of this book. We sat at the same outdoor table as at our first encounter and we took stock of the time it had taken for the project to come to fruition. Two years of new friendships, much laughter, and, above all, gratitude for having had the chance to know Azzedine, who is forever within our hearts and in the pages of *Taking Time*.

Daniel Melamud, New York City, July 2019

CONVERSATIONS

Whatever their domain, creators are faced with the same problems. I wanted to get them talking with one another—about their life, their art, and their relationship with time—so that they could share their experiences, and together we could raise the alarm against the increasing hysteria of our times and the way it has pent up our creativity.

—Azzedine Alaïa

Donatien Grau: Some time ago, you spoke of gathering figures from fashion and the creative world and asking them to take a fresh look at the idea of time. We then undertook the exercise together, inviting those who are close to the House, as well as the people they chose to talk with, and sitting them around the kitchen table for conversation. During those evenings, we spoke of our concerns and experiences with respect to time. There was no audience aside from your friends and collaborators, and it made for some extraordinary moments. We've transcribed them in this book, which I think contains several beautiful stories. But I must ask you: What got you thinking about time in the first place? Why is it important right now?

Azzedine Alaïa: It seems to me that we're living in an era of unprecedented acceleration. Through technology, the internet, Google, we have easier access to everything than ever before. We can feel this change in our lives: Everything's moving faster; everything's getting done faster. In fashion, we've barely finished a collection before we're moving on to another and then another. We must continuously dream up new ideas. I don't think ideas are so easy to come by. When I capture a good idea, I hang on to it and work it out.

The effect of all this haste and thirst for new ideas is the diminishing of our creativity. Never have we resorted to vintage ideas more than we do now. Never have we rummaged the past so much. We're copying clothes from the 1950s, the 1960s, the 1970s, the 1980s, and these "ideas" we claim to be inventing are retreads of what has already been done. They are not new. Acceleration is killing true innovation, the kind that makes a difference.

I'm not criticizing acceleration in itself and the vast possibilities it offers, but I think we must reserve a space for creation and for life. The young, caught up as they are in the acceleration, have no time for themselves; they have no time to live or create. They therefore advance without having lived, and the time comes when they find they have nothing to show for it: no body of work, no life. They've spent their time chasing down ideas that aren't theirs because they've been rushed. They've not been able to enjoy the riches that life has to offer, and they've not been able to create what they were capable of creating.

The past is clear, we live in the present, and the future is obscure—I often think about that phrase. This present that we're living, we must stretch it out because that's where we exist and where we can create. It's interesting to delve into the past, insofar as it ties in to the present. The future we know nothing about, and we mustn't worry about it. But the present—we're in the present, and we can act. It seems to me a mistake to delve too deeply into the past and forget the present, or to turn toward a future that is unknown to us.

DG: Do you feel this applies to fashion alone or to other creative fields as well?

AA: Fashion presents the most obvious case because you sometimes have exact reproductions of recent clothes whose designers still walk among us. They might see a brand take up an article of their clothing as is, without the slightest change. And nobody makes a peep.

Still, I don't limit my observations to fashion. It's often said that in art or literature, an artist has become old-fashioned, even as that artist continues to develop and evolve. Much later we realize that it was in that moment, when the artist was taking a little time, far outside the frenzy of the art world and the market, that some of the artist's most important works were created.

The same goes for literature. Certain authors exist well outside fashion; what they do is very potent and will remain so regardless of trends. Trends both exalt and exhaust us. Those who get swept up in them have the insolence of youth. They're carried along, but at some point the trend comes to an end, and then they must find the means within themselves to keep moving forward.

Above all, I believe there are creators in every domain. You can be a creator in clothes, design, literature, dance, cinema, art, even cuisine. Whatever their domain, creators are faced with the same problems. I wanted to get them talking with one

another—about their life, their art, and their relationship with time—so that they could share their experiences, and together we could raise the alarm against the increasing hysteria of our times and the way it has pent up our creativity.

I don't think there's a difference between the lives of creators and the lives of non-creators. All are faced with the same questions and decisions. Those who create must find the space to live their own lives, and those who don't seem to create are faced with the same problems. If there's a lesson to be drawn from these conversations, it's that the people who've delighted me with their presence ask the same questions as the rest of us: Why continue to do what we do? What matters? How should we live in this troubled world?

DG: You seem to make no distinction between a life and a body of work, or between life and work. For many, though, there is a difference between the two.

AA: I make no distinction. I live among people I work with, and they live with me. We work together, and we live together. If we are brought together by a common passion or task, then we cannot live our time in some other way.

This doesn't seem peculiar to what I do. My house is open to my friends. They work all the time, but they can come over. The time we spend together is at once friendship time and work time. We're always doing things together.

Sometimes people think of leisure and duty as separate: you must fulfill your duty before you can have time for leisure. But that makes "work" into a sort of prison from which you manage a brief escape. I don't see things that way: no leisure without duty. You simply have to make a space for creation within your constraints, and make your constraints into a creation. This goes for individual life, for everyone's particular work, and for the work of artists.

DG: But I think it's tied to your conception of life.

AA: When new people arrive in my studio, I say to them: "I'm not going to teach you fashion; I'm going to teach you how to live." At my side they can meet someone new every day. Those are the greatest riches, the ones I received from Louise de Vilmorin and Arletty. With them, we could always meet new people. Still today, when I wake up every morning, I wonder whom I'm going to meet. You must be open to encounters, open to your time.

DG: Some of these conversations have led to joint projects, like Adonis acting in Alejandro Jodorowsky's film *Endless Poetry*, or the dialogue between Jean Nouvel and Claude Parent in the *Musées à venir* exhibition at your gallery, which was born of their conversation about time. How did you envisage these conversations? How are they structured?

AA: My house is open. My friends, who are my family, can come over any day. If they're my friends, it's because I like them personally and admire their work. The two are not separate. I'm happy to have them over. It could be to have lunch or dinner, at the kitchen table, or for an exhibition, which would allow us to show their work in a different way.

Jean Nouvel and Claude Parent's exhibition is first and foremost a matter of friendship and respect: they had known each other very well and had worked together. Jean Nouvel has been a friend for thirty years, and our friendship with Claude Parent had been just as intense since our meeting. I cannot express enough how much I admired him, respected him, and appreciated him as a person. He is a true creator, and it was a great honor to host him and have this conversation. If we can continue that conversation, and create a space for it, so much the better. I'd like the same for all my friends.

DG: Your fashion is sometimes thought of as being timeless. Is this because you've managed to impose timelessness on fashion, which you can therefore call upon to "take its time"?

AA: I don't think what I do is timeless. I create clothing for women. I'm always looking at them. I see them on the street, and I look at young mothers and grand-mothers. I'm very aware of where they are nowadays. Because I create for them, the clothes I make contain the logbook of my observations.

But it's not every day that you can grasp a great sweep of time. You can try to capture little moments, but that's not what survives. The great moments demand more than vintage: you have to capture where you are. For years I've been trying to make a straight skirt: making a straight skirt that's right now is the hardest thing in the world.

For me, timelessness does not exist. It simply depends on what time you take an interest in. Superficial time, the short term, doesn't interest me. It doesn't last; it's quickly out of date. And everyone forgets it. What matters is what lasts, and what

lasts cannot be founded on too short a time. All the people we invited to take part in these conversations are people I admire, and not one of them is fixated in a short time. They've all managed to transcend.

DG: One last question: Why set up these conversations?

AA: I find it a shame that uncontrolled acceleration should so thoroughly sap our creativity in every domain. People often say that our era is less rich than some other, but it's not true. There are just as many people now as before doing great, original, and new things. But they're under such pressure—from industry, from consumption, from work—that they cannot create. As a result, everything has been separated into leisure and duty, which touches on the very idea of creation. I'm hoping we can avoid that kind of thinking: that we can think of leisure and duty as not being separate if we truly get a chance to do things and if we devote ourselves completely.

I have no advice to give. I've simply sought to present the stories of a few friends who are in the thick of the struggle, and who have managed to construct their time, so that people can see that it's possible.

This is just a beginning.

I

All the eras of our life, all eras, have an interest. You just need
the time to work. If you say, "I'm going to stop and write"
or "I'm going to stop and create," then hats off to you.

—Azzedine Alaïa

MAËL RENOUARD & CHRISTOPH VON WEYHE
with contributions by Anaël Pigeat and Caroline Fabre

Donatien Grau: The relationship to time is fundamental for both of you. For Christoph, it's the recurrent painting of a place from memory: Hamburg. And memory's role is key for Maël as well. I'd like to begin by talking about memory.

Christoph von Weyhe: Yes, it's true. Since the 1980s. The setting of my childhood—the city of Hamburg, and especially the port—has arisen in my memory.

It was so strong that I thought, "I've got to do some work around that memory." So I started making very precise, very figurative drawings at the port of Hamburg.

DG: It was a way for you to rehabilitate the memory, give it new life.

CvW: Exactly.

Maël Renouard: Do paintings have a memory? Do they remember that they're paintings? Can a painting you make refer to another painting from 1980 or 1985?

CvW: I made use of those figurative drawings and worked on a triptych. I made several versions of this triptych over the course of two or three years. The final version was a large canvas on which I brought the triptych's three elements together into one.

DG: When you create a painting, are you referring to another painting that you've executed in the past?

CvW: In this case it was a reference to the drawings I'd done, my sketches and preparatory studies. That's pretty much how it always goes. The painting always remembers the drawings.

MR: You always come back to the same place . . .

CvW: It's the same site, yes, but it's changed a lot.

MR: Do you try to show the changes or the permanence?

CvW: The permanence. But when I look over my work, I see an enormous change from the beginning. Now I'm drawn less to the architecture and more to the light, the atmosphere, and the forms.

MR: In the 1980s, you still made drawings that showed the port in the daylight. Now it's always night.

CvW: Yes, I began with daytime landscapes. And then at a certain point I rediscovered the night and its mysteries. It was a completely different landscape, more mysterious and less exact in the representation of the architecture, and I moved on to nighttime landscapes. I started working at night. I did a series of monotypes—

DG: So the night became a sort of score, a motif—

CvW: Right. People have linked it to German Romanticism, Novalis, and so forth. I don't deny that, since it's my culture, but it's not really that—or not only that.

DG: It's German Romanticism at a port, that's the rub. It's the absolute—at a port.

CvW: Absolutely. I very much like the world of labor. Otherwise, the port wouldn't have held my interest. The world of labor fascinates me. It's not static; it's dynamic. It's life.

DG: The question of the world of labor is interesting because you live a double life. You work here [at the House of Alaïa], and at the same time you paint. And you, Maël, have chosen to spend your time writing, to give yourself that time now.

MR: Yes, although it's not a definitive decision. I'm giving myself time for it, as

much as I can. At the moment it's a question of both chance and maturation. A long time ago, in 2003, I'd started to write a novel, and I was rather happy with the start. It began at night, in fact. And I worked at it regularly for about five or six years. I reread and rewrote it so often that I couldn't tell anymore whether it was worth anything. I lost my perspective on it. Then I became a speechwriter for a politician. I wrote a lot for about the next year, but not a single line for my own work. It was like taking a cure. And it changed my writing. It made my writing faster and more effective. I eliminated some of the preciousness, set aside the somewhat grandiloquent and paralyzing representations of what literature ought to be, the stuff you tend to develop when you stay within the academic world and focus on erudition and commentary—even if some of that has necessarily stayed with me.

It also gave me narrative material. So I reread the manuscript, which I hadn't touched in two years, and saw that it was no good. For a time, I thought I'd never again write literature, but in the end things went the other way. By a sort of dialectic, a new manner of writing—more creative than my old one at university—took root in the furrow of my political writing, which acted as a sort of liberating constraint. In 2012, after the elections, when I had some free time, I wrote *La Réforme de l'opéra de Pékin* in five or six weeks, with the sort of athleticism that speechwriting had given me. And it was far different from the novel that I had spent years writing.

DG: What was that novel like?

MR: It was about navigation. It had the usual flaws of novels or novelistic sketches by young writers, particularly the aspiration to totality. It had references to the great tradition of maritime novels: *Moby-Dick* and a bit of Conrad. Lots of allusions to the history of literature. The main flaw, the thing that in part kept me from finishing, was that I didn't have a clear ending in mind. The pages piled up, but huge amounts of the work went to injecting new text into what was already there. I didn't know how it should end, and I put off finding out.

DG: So you were avoiding the question of the end.

MR: That's one of the reasons it wasn't very good. Now I know that I have to write the end of a manuscript quickly in order to have the motivation and strength to finish it.

It could have been painful to abandon that novel; along with other things, it had

kept me busy for several years. I'd placed my hopes and aspirations in it. But, no. When I think back, it's not painful at all. It was an apprenticeship: I learned what not to do. It was like a catharsis. It's a kind of trash can, but also a reservoir. I go back and draw from it—sentences that I use elsewhere. The abandoned novel has even become a kind of character in the autobiographical fragments for the book I'm writing about the internet and the role of computers in our lives, the writing life included [*Fragments of an Infinite Memory*, published in 2016].

The worry that you're going to lose forever the manuscripts you've written on a computer—and sometimes the actual losing of them—coexists paradoxically with the common notion that nothing can ever be lost again, thanks to the internet. One day, though, in a computing misadventure, I did lose a few pages of the novel, and that helped bury it a little more.

DG: Maël, you mentioned the internet and the question of writing as a medium that has a specific relationship to time in the age of the internet. You, Christoph, hold painting to be a medium that affords a specific relationship to time.

CvW: Yes, absolutely. I hold painting to be a medium. I think I choose my motifs like a photographer, but I translate them like a painter. It's the relationship with reality and the excitement it generates, the body language. When I work with large sheets of paper, the process is relatively fast. It's often the transcription of an instant. Then I take them back to the studio, and I proceed to a much slower reinvention. The process can last two months, or even more for a large canvas. I used to fear losing the spontaneity, but now I think I've managed to hold the line. In truth, nothing's lost from memory. Memory is present during my work. I evoke in memory a landscape that I now know by heart but that's also never the same. Heraclitus said that we never go down to the same river twice; that's exactly right.

DG: Memory through the fixation of a color, too.

CvW: Yes, exactly.

DG: This question of memory leads us back to your work, Maël.

MR: Before I wrote any literature, memory was the theme of my philosophical work. I worked on the notion of Proustian reminiscence, which I wanted to establish as a philosophical concept. It was in line with ideas already present in the work of Merleau-Ponty, Deleuze, Bachelard, Jankélévitch. I wanted to build something phil-

osophical on the basis of the potent sense of the past that a melody or a scent can elicit. And for about ten years, I wrote articles—on philosophy, literary criticism, and cinematography—around this notion of reminiscence.

When I wrote *La Réforme de l'opéra de Pékin* I was aiming to write a political intrigue, but the theme of memory arose spontaneously. At the center of the story is an involuntary episode of reminiscence. In fact, it makes use of Proust's distinction between voluntary and involuntary memory, transposed to a whole other scale and context.

DG: And so we come to the question of history. You, Christoph, have set yourself a space that's become an ahistorical motif. Everything flows, but even if it changes, it never changes. In your case, Maël, there's also a motif—memory, let's call it—but it's always expressed in a historical context.

CvW: Yes, the memory of my childhood doesn't figure into that work. It was the trigger, but it has since sort of vanished.

MR: Because it's nighttime? Because the night has no history? Night is a space without an era—or, at least, a space where temporal differences are much weaker.

CvW: When I listen to certain pieces of music, memory comes back. But night is definitely the space where frontiers blur.

DG: Let's return for a moment to the question of childhood as genesis of creation. You were talking about this earlier, Christoph. Is it just as important for you, Maël?

MR: I long thought that my childhood wasn't very interesting as a literary subject. Yet the more time goes by, the more I think I could talk about it. But childhood is not the object of predilection for reminiscence.

DG: What was your childhood like?

MR: It was very happy, but I don't see much interest in it from a literary standpoint, maybe because there was so little literature in it. It was only after age sixteen or seventeen that I took a real interest in literature, started reading a lot; I even thought about reading everything.

DG: Why did you finally take an interest in it?

MR: I managed to find the twist, or the point of view from which I might speak of it.

DG: And what point of view is that?

MR: It has to do with writing the book about the internet. I remember things and phenomena from my childhood that happened in the pre-internet world. From time to time, in a somewhat abstract way, I'll say "in my childhood," but my childhood interests me less than the world of my childhood: the pre-internet world.

Azzedine Alaïa: It's fantastic to straddle two periods. You can see both worlds, belong to both worlds . . .

MR: I call up childhood memories to characterize a world and distinguish it from another.

DG: The idea of having the one world and the other has to do with the notion of community and the relationship between individual and collective experience— between microcosm and macrocosm.

CvW: I think what I do is important enough to me that it touches other people. In particular, the method I use can touch other people, or so I hope.

DG: But what are the prerequisites for it to touch other people? Abstraction? Motifs? The idea that it's not just personal?

MR: Behind *La Réforme de l'opéra de Pékin* lies a somewhat hidden concept, that of metempsychosis. In a way, the book is a Chinese metempsychosis. And there are several other texts—either already written or in preparation, even very old things that I've done, poems written fifteen years ago—that touch on the idea of being transposed into another world, another time. It's a way to cross personal life with history. It ties in with Schwob's "imaginary lives." More than imaginary lives, though, they're metempsychoses.

DG: It's really the idea of a play on permanence and movement, as in Christoph's work. What remains when you change the time or the place . . .

MR: From the standpoint of writing technique, there are two simultaneous aspects to transposing myself into these other times and places: a search for material detail, where I proceed by trial and error, and a sense that in the

depths of psychology there exists no absolutely fundamental difference.

AA: Every time I've gone to another country, I've thought there'll be a difference, and there's nothing of the sort. I've never felt like a foreigner in any country. People have the same human language. They live the same lives. Their gestures are the same. We've invented the idea of difference. Or if difference does exist, it's superficial.

CvW: In representation, the spirit of a place at a given moment is fundamental—the perception I have of it. I take up these elements, shift them around, transpose them. It's not a photograph. Photography corresponds to a fixed era, whereas painting does not. Painting's mission is not to correspond.

MR: Above all, though, photography doesn't work as well at night as during the day. Painting is to photography as night is to day: another mode of expression, another world.

CvW: Absolutely. Friends came to photograph what I was painting, and the photograph couldn't hold on to the poetry.

MR: It's the port of Hamburg, but it's more than that. It's all ports. And it's also an experience of contemporary life: the luminous networks we see at night, when we arrive at a port or when we fly over a big city in a plane. The heaviest industry takes on a strange, almost fairylike aesthetic dimension.

CvW: And it's incredible because it's easy to think that the landscape doesn't move, but it moves every evening. Every evening it's different, depending on the cloud cover. Every evening there's a different ambience. That's why there's an infinitude to it, and why the fascination of it lasts.

MR: Does a painting capture an instant, or do you bring several nights together into a single painting?

CvW: It's always a moment. The big sketches I do in gouache are always of an instant . . .

When I work with memory, a certain amount of the reality is lost, but the whole point for an artist is to restore it in your fashion. It's not a photograph of reality; it's the work of memory.

It's also the work of habit and novelty. You work within a space, which is the canvas, and you necessarily produce a composition that fits within that space. A perpetual re-creation.

Anaël Pigeat: Has your treatment of that landscape evolved over the years?

CvW: Yes, the treatment has evolved. Right now I'm repainting the canvas with a streak of gray, which changes the perception and unifies the work more.

MR: Being at a fixed spot allows you to perceive the changes.

CvW: The work evolves. I know there are decisive stages. One evening, I made my first large gouache in color, and afterward I made two paintings based off the gouache. You think you're always doing the same thing, and that you've exhausted a subject, and right then you make a new discovery.

I had a crisis five years ago. Afterward I thought, "It's inexhaustible. It's always changing! The paintings I make are very different." I've long had a plan to introduce the human figure, the figure of the world of labor. It rarely appears. But I finally came back to the port itself, and in a way that I find very fruitful. The years 2012 and 2013 were very fruitful.

MR: When you started working on the port of Hamburg, did you think you were making a break?

CvW: Yes, and I was wholly aware of it. When I'd come back to Paris from Hamburg, I'd take the night train. The last image you have in the train as it leaves the station and crosses the Elbe is a view of the port at night. That sight so fascinated me, with all the lights, that it lodged in my memory. And one day it rose up, with great force. I just had to do something. That was the trigger. First the view, every time I left the station and looked out the window before turning in . . .

MR: But does it tie in with a childhood memory, to seeing the port of Hamburg when you were a child?

CvW: Yes, but back then I'd always see it during the day. It's very different during the day, almost banal. It's a port that looks like any other. But at night it's like a powerful hallucination!

There are two big bridges spanning the Elbe. In the train to Bremen, it's on the right when you look out the window. You have the port in front of you, as far as you can see. And I thought, "That's incredible!"

There are even fires. In the first triptych, the middle section is red. I wanted to re-create the fire, the flames of the refineries . . .

MR: At night, when you arrive at Le Havre, after crossing the Seine on the Tancarville Bridge, you see tongues of flames, fire-spouting chimneys, like at the start of *Blade Runner*. Such landscapes are spectacular at night.

CvW: I always try to avoid anecdotes. For example, there's a district in Hamburg that Heine speaks of in a beautiful poem in which he evokes "sirens," the women who call to seamen, in the quarter of Saint Pauli. The term *sirens* haunts me, especially because the last of Debussy's Nocturnes is titled "Sirènes," a choir of women who sing wordlessly . . . One of the most beautiful things in the world!

I pondered that for a long time and I thought, "I'm going to do something on the quarter with sirens in it." But I couldn't. Why do I forbid myself to do it? Out of a silent modesty. I don't know.

DG: Have you ever wondered that, Maël?

MR: I was wondering about it as you were talking . . . It could be an interesting challenge to see how you measure up to what's already been done. Time can help us or free us, insofar as it's not necessarily up to us to judge what we can or should do. Time will tell.

AA: It's time that changes. When I do something, I never wonder whether so-and-so did it better. I try to do things within my era and with the means at my disposal.

I saw an exhibition on the fashion of the 1950s. Materials and techniques have evolved since then. You can express yourself with the same motif, but in another way. In the 1950s they cinched and kept things tight. Looking at the clothes, I thought, "The materials are different today." You can keep the form, but you'd use a much more malleable fabric. Today a woman can wear a tight dress and still run in it without impediment. You can sleep in the dress, fold it, stuff it into your bag. You're making a different dress. But the idea, the form, is already there; it's already been done.

MR: In what I do, the historical material often exists already, but there's no finished literary form to serve as a model. I could say that in its brevity and relation to history, *La Réforme de l'opéra de Pékin* has to do with the work of Schwob, Borges, Michon, and Quignard. I was thinking about them as I wrote that novel, and while writing other texts. They were helpful, inspiring examples. But there are many differences, too. In the execution, the inspirations recede into the background.

DG: What's present in the background, and nevertheless perceived, is important for you as well, Christoph.

CvW: Yes. Seurat, one of the greatest painters of the nineteenth century, is one of my major influences. I'm aware that my world is close to his. We share the same fascination. Seurat was fascinated with the theater, by cafés and lights.

DG: For both of you the sea is also very important. What does the sea represent?

CvW: The idea that what repeats does not repeat. However immutable the landscape might be on the shore in the evening, it's always a shore that you're on. What we see on the other side is so beautiful . . . It's that landscape that's unique.

In Marseille you have the sea before you. There's no horizon. In Hamburg it's an estuary, and when the boats arrive it's often at night. The ships, the big ones, are monsters, incredible floating cities. You wonder how they could possibly make their way in! But they're guided along by little boats . . .

The idea that you could leave, that you have to leave. That's another reason I decided at one point to come to Paris.

MR: What touches me about Christoph's paintings is that he reminds me of childhood memories, memories of sailing past the industrial port of Saint-Nazaire, near Nantes. As a child aboard a tiny sailboat, I was amazed by the masses, the sheer size of those port structures and the great cargoes—and, at night, by the enigmatic play of all those lights that we see in Christoph's paintings.

To answer your question more precisely, at first the sea interested me less than sailing. I like to look at the sea, of course, but for me it's always been the terrain for navigation. In other words, the terrain where you take a technical object, a boat, and make it move forward—in a spirit of competition, even. When I was fourteen, I wanted to draw boats. I was looking for performance and elegance in an object.

What interested me was the relationship of the boat to the element, the interplay between them. This doesn't mean I couldn't have a more contemplative relationship to the sea, but that came later. It was secondary for me.

DG: In both of you, there's a sense of permanence and, at the same time, an awareness of changes in time.

MR: Yes, even if that permanence is considered and nuanced. It strikes me particularly when I write about the internet. The permanence is channeled through syntax, not vocabulary. I'll speak of Facebook, Google, and so forth, and I'll use the new terms in a sentence that we might call classical, as you do, and as certain critics have already done in discussing *La Réforme de l'opéra de Pékin*. It can even become a game—like in the pastiches of La Bruyère—as seen in the insertion of Google and computers into a famous page from *The Princess of Clèves*, to be found in that book on the internet. It's a classicism that welcomes the contemporary, gives it form, with a sense that the conjunction might produce a singular result. I would add that, in my development, it's the fruit of an evolution. At eighteen and twenty years old, I was deep into the history of literature and philosophy. I wasn't interested in the technological revolutions then taking place. I was even rejecting images in general: the images of cinema, for example. The text had become a sort of absolute. It was a kind of hyper-classicism: closed and, no doubt, a bit sterile because in the end there wasn't any prospect in it but commentary, or references, or allusions to other texts.

DG: Why did you want to be so classical?

MR: I felt the need for a kind of asceticism. I alternated between ascetic and nonascetic periods, and it was during an ascetic period that I banished images. I was also sort of expiating my childhood, when I was bathed in images, as in most contemporary childhoods, and during which I felt I hadn't read enough. Reading books, as many books as possible, and not looking at images—it was all of a piece. That lasted two or three years, and then I got interested in cinema again, thanks to a text, actually: Deleuze's *Cinema*. I realized that I got a lot of pleasure out of writing about cinema, that the relation between text and image gave my writing a certain vigor. It was still commentary, or criticism, but it suddenly seemed closer to a certain kind of creation because the object, the reference of the text, was heterogeneous to it. The same thing happened a little later when I started jotting down thoughts about the internet and the digital revolution. So, that bizarre ascetic period was like a phase in a kind of dialectic. It might have left behind a classicism

of form, which is like a point of view on the contemporary.

AA: Throughout my childhood, I was fascinated with Velázquez and Zurbarán. I'd seen them only in books. Your first sensation, from the age of adolescence, is the strongest one. It was a mystery to me. It seemed unreal. I went into my imagination, dreamed of it, built a world that wasn't the same as my own and not the same as Zurbarán's or Velázquez's. One day, attending a salon, I came face-to-face for the first time with a Velázquez. I looked at the painting, looked hard at the paint, and thought, "My God, those are really thick layers of paint, and yet the lace is transparent—all that vibrant material." You get a different feeling from a photograph.

DG: Why should you need to be classical?

CvW: That's a good question. I've wondered myself.

AA: Every time I see an exhibition, I think, "Why did we invent such outmoded words as *classical* and *new*?"

MR: I'm not saying you have to be classical. I observe that giving a classical form to contemporary material produces certain literary results that interest me, that suit my taste.

DG: But why should the form be classical?

MR: Should it? That's the way it is for me. But I'm also interested in things that can be totally different from what I'm trying to do.

DG: Is abiding by a certain classical form part of what you feel?

MR: It's not something I keep constantly in mind. In writing, it takes the form of rejecting certain fashionable turns of phrase and clichés, paying attention to punctuation—little technical matters that stem from slow, repetitive craftsmanship . . .

Caroline Fabre: It differs in form, not in content.

MR: It's also a liberty, a way of choosing. The modern says, "I must speak of this because everyone is speaking of it." Whereas the classicist says, "I want this. I can speak of it." But it's a choice. That, too, is where the difference lies.

CvW: Classical certainly does not mean outmoded. On the contrary. It can't be outmoded.

AA: We speak of the eighteenth century's language as a classical language. What did people know at the time? In the eighteenth century, people reigned young, whereas today our knowledge hasn't yet peaked at forty-five. By "classical" we mean a turn of mind and nuance in the French language. But the question of time has to do with the time we spend acquiring these things. In truth, when we step back, when we look at Matisse, Cézanne, and others, there really is no classicism, no modernity. For me, there is no boundary.

MR: I've come to realize that when I write, I'm often speaking of the relatively recent past as if it were remote. Or even of the present, the present of life with the internet. In this sense, the classical form creates a sense of time. It gives the present temporal depth and intensity.

CvW: I like being in the present, in the immediacy of a place. Because I'm always afraid of repetition, and so I oblige myself to get to the heart of the pictorial problem. From there arises the possibility of shifting it, going elsewhere. There's something in points of light in the night that connects back to an origin. That perception has evolved, I think. I see it a different way now than I did ten years ago. The painting is more fluid, more vibrant, more felt in my own emotion . . .

I used to be colder, more distant from lived experience. Now I'm more in the immediate, with more engagement, I think. I'm more vibrant today. I think I'm better able to understand. There's more emotion. I'm both returning to the origins and taking up the history of painting. I mentioned Seurat, but there's also Monet.

I remember our pilgrimage to Belle-Île. We were in a little hotel. Arletty had a house at Belle-Île. The cliffs that Monet painted are a hundred meters away.

And Cézanne. I saw Mont Sainte-Victoire when I was in Aix, and I completely understand why he made it the hub of his language. Cézanne thought of himself as classical. When you see his last bathers, they're like stones! He paid extraordinary tribute to Poussin and Delacroix . . .

AA: The problem isn't just to be classical, or strictly modern, but to move beyond both. Copying classicism isn't being classical; copying the modern isn't being modern. Those criteria make no sense. Being outmoded, being classical: no. Being of today: yes. When

the young come up, they have a vision. They discover the world of art, and that vision exists on its own. It doesn't bother with the classical or the modern.

DG: But the memory plays a role for you. In your dresses there are traces of Zurbarán, for example.

AA: The painting you're referring to is my favorite work of Zurbarán's. And not for a second did I think of Zurbarán. I made the dress for a girl, made her a cape, and once I set the hood on her head, the image of Zurbarán's painting came to me. It's crazy, and at the same time it's what you were saying, Maël: the mind records.

The first time I saw a dress by Vionnet, I was at a client's house, and I saw a woman's picture on her nightstand. I said to her, "She's funny, that woman." She replied, "That's my mother, in 1935." And I thought she was wearing a dress by Comme des Garçons. "That's impossible!" I thought. Like those *drapés* I spent five hours on. Vionnet would send out draftsmen to copy Greek *drapés*. She even sent people to Tunisia to see how to make a fabric into a seamless *drapé*. It was perfection. And so I made that dress.

MR: There are also things we do that resemble things we don't even know exist, despite the affinity we share with them. Late last year, in one of Anthony Powell's notebooks, I found a citation from Robert Burton's *The Anatomy of Melancholy*. What struck me was how close it was in theme and construction to the first sentence of *La Réforme de l'opéra de Pékin*.[1] Had I read it beforehand, I'd have been very happy to say that it was a reference to Burton, but that wasn't the case!

AA: That's absolutely true. We do things and one day discover that they've already existed! In any case, everything has already existed.

CvW: I'd like to talk about melancholy. I'm obsessed with it.

MR: For me, melancholy ties in to what I was saying about reminiscence, memory provoked by association, a scent, and so on. In a way, melancholy is, from an affective standpoint, what reminiscence is from an intellectual standpoint. It's an aesthetic sense of existence. It's different from depression.

[1]"Today we hear of new Lords and officers created, tomorrow of some great men deposed, and then again of fresh honors conferred."

CvW: I'm a melancholic, too, and I found echoes of my feeling very early in Dürer. One of his most beautiful works is *Melancholia*, which contains important symbols of time: the hourglass, the reckoning angel, a table of figures. A major Renaissance work.

Not long ago, I discovered in the first cycle of six quartets of Opus 18, the most important six quartets of Beethoven's youth, that the sixth quartet ends with a movement called "La Malinconia." These two immense geniuses keep me company through melancholy's night.

My fascination for the night is related. Since antiquity, melancholics have sided with Saturn. They're on the side of blackness, and color is perceived through blackness. Memory governs their relationship to time.

AA: Modernity is speaking of one's own time. Your era is what determines modernity—the way we adapt to it and take on its form.

MR: I draw a distinction between melancholy and nostalgia. A nostalgic would like to return to the past. With melancholy, the present is intensified by the past.

DG: Melancholy represents an aesthetic relationship to the world. The big question today is the relationship between the aesthetic way of life and a political way of life, between the melancholic and the "heroic."

MR: I think they're related. Political life ties in with history and the past, but also with destiny. We entrust our lives to forces that are beyond us, and success and failure pass henceforth out of our hands. There is no melancholy in the experience of a certain powerlessness at the heart of power. De Gaulle employs the term *melancholy* several times in his *War Memoirs*.

CvW: I understand what Maël is saying. We don't live—cannot live—in an ivory tower. I'm not insensitive. I'm in touch with my surroundings. It's true that I'm not engaged in any political action and will never be. My father was very engaged. I've separated myself from that since childhood.

The question of the community is to me fundamental. I hope it doesn't feel too cast aside. I don't feel it that way. I don't express political things, obviously, nor am I doing conceptual work.

What I do intends to touch the person, and it does touch people. The people who

see my work aren't insensitive to the vision I'm developing—not of the world but of a certain world, a world both local and universal, that ties in with the internet. It ties in with my interest in that geographic place, which resonates with me. It ties in with my memories and goes beyond them to achieve a kind of universality.

MR: Christoph's paintings also evoke a somewhat mysterious world of labor, one that holds sway in the dead of night—the parallel world of those who serve every night as the precursors and sentinels of diurnal existence. A night that is neither absence of light nor absence of activity. One that is in fact the opposite: an intensely lit, intensely active night.

CvW: That's what is important to me. If it were just lit up like the Champs-Élysées, I wouldn't be interested. Instead, there's constant, intense activity. Everything's in motion.

DG: At the heart of what you both do is a sense of how powerful the present forces are. The force of history, the force of memory. Both of you deal with serious issues, however modest your motif might be.

MR: In a way, a motif, or a character, in its modesty or obscurity, specifies the scale of the issues.

CvW: That's really the fundamental question: the question of our presence in time and space. This is what Wagner's Parsifal speaks of in an enigmatic phrase of the first act. It's Gurnemanz speaking to Parsifal: "You see, my son, time here becomes space."

MR: Time appears as soon as I write a text. It not only appears but also plays a role and provokes something: either by distance or by the conjunction of two distant things that, at a specific moment, end up close by and facing each other. This is the essential material. It's always one of the characters.

AA: That time is definitely multiple: the time in which you are, the time in which you live, the time that remains. At a certain point, you really have to bring time to a halt to do what you need to do, in time.

MR: My impression of late is that my picture of time has changed. This might be because I'm approaching the midpoint of my life. It used to seem to me a sort of infinite straight line, and now my relationship to the time span of my life has become more spatial. I feel as if I've climbed a tower, from which everything seems

simultaneously exposed, so to speak—past and future alike. I can almost see, almost touch, the moment when I turn fifty. It feels as if time has become spatial, and life has become finite. Life has become like a geographic territory, where you can go here and there, but you can't go everywhere. You have to choose. It's a sense of finitude that isn't tragic because it ties in with a sense of mastery—relative mastery—over your own life, which at the age of twenty seems to escape you because of the great extent of the unknown and the distant.

AA: It's not a matter of age. It's a matter of awareness.

CvW: I couldn't have spoken the way I'm speaking this evening at twenty.

AA: You've taken your time. All the eras of our life, all eras, have an interest. You just need the time to work. If you say, "I'm going to stop and write" or "I'm going to stop and create," then hats off to you because you've understood that the system destroys at the instant of full creativity. You have to advance and advance. Time will do the work.

11

An artist who can reinvent himself is an artist unbound by time. It's always your time; it's not time that conditions you or forces you to submit. It's your time, just as it's your talent.

—Vittorio Grigolo

Alexandre Singh: Will you be getting up early tomorrow to warm up?

Vittorio Grigolo: As a muscle, the voice is the last to fall asleep and the last to awaken. So you have to get up two or three hours before rehearsal for the voice to be fully awake. And you, do you get up early?

AS: As soon as I can. That said, I'm not very effective without eight or nine hours of sleep.

VG: Me, neither. For the voice, the more you sleep, the better off you are.

AS: My ideal would be to sleep for eighteen or twenty hours, get up, get onstage, act—

VG: And have no life. That's what I've got!

AS: Vittorio, you were saying that you'd played the same role, a role like Rodolfo, several times. Normally, a theater actor plays a role once or twice in his life. But in opera you might get onstage and play the same role almost every year. Do you have any particular relationship, psychologically, to the characters whose lives are so closely intertwined with your own?

VG: No. What changes is the point I'm at in my life. The character is always differ-ent because the man is different. The man has different stories: I have a different life, I meet different people, I'm at a different point in my life, and my relationship

to time itself is different. I'm currently in a period where I'm doing many things and have no time for myself. I'd like to have that time.

It's true that I have control over my scheduling, but when we take sleep, performance, and study out of the equation, there's not much left for me. But the time that does remain is always the most gratifying time because it's my own. That's the time where I needn't be steered by someone else. You, you're an artist, you create your works, you take your time, and you express emotions in your time. I must be capable of expressing emotions in a time that doesn't belong to me, or not to me alone.

AS: Yes. When you're onstage, you can't just stop to—

VG: No. I can't say, "I love you," or express my sadness the moment I live it. I must sustain a bar of music, and during that bar I must be able to express all those feelings. It's even harder than acting. I must act during a measure that doesn't belong to me, that belongs to the music. That is the challenge. But an actor is always growing, always expanding his experience of life. There's always something in the score that you see better through the eyes of a man with more experience.

AS: Would you say you're becoming more profound in your art?

VG: Yes. Even my voice is maturing, getting rounder, gaining in color.

AS: In the commedia dell'arte, a mask is called a "persona," the idea being that the mask contains the character, that when you don the mask the character pervades you.

VG: In your works, where does the mask end and where do you begin?

AS: We might say that all the characters you create are aspects of yourself. After all, it's hard to express something that you have not personally experienced in some form or another. Hence, there's a little of the author's voice in every character he creates. I should note, however, that I don't draw a huge distinction between lived experience and experience gained "at second hand," so to speak, or even through another work of art. We humans are extremely empathetic creatures, and very imaginative as well. We have a real knack for projecting ourselves in a significant way into the lives of others, whether those lives are real or fictional.

VG: How much drama and how much pleasure are in your stories? How much

time do you accord in your work to joys and sorrows, to light and dark?

AS: Half and half. You need the brightest light to cast the darkest shadows.

VG: Have you had as much drama as joy in your life?

AS: My life is fairly gray in comparison to my work. My joys and sorrows don't hit the same highs on the Richter scale. And, to be honest, I wouldn't have it any other way.

VG: I am, I must admit, completely different: I'm fast in everything. That's no doubt why I have a tendency to burn through my moments, because I'm always striving for more, striving to get it right now. When I think I lack the time, whenever I go somewhere new and find something interesting, I wish I could lock my discovery in a box and carry it with me. But it's not possible. I'd like to gather all the people I like and take them with me; they'd come along anywhere I wished to make myself liked. This is perhaps my biggest battle against time: always striving to be liked. I'm always looking for confirmation from the people around me. I always want a confirmation of love, and I don't have the time to get it. So I always try to show what I'm like. I haven't the time to hold back, to study, to try again. If we like each other, we like each other, and if not, it's over.

Donatien Grau: The two of you are polar opposites. Vittorio, you intensely live each of your characters, and it has an impact on your life. All those opera characters you play are, to some small degree, you. Just as you become the tragic characters.

AS: Vittorio, would you say that those characters live more in the text of the libretto or in the notes of the score?

VG: They exist in me, not in the text or the music. I'm the one who takes them onstage; at that point it's no longer the composer or the music. The instrument is my body, and my body is alive. It's a thing that lives every day. We have experiences, we feel good, we don't feel good: it's all in the physical. Everything is a matter of the physical, not of the music. The music, if you don't have great artists to play it, is just a nice page of ovals and black dots. And once the composer has died, what's left to serve us as a reference? We no longer have the composer to say, "Ah, well, I was thinking of such and such when I wrote *La Bohème*. I was in love with a woman at the Moulin Rouge, and I wrote that music."

Alexandre, explain to me the relation between the time of your works and the time of your life. I'm curious to know.

AS: My life is my work. But the work is often slow; ideas filter for months, and then there are brief periods of intense creation—and intense stress! There's a lovely moment in François Truffaut's film *Day for Night* where Truffaut explains to a young Jean-Pierre Léaud the difference between the world of life and the world of art and the relation between the two:

> "I know, there's private life, but private life limps along for everyone. Movies are more harmonious than life, Alphonse. There aren't any traffic jams in movies; there's no idling. Movies push on like trains, see? Like trains in the night. People like you and me, as you very well know—we're born to be happy making movies."

Azzedine Alaïa: Time isn't the same for a singer like you as it is for an artist. The instrument isn't the same, and it isn't used in the same way.

VG: How much Alexandre is there in your characters, how much time from your life in your stories? I want to know how much your time of life, of your experiences, of your youth there is in your work. Do you always come to the present laden with the past, so as to have a better future?

AS: When you tell stories with fathers, grandfathers, artists, prostitutes, singers, engineers, the experiences aren't necessarily ones that you have lived, but I nonetheless think of emotions that we've all felt, directly or through empathy.

We cannot overestimate the empathetic quality of humanity. After all, it's the chief mechanism of art. The subject of every story is what it is to be human: to be born, to feel fear, to want to love, to want to be loved. The experience of being human is head-spinning and frightening, yet it can be utterly commonplace at the same time. Art's objective is to try to find a story in that confusion of sentiment and distill it to its purest essence.

In the same way, writing a story is a fairly calculated exercise. You prepare it like a Swiss watchmaker assembling a movement. This scene connects with this other one; relieving the tension in this character will turn this other character into a total savage, as in a spiral. It's a dispassionate enterprise of precision and technique. And yet the beating heart of a story, the ultimate fate of the characters—all of it is very dear to me. Of course, many elements from my own life end up in my work.

They're the elements that remain, that are the most available. But I give them no more or no less weight than I give to ideas I collect purely from my imagination, or from the lives of friends and my own encounters, or from the plays and novels of writers I admire. What matters, in the end, is that the individual parts cohere into an enticing story. A story that describes an emotional "truth." And yet that "truth" is constructed to produce an artificial effect. It's a love letter written with care and attention, with the purpose of altering the judgment of readers, so that the author can have his way fooling them.

AA: Between music, painting, and fashion, I feel that time has been too sped up for creation.

VG: The time I lose is my life's time: the time for me to take my time in life. But in what I do, I don't speed up. I take my time. Sometimes I feel that I have no time because I sign on for operas that I haven't studied or that I haven't sung onstage in a long time. So I don't have much time to commit them to memory. But in that case I draw heavily on my intellectual qualities rather than on my vocal ones. I push my understanding harder, so that I can take things in and put them together and find out what happens in the piece, and what its emotions are, and how I can find its echo in my own life.

When singers talk about pushing, they don't mean the sort that hurts the voice. When the emotions are in charge of a voice, that voice will always be long-lived. When you make use of the interest on the emotions and not the initial capital—whether it's in fashion or in art or in plays—your potency will last. Because it stems from a need. When you lack the time and you want to achieve something in a truly limited span, you want it, and it is desire that makes the difference. I must do it because I want to, and not because someone else has hired me to do it.

It's an inner need. It's not someone else, it's not money, it's not external time that interacts with the human being. It's the inner time of the artist, which is completely under the artist's control. It's dominated by the charisma and character of an artist who knows what he wants, who knows where he wants to go and when he wants to get there. He knows what he must do to keep time with him. When I do some-thing, then, I do it in a time that belongs to me. Above all, however, that time has a nonmaterial, non-external basis—an internal basis. Like a baby that cries when he gets hungry. A baby breathes perfectly from the diaphragm and has perfect tone. He can cry for hours. The voice never falters, and everyone in the building can hear it.

Why is it that a baby never loses his voice? Because the voice is supported by a true need: he's hungry; he needs love. It's a true emotion that fills the time. When you don't have a real emotion to fill your time, you lose your voice. When you have no real need, you concern yourself only with technique; you make lovely clothes, but clothes without soul. It's not like Azzedine, someone who's at work at five in the morning, watching the animal channel and listening to music and pursuing the quest. Azzedine is crazy, and a genius.

We speak of genius, not of regularity. An artist's time is never the time of a common man, of a person who works Monday to Friday. There might be people who are artists in their salaried jobs. Here we return once more to the need for a time we choose. It's possible to work Monday to Friday on work we've chosen, and that time is therefore special. It's chosen, wanted time, and it does not have the same meaning. How many people work in offices but want to be designers, or yearn for a time that will never belong to them? Without that energy, without that emotion to support a passion, your voice will die off, like a big coat slipping from your shoulders.

AS: It's true there's great tragedy in not having any control over your own time. In being forced to spend your time doing things you'd rather not do. That's often why a baby ends up bawling. Because he doesn't want to eat. Because he doesn't want a bath. I'm fascinated by the moment in life when a child, full of needs, takes action in a world he doesn't control. For a baby, the parents are gods who control every aspect of his life. I'm curious about that moment when a young child must become an actor. He starts to cry, but then quickly exhausts the emotional reserve that feeds his histrionics. So he stops, takes a breath, and searches his memory—his rather short memory—for a sufficiently traumatic experience with which to fan the flames of his fury. I enjoy seeing that moment when the child starts trying to manipulate the people around him, in a deliberate but as yet not necessarily conscious way.

VG: I was born to a generation that isn't mine. I'm always thinking that my time is not its time. I always think of myself as inhabiting a medieval time; I think of myself as a knight, a hero. I like the idea of living a short life. Right now I'm studying *The Tales of Hoffmann*: "Life is short. You have to liven it up as you go along. You have to." So it seems to me that that time is a time that goes by too fast and doesn't allow people to realize it's still possible to live one life instead of striving to live four or five in a lifetime. Everyone says: "Ah, but I've got time, so I can make another life for myself."

In this century, where time has always gone fast, where we've always reached for a

sort of shorthand communication, we're always thinking in the back of our minds that we can remake ourselves. In 1967 Marshall McLuhan coined the phrase "global village." The world is going to become a global village. Now, time has been shortened by jets, by Facebook, by the internet. But the most important thing is the need for communication, which has been stymied by electronic systems that allow no emotions or meaning to come across. Conversations by phone shorten distance, but when I come to your house, you see me, you sense me, I touch your hand. We've sought perfect communicability and believed that the internet, the telephone, and other media could bring the world together, but only for matters of business. Because once I make use of a medium, that medium takes me over and subjects me to its time. So communicating, the thing we're doing this evening, is something that allows us to hear, touch, and sense one another. With the internet we've lost everything.

AS: I agree with Vittorio.

DG: You have a somewhat distant relation to the world, and because of that your work is different.

AS: The sense of alienation with respect to a changing world is universal in human history. Let us acknowledge, though, that in ancient history, great innovations were rare and well separated in time. But that doesn't mean they failed to inspire the same excitement and fear that technological change inspires today. We should perhaps keep in mind that, tempting as it is to think that our own moment in history is unique, we have always been confronted with developments and breaks in continuity, especially where communication is concerned.

The reason we have so much information about Greek philosophy, for instance, is that it was produced right when an oral tradition was giving way to a written tradition—a change that Socrates bemoaned. Socrates placed great stock in thinking for yourself, and he considered oral dialogue to be the greatest of pedagogical methods. Having his words carved in stone by Plato, fixed forever and imbued with terrible authority, would for him have been anathema. He considered it a devaluation of thought. In Great Britain, similar opinions condemned the advent of the inexpensive printing techniques of the pamphleteers and the proto-newspapers that soon littered the streets of London.

Some people might think me enamored of the past, or hostile to the modern world, but that's not really correct. I'm simply taking stock of the great mass of culture and

change that has accumulated in the brief time we've had on this planet. Hastening to love the new just because it's new is as strange as rejecting change out of some penchant for anachronism. What delights me about modern technology is that information about the past, once so hard to find, is now just a click away. In this way, the present has brought us closer to the past than we have ever been before.

AA: We try to live it, but we should also leave a little time for ourselves. Otherwise we'll have done nothing but serve the passage of time.

AS: Life is a dramatic framework. There are good things and bad things. God's finest deed was to introduce the serpent, because things would otherwise have gotten boring.

VG: In life, there's a kind of time that is in touch with and relates to everybody, a time that everybody handles the same way. I think it's important to visualize all those moments, those equal moments of time that everyone experiences the same way. And, above all, there's one very special moment in life: the moment of sin, the moment when Eve chose to touch the forbidden fruit. The moment of sin is the moment that connects us all and ushers in free will. It's what sets humanity before choice. In that moment, you have the time to choose whether you will go to the left or to the right. It was the choice of Eve and Adam. It's our choice today.

AS: Certain neurobiologists believe that free will does not exist, that it's just an illusion. Suppose we could know the position of every particle in the universe and, at the same time, its velocity, which thus precludes quantum mechanics. If we also knew the laws of nature in full, we would be able to predict the exact future of the world: every act of every individual would appear in a predefined, immutable order.

This is exactly parallel to the relationship between an actor and his text. When an actor playing Hamlet steps onstage, he is lost in torturous indecision. Like the actors playing Romans in Roland Barthes's essay, the sweat beading on their brow, our Hamlet struggles against the unspeakable suffering of choice. And yet, no matter what happens, he will always make the same choice. When all is said and done, Hamlet will always end up dying beside Laertes and Claudius. Because it is written. Every performance, every evening, Hamlet must live through that Sisyphean hell. We from the outside might consider that Hamlet has no free will, that his every choice is inevitable and belongs to a preexisting order, but that has no importance for the character. He feels the weight of decision. For him, all of it seems to be free will. And that's really the only thing that counts.

VG: How many times in life have you made a choice?

AS: As I've said, we think we choose all the time.

VG: What has been the result? If you could give me three choices, what would they be? What is this time that you've taken and that has made you into the artist you are, or into the man you are?

AA: I still think there's a path in life, and decisive moments as well. I've lived that moment. Previously everything had been for later. At the death of my sister and of my dog, I realized that the people I loved—I'd never had the time to tend to them. Today people don't have the time to live their love stories. We chase after success. Today you're a star; tomorrow you're a star no longer. And we think that what we are—what others believe us to be—should determine what we are truly, and what we do.

I stopped doing collections because I wanted to bring time to a halt. The pressure is on nowadays for people, for creators, for artists: they chase after time and become almost hysterical about it. But I'm living and trying to exist in the time of today's youth. I'm always living the era. I try to help young people in serious predicaments. Things are really tough for young people today.

VG: You're searching to communicate with a public, just like me. I'm always trying to draw a younger audience to the opera. I'm constantly reinventing myself. An artist who can reinvent himself is an artist unbound by time. It's always your time; it's not time that conditions you or forces you to submit. It's your time, just as it's your talent.

III

Even the things we're not going to do, we have the illusion that
we're going to do them. . . . That's where you're free. Even if
I won't have the time to do this or that, I'm free to dream that
I'm going to do it, and the dream fills me with hope.

—Rossy de Palma

Azzedine Alaïa: You, Rossy, are an actress, and you, Blanca, a dancer. What is your relationship to time, in your work and in your life as women?

Rossy de Palma: I can take greater advantage of time as an actress, and that implies a life. You can live many more things by looking at characters and using your body as a tool. You learn from the experience. After you've performed a role, life is more interesting than it was before. Every role is like donning the cape of a new life. Cape after cape after cape.

Blanca Li: In dance, your relationship with time is very close to your relationship with your own body. There's a sort of memory in your limbs, so that when you execute a movement, you're taken back to when you learned it. Even today, I'll work some exercise and see myself as I was years before or remember the exact moment when I learned it. It's a consequence of the profession, of the know-how. It's a bizarre sensation, like strong flashbacks that come every now and then, in a very natural way.

AA: It's your body's memory.

BL: Yes. Above all it's the memory of the moment you learned something with your body. I imagine it's the same for an actress.

RdP: Yes, we actors can experience that particular power of memory. But in my experience it's more of an emptying out. I'm not interested in intellectualizing

characters. Instead, I clear out space for an event to take place, as an animist would. I'm surprised to see sometimes that my body will move differently from the way it moves in everyday life. I've loaned my body and my voice to an animate thing. I don't know what it is, but it happens. In this sense you can truly sum up acting in the famous phrase: "In acting there's only the present."

BL: I began thinking a lot about time when my father died. It really unsettled me. At that moment something changed in my experience of time and my analysis of life. It's the moment we switch generations and move forward in life. Time takes on other dimensions. It's very strange.

RdP: All artists think they're immortal.

AA: Death helps us understand that time passes. Before the death of my grandparents, I'd say, "Later." But after that moment, time changed. It accelerated. I couldn't say, "Later, later, later," anymore. You realize that life is getting shorter and shorter. An artist has a lot to get done. As long as you're in shape, you should figure out how much time you have and step up the pace. Later you enter a period when you have to think differently. The brain works the way it did when you were eighteen, but the body can't follow. So you fight to keep it from falling apart. You don't want to let it win.

BL: Yes, because you start thinking about your own death. Once you start thinking about your death, you have to evaluate the time you have left. As an artist, it's strange to think of the time that's left and of the things yet to be done. We're so into our creativity that the urgency ends up dominating our thoughts.

Since my father died, I've been thinking in terms of urgency. I think that I should be doing more in less time, that I should be more radical. I feel that I ought to be doing things the way I feel they should be done and stop letting things overwhelm me. I do what I have to do. I don't take detours anymore.

RdP: It's the same when you become a mother, too.

BL: Yes, maternity gives you a new reference point in time. You start counting by the age of your children. It's a new start.

Donatien Grau: What's the dynamic between your time for creativity and your time for life? And the time for your children's lives?

RdP: It's horrible. When you're an artist, you're in your own dimension. You have to set it against reality, the pragmatism of reality, and all the obligations of reality.

BL: I made the decision to become a mother. I didn't think it would happen to me because I'd never felt myself to be very maternal. Then one day it just hit me, like a need. I had a child out of a real, well-considered desire, not by chance. It was an essential decision. I became a mother. That role is part of my life.

I've always given that consideration to my children. It's very important to me to share what I do with them, so that they understand that it's my profession, so that they can partake of my adventure as an artist. I include them as much as I can, so they understand that when I leave it's important to me, and it can be important to them as well. You don't have a choice when one of your parents is an artist. You have to live with your father's or your mother's passion, and understand it. The more you involve yourself in what your parents do, the closer you can come to that world and the more you understand that your parents are not like other parents. They're not going to be around as much.

The time you spend with your children is rare and precious when you're an artist. You want it to be of high quality. For that, too, you become radical. When you have children, you have to be effective. You want to be an artist and can't live without your art, but you're also a mother and can't live without that, either.

Your time—whether it's your life as a woman, a mother, or an artist—is infinitely precious. You have to be effective and pertinent, in total accord with what you do and what you produce. Otherwise you're better off elsewhere.

DG: Rossy, you were speaking of an actor's time as suspended time, time that's elsewhere. How does the relationship between time that's elsewhere and the time of life play out?

RdP: I've felt it that way ever since I was little. I was constantly thinking I was missing out on something elsewhere. I'd play, but I'd think that somewhere else, in some other place, I'd be having more fun. Sometimes when you're young, the people around you, even when they aren't hostile, aren't necessarily your real family. Later, when you grow up, you find people who are like you and you can feel comfortable with. You think, "I'm not alone. I'm not an alien. I'm with people who are like me." But not in the beginning. My first love was Dadaism, which was like an oasis for me. There were things I didn't understand intellectually, but I found

relief in it. There was something there that was waiting for me. My first heart-break, as I recall, wasn't over a boy; I was madly in love with the moon. Then someone told me that the light of the moon wasn't the light of the moon. It was the sun that provided the light. That was a terrible disappointment because I'd thought the moon was independent and didn't need anyone else to shine with that beautiful light. I was really upset.

DG: The time you spend around the oasis of acting is sort of illuminated by the time you spend within it.

RdP: It's like when someone says, "I live in Instagram. I do what I need to do here, but the land I really live in is Instagram." Instagram is the book where you can make your dream a reality. Real reality is difficult and prosaic. We're sort of allergic to all that. We want to be always open to creativity and dreams. That's what keeps us going. Otherwise, I'd be depressed. Even the things we're not going to do, we have the illusion that we're going to do them. The illusion comes free of charge; no one's going to tax you on it. That's where you're free. Even if I won't have the time to do this or that, I'm free to dream that I'm going to do it, and the dream fills me with hope.

DG: It extends the idea of time.

BL: Absolutely. Sometimes you say, "A year from now I'm going to do such-and-such." And then one day you realize that the year's gone by. You might have a strange sense that the time between the moment you decided to accomplish some-thing and the moment you finally realize that you didn't do it never went by. You wonder what you did during that time, and you realize you did fifty million other things. Paradoxically, you can simultaneously feel that time has flown and wonder how you could have done so much in just twelve months. Sometimes time's gone by like a hallucination. As a child, you're always waiting. As an adult, you feel that time goes by faster and faster.

RdP: It goes by very fast when you're happy. Ten minutes feels like an eternity when you're upset.

BL: That's something I keep in mind when I plan out a show. I love going to the theater, but when a show bores me, it starts to feel long, eternal, painful. Every second I'm sitting in a theater seat watching something I don't like is excruciating. Whenever I put on a show, I think of my own experience. I'm careful not to

impose that terrible sense of boredom on my audience.

My shows are super fast, maybe for that very reason. My mind needs to be engaged. When I see something, I should be utterly absorbed, or else something's not working. I should disappear and melt into the work. If I'm watching a show, I should forget who I am. I shouldn't exist anymore. If I sense myself, if I'm not comfortable, there's a problem. It's the same with any work of art. You should be sucked into another world, and time should become immaterial.

DG: In a way, speed in a show is a means of suspending time.

BL: It's so that people won't have time to get bored. Creation allows you to convey emotions and sensations. You put other people through an experience. To provide that for your audience, you really have to believe in what you're doing; you have to live it to the fullest. You can be wrong, but it's imperative that you're 100 percent yourself when you create. I couldn't create any other way. When people come see a show, they buy a seat and make some kind of trip, short or long, to get there. I've had people come from other countries to see my show. They open themselves up to you. It's a fabulous show of love, so you have to be at your best and not disappoint them. And for that you have to plunge that person into the rhythm of the dance.

RdP: Sometimes in a show there'll be a moment of suspense, when nothing happens before some event takes place. There's a beat of mystery.

BL: I'm not saying that a show without action is empty. There are some minimalist shows that are absolutely magnificent. But it has to be well done. There are infinite ways to convey an emotion or an idea, and calm and silence can be extremely effective. Bob Wilson is the best at that. His work touches me deeply.

Dance produces its own rhythm: one, two, three, four. Dancers spend their lives keeping time. They're clocks. They beat time until the rhythm enters their subconscious.

RdP: It's the wonder of poetry: going beyond time.

BL: Yes, it's true. In dance, you always have to get past the technical stage, where you're learning the movements and counting and subdividing the time. With repetition, the rhythm and technique become second nature, and you reach another level of understanding your movement. From that point the movement almost

performs itself. Then you're free. But a dancer faces a long road to freedom.

AA: After a certain time, there's a different emotion in the same gesture, the same rhythm, the same movement. You can feel that there's something there, a kind of freedom.

BL: Some dancers never get to be free because they remain at a technical level. Only those who get past technique achieve freedom.

It's dangerous to know you're going to make a movement. For example, if you want to slap somebody and they're aware of it, they're going to flinch without meaning to. There's the same problem of anticipation in dance as well. You learn the first and the second position. If you're thinking about a movement's end while you're still starting the movement, you endanger the poetry.

AA: Except for a solo dancer. She can do it. She can imbue her movements with emotion, more than she could in a group. In a group, you have to line up, all at the same time, making the same movement. It becomes a regimented show. But a solo dancer can make more emotive movements. She does it on her own.

BL: People often say that the great dancers are very bad in groups because they're too visible.

When I was little, I was on the national gymnastics team. I wasn't any good in a group. I couldn't blend in to the ensemble when the choreography called for it. I learned to do that later, as the years went by.

RdP: I acknowledge that I'm bad at doing things the way everybody else does them. I have trouble with that. I need room to choose, room to be vibrant.

AA: You need to create your own time, establish your own rhythm.

BL: Being different, having very specific and personal desires, can cause problems in certain professions.

When I choreograph for the stage, I can have a dancer enter the stage, stop, do nothing, look at the audience, and then gradually move an arm. All of that could last three minutes. Onstage you can suspend time. But the same thing won't work on film. Time doesn't work the same way if you're choreographing for the stage

or for film. That's why filmed shows are generally boring. Images require another rhythm.

DG: Rossy, you have experience in cinema and in the theater. Those are two different kinds of presence, two different temporalities.

RdP: So many things happen behind the camera, it's something of an adventure. When you're a director, you're interested in everything that happens in front of the camera. When you're an actor, none of that is your responsibility. You might make bad films, but you travel, or learn a language, or meet interesting people. There's always something to be happy about.

In the theater, though, I'm incapable of doing anything if my heart's not in it. If I'm not feeling it, I'm incapable of bringing out the things I otherwise bring out every day.

I can safely say that I've had my ups and downs in cinema, but in the theater everything I've done has been good. I have to be there. I have to be able to produce that presence.

AA: You forget your anxieties and your troubles. There's a moment when you're no longer in time. You're living in a dream. You don't think about passing time. In moments like that, when I'm working, I don't want to check the clock. When I get up every day, I wonder what day it is. I don't wear a watch.

BL: At rehearsal, the dancers will sometimes interrupt me because they're hungry, because it's two o'clock and they have to stop. I'm so absorbed in what I'm doing that I don't have the same sense of time.

AA: It's hard on dancers. Theirs is the most difficult career.

DG: Along with an actor's.

AA: For actors, it's a matter of period. First you're a young lead. Then comes a time when it stops, or else it continues. You have to make it to the next stage. If you succeed, you play fathers or grandfathers. Those are hard transitions for actors. For dancers it's even worse. Once you hit forty-five, it's over.

BL: Yes, and it's not fair. You should be able to dance for as long as you like.

AA: You can dance in another way. You're under no obligation to make dangerous leaps to dance. It's hard for prima ballerinas. Once you become a prima ballerina, you have very little time left to dance, and the competition arrives. It's terrible for dancers—worse than for actors or singers. You can sing until you're eighty years old. Your voice can last if you take care of it.

DG: Rossy, you've lived the actress's experience—

RdP: When you're an icon, you're ageless. You're immortal! When I was twenty, I was abnormally mature. I had my fit of madness at twenty-one, and that's when I had my adolescence. Afterward, I settled down. Now I'm turning fifty and feel younger on the inside than ever before. I feel that there's finally some sense to what I am. Up until now I've just been going down roads that take too long. Now it seems that the real me has emerged. The first word my daughter ever said was *no*. It's taken me forty years to learn to say no. People should learn to say no; it's important. I try to make time as I please. I think to myself that we can change the sense of our biology, that we can get past that frontier with our minds.

BL: I hate schedules. They're intolerable. I need to be able to set my rhythm day by day and spend the day as I see fit. I'm always telling my dancers, "We'll take a break whenever we like." But when I'm working with an opera house or an institution, everything's scheduled down to the second. There's the ten-minute break, then a break at three o'clock, and then you're not allowed to work past a certain time. You're in the middle of rehearsal, living this wonderful experience, and you can't squeeze out another fifteen minutes. People interrupt you or stop you from working because things are on the clock and you're going to have to pay double if you stray even a little from the rules. I really had to work to accept that. I find it shocking the way we keep institutionalizing art. They impose a schedule that doesn't work for you, and you're timed, and they work out your value by the hour. Every day when I'm with my dancers, I'm reinventing time.

I think you need to keep time elastic when you're creating. Things get so organized sometimes that creation ends up being the last thing you consider. You're in the middle of creating, and it's of no importance. I find that very sad and very frustrating.

DG: Whether you're making a film or putting on a play, the lead time is long, and the actual filming or staging is extremely brief by comparison. What's that like for you?

RdP: I like the line that Victoria [Abril] would always say: "When you do

something right, they'll say, 'Ah. That's good.' No one will ask how long it took you to learn to do it so well." There's a lot of time put in behind every piece of work.

BL: There's a lifetime—a life's worth of learning, consideration, maturity, and evolution. Every minute counts. Every decision is important. Every day you have to make a choice: yes or no. If you're wrong, your decision will have consequences.

RdP: I like it when there's a little door left open to chance. A mistake can lead to something brilliant. If everything's by the rules, if nothing can move, not even a little word, not a line that you've written, then you miss out on the possibilities of the accidental, which is a source of richness in creation.

AA: And of emotion, too.

RdP: Some things happen only by accident. And the blend of chance and creativity can result in something more interesting than the product of an obsession.

DG: Is that possible in dance?

BL: Yes. There are plenty of accidents in my shows, and I love it. I'll often provoke them. I provoke chaos so that things happen that I might then decide to keep. The dancers are unaware. We'll be playing and get into something crazy, and then the effect I've been looking for will arise. Sometimes I have to destabilize the rehearsal, to break the dancers out of the mechanics of their "one, two, three, four . . ." It's in the service of the choreography to let the sensations emanate from within.

DG: It's the unconscious at work, too. You don't think; you do, and then you see.

RdP: Whenever I become aware, I mess everything up. It's my big problem. You produce differently out of unconsciousness.

DG: Working with material creates a kind of hypnosis, outside of time, outside of thought. When you design a dress, Azzedine, you're not operating within a conscious mechanism.

AA: When I set out, I think about what the material can yield. In the beginning I didn't know mesh or thread. I saw knitting. I watched. I saw the thread and thought, "That won't make a good stitch." These days there are programmed machines. You can make whatever jacquard you like. You just supply the pattern.

But not back in the day. When we were making jacquards for Grenade, I went with Jean-Louis Froment to see what fabrics Grenade was using in its great period. I asked the girl who did the knitting to knit something. She tried. I found the fabric ugly, and we wondered what we could do with it. I said to her, "Could you wash it?" So she washed it in a machine, and the fabric knitted together and became interesting. It made for a great stitch. So I said to her, "This is great. Keep it. But a woman who wears that and gets it snagged on a chair will end up tearing her skirt to shreds. So it's no good." So I said to her, "You can't cover it like tulle?" She did, and suddenly the dress was fit to be worn. Otherwise it's just good for exhibition.

DG: And not for living.

AA: Right. I've made dresses that aren't for living. It's a necessary quest. There's no point exhibiting your best-selling dress in a museum. You can show it at a grand exhibition, for historical reasons, but a simple dress can't be shown by itself. What's shown in a museum can't necessarily be worn. A woman won't be comfortable in the garment. It's like the difference between dance and the opera. At the opera, it's enough if the singer can sing. In dance, it's another story. The dancer has to be at ease. Things have to be aesthetic, and the body mustn't be impeded in its movements.

DG: There's a real parallel between dance and clothes. They always belong to an era and come out of it. That's something you've worked with a lot, Blanca. You play with several eras, from ancient Greece to robots . . .

BL: Dance is ancestral. It has existed in all civilizations. It's a primitive mode of expression that forms part of history. I find it interesting to try to understand how it was experienced in different eras.

Greek sculptures are always in motion. I felt like inventing the time between the positions. I spent a lot of time observing the various positions of figures on the pottery, and I reproduced them with dancers. From there I was able to invent the space and time between the positions. I created a whole ballet that way, taking as my point of departure certain postures and imagining what happened between them. It was a lot of fun to try to re-create those movements without really knowing why they'd been drawn or modeled in that fashion—without possessing all the keys to that iconographic language.

In the same way, to take up the robot theme, I had in mind all of the imagery that was associated with the year 2000 during my childhood. Robots were super

futuristic, fantasies that had existed in the history of literature and painting for a long time. One day I found myself face-to-face with a robot, a real one. It wasn't an object out of the future anymore. Robots have arrived. Something we've dreamed about for centuries, that we've invented and reinvented, is now here. These robots exist today, and they're going to become part of our life in an increasingly normal and everyday way. Faced with this, I thought that my time had changed, that one day machines were going to be part of live shows. Either we look backward or we look forward.

DG: You go from baroque music to nineteenth-century music and on to Greek dance. Do you have a sense that you're doing something new? How do you position yourself with respect to that exigency?

BL: I've always said that modernity couldn't exist without tradition. It's critical to know what's happened in history so that you can propose new things and take things further. A lot of people try to invent without having taken the trouble to look back at what's existed before them.

RdP: I'm a dilettante. I learned all by myself. There are many things I've been unable to cultivate and that I've filled in by instinct. Sometimes I tell myself that I'll learn certain things in my next reincarnation. In this life, I don't have the time. It's true, though, that you discover artists you've never seen but who are well known to other people. You discover them, and you say to yourself that it's a wonderful thing. Or else you create something only to realize that someone else has already done it. Then you feel that you've achieved a communion.

BL: It's essential to look into the past. Whenever I'm working on a show, I always undertake some documentary research. It's always fascinating. You discover some incredibly modern people! What Bosch did in his time is truly extraordinary. Every era has its share of fascinating artists.

DG: Rossy, you were saying that every role has been a life, and that at one point in your own life you finally learned to say no. Maybe it's because art allowed you to live all of those other lives.

RdP: Yes, because your life is much more intense. You can feel that you're living it to the fullest, even if you can't do other things you'd like to do. By interpreting other people, by embodying characters, I've filled my life. I'm more of an artist than an actress. But actors—and this is a disturbing thing—do well only when

they're interpreting a character. Afterward, when they return to their life, they don't know what to do anymore because they lack a script telling them their name, and whom they've met, and what they should do, whether to cry or laugh. I've known a lot of actresses like that. It's unsettling. Not as many men. Vanity is masculine. Me, if I'm not working in cinema or the theater, there are so many things in art that excite me that I have no trouble. But a lot of actresses have this crazy void in their life. Sometimes they're great actresses because they're so very sensitive. They're like a material; you can do with them what you will.

AA: In your case, though, there's a line running through your films between what you are and your various roles, and it allows you to give yourself over and to exist at the same time.

RdP: Absolutely. I'm always discovering something. I don't study. I never learn my lines like a parrot. You always have to leave something up in the air. I'm in favor of working on rhythm, so that something fills in the rhythm. If everything's already full, nothing's going to happen. I focus on the character's glance, and then the character follows along; the character's body follows her glance, her movement, the way you would in normal life.

When you do something, you don't know why, and it's better that way. That's where you surprise yourself. Pottery, for example. I've made sculptures. The terrible part is wondering what you're going to do. And the wonderful thing about molding without thinking is that the result can surprise you. You wonder where it came from. It's not premeditated, and you're your own first spectator. It's wonderful.

DG: It's the question of choreography: how to bring things together, how to retain the initiatives, the moments of creation, within a grand architecture. It presupposes that you deal with time from above and from below: microcosm and macrocosm.

BL: Time and especially rhythm are all around us. I like to watch people walk, to observe their physical presence. You can learn a lot about people from the way they present themselves, go from place to place, walk, move their hands, and speak. We reveal a lot about ourselves through our rhythm.

AA: I'll often watch the way clothes move on a body. You see how the fabric shifts depending on who's wearing it and the way they move, whether they're moving quickly or slowly.

RdP: In creation, there's the work, the search, the things that you don't know but that excite you. There's all that, and then there's the moment when you get down to work and get carried away, even in writing. You don't have to think anymore because everything falls into place, and you're carried away, and you discover what you didn't know.

In the theater, there are directors who resort to anxiety to get their work done. I don't like that. I think it's pleasurable work. There are a lot of directors who take pleasure in torture because they expect to find something by that method. I don't like working with overly rigid people. It stifles me and goes against the nature of creation. But there are people who operate very well that way—people who'll say, for instance, that you shouldn't eat because you rise to another level when you're hungry. We all have our way of working. I don't like people who torture you and apply the lash. It takes all the pleasure out of things for me.

DG: What you say raises the question of working with others, especially in long-term collaborations: Rossy with Pedro Almodóvar, and Blanca with her company. How do you handle having a common life, so to speak, and a common project?

RdP: It's true that you establish familiar ties over time, but the two things don't fully connect, even if you know someone well in a domestic or family setting. When we work, we're all operating at another register; we're more serious. We're all dealing with our doubts. We work with those materials, too, and those emotions. I've always been very comfortable with Pedro. When he got famous, though, he'd call someone up and the person wouldn't be able to relax, even if they were a good actor, because they'd be starstruck. It's a shame because it would prevent anything from happening between them. I've never been afraid to work with him. I found it exciting when he'd come up with something, whereas somebody else might have panicked.

It's different with every film. The last time I worked with him was for a small role. I knew someone was going to hand me a slip of paper, and I told myself I was going to have to do something with the paper but I didn't know what. I spent all my time thinking about it. Later, he told me that I was going to swallow the paper. He'd give me little bits of paper, but in my mouth. They were so small that you couldn't see them on camera. In the end, I spent the whole scene swallowing paper. Pedro and I both were wondering what we were up to with the paper.

The scene was so short that we had to do something dense, and this paper idea was

perfect. I'm the small-role specialist, and it's very exciting, because when you have plenty of time to tell a character's story, you can wonder what's happened to that character. But when you have a small character, you have to find a way to play it naturally. They are moments of intensity. You focus a lot of attention. You should defend a character, even a psychotic killer. You mustn't judge the character.

AA: And for you, Blanca?

BL: I've never felt better in my work than I do today, thanks to my team, who've been with me for almost twenty years. I've managed to surround myself with people I love, who live their work passionately, just as I do. That's something we have in common. They are ready to give me anything so that things turn out as well as possible. That's a gift of incredible value. Thanks to them, I can do things now that I could never do before. For example, if the company needs to tour and I have other obligations, I know that the person who's going to manage the company in my stead has my same eye for detail and will correct things almost more rigorously than I would. This gives me immense freedom, which in turn allows me to give myself over to creation. All the time that I used to have to spend on the company I can now delegate to people who are as good as I am.

I can be doubly effective. They're not at all in awe of me. They're real friends. We can have frank discussions, and their opinion has great importance for the decisions I make. One of the hardest things for an artist is to trust in other people. Having two or three people who can tell you the truth is a real stroke of luck. They've chosen to be at my side.

Of course, a lot of people go, too. They spend a part of their lives at your side and then take their leave. Some you don't want to part with, but it's understandable that fantastic personalities might decide to do something else.

But they're part of a moment in our life. They're people who will later have careers of their own. That, too, is a wonderful thing. Our life finds a kind of continuity in theirs.

IV

Time is a composition: something that can be stretched,
compressed. It's a time-space construction. Time in theater
is different from the way we experience time normally.

—*Robert Wilson*

If you take your time, you either waste time or save it. Taking
it, wasting it, saving it—three propositions that speak volumes
about our unconscious relationship to time. Between wasting
it and saving it there's a whole relationship to the world that
we express through time. It's at once material and immaterial.

—*Isabelle Huppert*

ISABELLE HUPPERT & ROBERT WILSON

Azzedine Alaïa: When I think about Bob and Isabelle, I think about a specific relationship with time: slowness and risk. Something out of the ordinary.

Robert Wilson: Very early on in my career in theater, I made pieces working with long durations of time. My first play, *Le Regard du sourd* [1971], here in Paris, was seven hours long in silence. The French discovered my work. I followed with a twenty-four-hour performance at the Opéra Comique. Again, it was a silent work. That was then followed by a seven-day play that was basically silent as well. That's when I met Isabelle.

People talked about the slowness of my work, the slowing down of time. But for me time has no concept. It's something you experience. Susan Sontag said, in the early 1960s, that to experience something is a way of thinking: you see a sunset, you have a response, but it's not necessarily cerebral. It happens physically.

Time, in my work, is a composition: something that can be stretched, compressed. It's a time-space construction. Time in theater is different from the way we experience time normally. For instance, sitting here at the table together: it is something constructed. In the end, there is the yin and the yang; it is artificial, and yet at the same time it relates to nature. What is the time for the sun to set? What is the time for a cloud to move? What is the time to daydream?

It's a construction that is artificial but that, in the theater, still allows time for people to think. Most of the time, when I go to the theater, there is no time to reflect or

65

to think; what's happening onstage is something that's sped up. In one of the most recent works Isabelle and I did together, *Quartett*, it's difficult for the audience to see her entrance. Through the performance, you go into a different mental space.

That's different from Broadway, and opera, as we normally see it, which is dealing with sped-up time. Theater can be, and should be, a time to think and to reflect. Those who live in cities with busy lives need that moment when they can truly experience the connection with a world where they sometimes feel lost.

My dream, when I started doing theater and created this seven-hour play in Paris, is that I would like to make a play that would always be going on. If you wanted to go at two o'clock in the morning or at eight o'clock in the morning, if you wanted to go on your coffee break, you could go to a park and daydream, watch clouds or people walking. It's this dialectic in the concept of time that I want to reconcile in theater, something artificial and close to nature.

Isabelle Huppert: When Azzedine asked me to come talk about time with Bob, I was delighted. Nobody would be better at talking about time than he. It's with him that I came to the deepest realization of how time could be different in the theater than it is for others. I realized that time, the way he imposes it, could be a provocation.

I have a concrete example, separate from the work I've done with Bob: once or twice I've had a chance to hear him address a large crowd. He begins with a long stretch of silence. And in that moment, time is like a language for Bob. Time is a language for me as well.

If you take your time, you either waste time or save it. Taking it, wasting it, saving it—three propositions that speak volumes about our unconscious relationship to time. Between wasting it and saving it there's a whole relationship to the world that we express through time. It's at once material and immaterial.

RW: As I said, theater is something artificial, so I think about it abstractly. There are very few actors who can think abstractly and understand the meaning of the time-space construction. Isabelle can. I don't think I told her, or anyone has told her, what to think.

Quicker, slower, more interior, more exterior, harder, softer: all these are formal directions. As a director, you make a form. The form is not really interesting. It's how you fill in the form, how you give it a structure. But I never talk about the

meaning of something; that is not the space I inhabit.

The time-space construction is very rigid, but it has a kind of freedom. It can liberate you. Once you learn it, you can experience whatever you want. I remember when Isabelle and I first did Virginia Woolf's *Orlando*—it was so interesting to see her with the Woolf text. I came back after fifty, sixty performances. She said: "You didn't like tonight, did you?" I said, "Well, it was OK." She asked me, "What's wrong?" And I answered, "When we first did it, the audience could get lost."

It's like reading a good novel: you can read it one night, and then take it up another night. That way of experiencing the text makes it an experience. The performance of *Orlando* had become predictable: the audience knew how to laugh; they knew this and that. They were programmed and had forgotten the crucial rule: it's OK to get lost. That's what we're all so afraid of as performers or singers: that in the middle of a situation, we would just be lost.

Television is a completely different time structure. That's the structure that does not allow you to get lost. It is a time where every two or three seconds, maybe ten seconds but no longer, you have to understand the message. The Broadway shows are the same now. I went to one a year ago with Julian [Mommert], and I said: "Let's clock it." Often, the audience will respond, and it never takes longer than thirty or forty seconds: "Do you understand what I'm saying? Do you understand?" And at the end you don't understand anything. It's all done like television.

It's OK to get lost! Let them go. In a work like *Einstein on the Beach* that I did with Philip Glass, there's nothing to understand. So, time is different in theater than in the stream of culture. It helps us refocus on where we should stand toward it.

Isabelle is one of the few artists I have worked with who can think abstractly and understand that we don't need to tell the audience to think what we're thinking and hold their attention all the time and always respond to what we're predicting. It's a different space—and the reason to make theater.

IH: Listening to Bob, I feel that he's providing the perfect definition of drama, and of acting—perfect to an absolutely extraordinary degree. More and more, my ideal in acting—and I'm experiencing it in the work I'm doing right now—is to constantly try to destroy the predictable, to break with rhythms, to convey a sense that we have no idea what we're going to say next, what things are going to be like afterward. More and more, that's becoming my absolute quest. Most of the time we play the music

we already know. Acting is about losing the other, losing yourself. I've tried to accomplish this several times lately. It's like singing: there'll be a note that carries you far, far away. I've always considered drama as coming below singing.

The great French director Claude Régy makes a distinction between music and the word. He says that music's superiority over the word is that it isn't sensical. It doesn't convey meaning the way words convey meaning. Insofar as it's nonsensical, music liberates the mind. As an actress, I try to reach the moment when the word makes sense and no sense at the same time, because that seems to me the closest thing to human truth: when you're simultaneously in the truth of the word and in the unknown of what you feel.

I know that Bob has understood one thing above all else: that there's something superior to the meaning of words. He never gets attached to the exact meaning of a word. Instead, he's concerned with all of the intuitions you might have of someone. When people speak, you don't necessarily listen to everything they say, but you pay attention to the impression they make, their movements, what they emit besides words. Bob seeks to find what a being can emit beyond the word, through rhythm and movement. It becomes musical. He proposes a form, a seemingly highly constructed universe. But within that construction he allows the person to come through, maybe more than the others. There's a dialectic in his work: the stronger the constraint, the more the person can exist.

RW: The more mechanical we are, the freer we become. Andy Warhol said: "I want to be a machine."

When I presented my first play here in France, *Le Regard du sourd*, Charlie Chaplin came. And he came back a second time. There was a seventeen-year-old Israeli girl who was performing. She said: "Oh, Mr. Chaplin, when you do that flea act, in *Limelight*, it's so marvelous. How did you come to do that?" He said: "My dear, I have been doing that for forty-five years." It's true: the flea act appears in many of his films. It was timing. It was only by repeating and repeating it that he became freer.

You can start to play a Mozart work on a piano when you are two years old, and when you are eighty-two, you are still learning how to play it. You have not found a solution, but maybe you have a different freedom than when you learned how to play it for the first time. Freedom comes from programming the computer and doing it. I once had a conversation with Suzanne Farrell, who was dancing with George Balanchine. She was so beautiful. She said she knew eighty-something ballets.

I mentioned a moment in Symphony in C. She said, "I would never know that movement, but I know when I do it." That movement had become mechanical. She couldn't tell me what the movement was, but her body knew. She had rehearsed it so many times that it had become automatic. That was her freedom in dancing.

"Examples gross as earth exhort me. / Witness this army of such mass and charge / Led by a delicate": that's *Hamlet*. I learned these lines when I was twelve. When I say them now at age seventy-three, I have a different feeling, but it's something that is engrained in my computer. I have a freedom in speaking the text.

What Isabelle said is right. There is a dialectic: we think freedom is just improvising, but actually freedom can be something mechanical. In the machine, we find freedom. I think Andy [Warhol] was right when he said, "I want to be a machine."

IH: That's what Patrice Chéreau said about me. I am a machine.

RW: Isabelle is one of the few actresses I've met who is not afraid of being cold. Actors and actresses often dislike being cold. But being cold is the way to be hot.

IH: Azzedine brings coldness into play in his designs, too. You can never wear jewelry when you're wearing clothes designed by Azzedine. It's like a miracle. I use this as an example of the definition of Azzedine's work.

AA: Arletty would tell me, "I'm virginally pure of all decoration." When I did my first fashion show, I lacked the means to include jewelry. Arletty's turn of phrase saved me: hosiery, pumps, and no jewelry.

Isabelle, you number among the French women we need to honor, along with Arletty and Louise de Vilmorin. When I saw you for the first time, I said, "This girl's got something. She's discreet, she's got a presence, and she doesn't comport herself like a star. She's got a sense of things. She's not artificial. And, especially, she's got the nuances down." We're speaking of time. Coldness, I agree with Bob, is a condition of heat. Not otherwise. That's the way it is with time: coldness is the feeling of presence. As with Isabelle. And it's also a way for time to move beyond immediacy. Heat goes quickly out of style, but not coldness.

RW: Let me tell you a story. When I first came to Paris, with my first play, I went to the Espace Cardin seventeen times to listen to Marlene Dietrich. I finally got up my courage and asked her, "Ms. Dietrich, could we have dinner?" And she said,

"With pleasure."

So we were sitting at a restaurant for dinner, and a man came to the table and said: "Ms. Dietrich, you're so cold when you perform." And she said, "But you didn't listen to my voice." She turned to me—I was twenty-eight, twenty-nine—and she said, "The difficulty is to place the voice with the face."

It's true. Her body would be icy cold with the movements, but her voice would be hot and sexy. And that was her power. I did the *Ring*, and the singer I worked with first had just done the role of Brunehilde at the Bayreuth Festival and had sung it expressively. I said: "Gaby, be ice and let the voice be fire. That will be your power." And she was so much stronger. Dietrich's phrase was a lesson, a bell ring, that helped me forever.

AA: Isabelle's the same. She's a volcano beneath a veneer of coldness.

It's also a matter of presence. She seems very tall onstage. Bob, you were speaking of space-time. Size in space is also a length of time.

IH: At one point in *The Piano Teacher*, the film I did with Michael Haneke, I tell my young student to play cold. When I hear him play, I realize that the way he plays allows me to intuit that, if he likes the way he plays, his love won't be true. There's something off in his playing. As an instruction, I say, "Coldness. Does coldness mean anything to you?" The minute I hear him play, I fall in love with him, but I also understand that his conception of love is totally opposed to mine. The way he plays informs me about his relationship to life. He doesn't play cold, so he's a liar. Because for her, the cold is truth.

RW: If I put this dark jacket over this dark jacket, that's one thing, but as soon as I put the white napkin, the jacket looks darker. It's always those opposites. If the director tells the actress to go left onstage, you think you're going right; if the actors go up, you think you're going down; if it's *King Lear* and you're playing Shakespeare's great tragedy with Cordelia, you have to laugh or it will never be a great tragedy.

I just did *The Coronation of Poppea* at La Scala, and it is a very dark story. At the end you need some light. *Pelléas et Mélisande*, which I am doing at the Opéra de Paris, ends with a death. But the end shouldn't be performed tragically. No. The color of the voice has to be light. She's dying: we need light. There's no reason to make

theater depressing.

In the darkest moment you need light. I want to make a new work with Jessye Norman in which she sings African American spirituals: a race of people, enslaved, beaten, not allowed to read a book except the Bible, oppressed. And in the whole repertoire, there is not one song that is not about hope, not one song that is negative.

I did Schubert's *Die Winterreise* with Jessye, three or four days after 9/11. She called me and said, "Bob, I can't sing tonight." I said, "Why?" It was ten in the morning. She said, "Because I will cry. I've been crying all night, and I can't sing." And I said, "This is the time, Jessye. We must hear your voice." So she called at four o'clock and said, "OK, I'll try."

We started. There are twenty-four songs in the cycle, and after the third song she began to cry. Tears were streaming down her face. The pianist had stopped, and finally after several minutes Jessye stopped crying. And then she stood for ten minutes. The audience began to weep. What she felt inside was so beautiful and deeper than any emotion she expressed, just standing. Not many can do that. You need that light. Jessye brought light to the darkness. It was uplifting, and it took us out of the darkness.

V

I truly believe that we belong to an era and that architecture bears witness to that era.

—*Jean Nouvel*

Azzedine Alaïa: I'm very impressed with your drawings, Claude Parent. They always seem to be pointing the way to the future. What is your relation to time?

Claude Parent: A woman recently gave me the key to myself—a woman who's writing a book about me. She said, "Bottom line is, there's something in your head: defiance." She gave a good account of my character. I approach everything with a will to defy whatever that approach brings. I have an elder brother who was a champion of French patrimony. He was "up to here" in historical monuments and a member of the Monuments Historiques [department of France's Ministry of Culture], which is equivalent to UNESCO. He was president of the assembly twice. He spoke to us of "cultural heritage" his whole life; that's all we'd ever talk about. In fact, the first thing I ever defied was cultural heritage. First of all, why is it sacred? Of course, some of my own constructions have now been classified as "cultural heritage," but I've always wondered why it was made sacred. We mustn't touch it, can't tear it down . . .

For me that's worth defying. I don't understand why, and every now and then I return to the question. I'd think about museums. We have to start by breaking them all up, closing them down. They're bad for our health; they're no good for life in the future. Cultural heritage is about living in the past. We're living in the past! Within my meager means, I've tried to get as close as I can to living a new life. Having a house with inclined planes—it doesn't seem like much, but it raised some eyebrows at the office.

Jean Nouvel: The relation to temporality, and to modernity, is one of the most diffi-
cult questions for an architect. The first bit of philosophy I acquired was that being
ahead of your time makes no sense. Even if notions like utopia exist and set forth
a direction, what's hard is being *in time*. At the same time, it's really hard to stay close
enough to the cliff's edge so that if you took two more steps you'd fall and then say,
"How am I going to deal with all the questions that people ask and that are, in fact,
traps? How do I know I won't regret things later?" I think you have to find a philosophy,
an ethical rule, that will allow you to bear up under this pressure.

My philosophy and my rule—with all the elements I have in hand and the infor-
mation I'll seek out for every situation—is to take that analysis and do as much as
I can with it. I'll decree that whatever is done is done by the architect I am at the
time, and that's all I could have done.

And with that I'm already pretty well covered. It lets me breathe, lets me do some-
thing that I know is for me and is "in time." Although, of course, accidents happen
and it will eventually be looked upon automatically, from a certain remove, in light
of what was done at the time. That's why it's important for architecture to be dated.
A work of architecture should not be ahead of its time or behind it. It should bear
cultural witness to a moment, an era.

CP: I agree wholeheartedly, and my great act of defiance can serve to illustrate.
Here's how I responded: with the oblique function.

I meet this guy who's a master glazier. He fashions little bits of glass off in his
corner, but a painter steps in and shows him the two houses I've done, so he says,
"I'd like to meet him." You can see how intransigent Paul Virilio was—he was the
guy. I meet him, and we become associates. During this association, with each of
us enjoying great liberty throughout, we're struck by an idea like a bolt from the
blue. We're at a table in the basement. We design the church of Sainte-Bernadette
de Nevers on an incline.

Why on an incline? Because they'd added a floor and it foiled our plans. We had
to do a sloping roof, and a sloping nave, and so on. So Virilio and I say, "Perfect!
Why not make use of the constraint?" And Virilio says, "Let's live obliquely!" He's
the one who coined that phrase. I say to him, "I'm going to be hitching my whole
personal life to this, whereas you and your little bits of glass will go prancing right
along. Every one of my clients is going to leave me, and the ministries are going to
take me for a madman or a dimwit. I'm going to be caught with my pants down,

without a client or a penny to my name. And all for a nice turn of phrase. So I'll just sleep on it, if you don't mind."

So I sleep on it, and in the morning I say: "All right. I'm slitting my wrists but it's worth it." That oblique marked my suicide as an architect. I've never been able to aspire to a certain level or type of commission. People would ask, "What's your biggest regret? You're at the Biennale in Venice, having done or said nothing, twiddling your thumbs. You're at the Tate Gallery in Liverpool. You've had to do nothing to get there. They seek you out. You've got nothing to complain about!"

Oh yes I do! I'm deeply anguished. There's a malediction hanging over me. I've never gotten any support from the profession. There's always been a gulf between my peers and me. Even those who like me have fallen away. There's nothing to be done about it. They can't utter the word *oblique*. No one except you, and that makes you my sole witness. People would say, "Parent? We can't go along with him. He's one of the utopian architects, but he goes too far."

JN: If you go too far with utopia, everything goes to pot.

CP: They'd say, "You're going too far because you're attacking the foundation of man, which is to set himself on a horizontal plane, feet together, and wait for it to happen. Reject that fact, and even utopia won't go along with you. Because it isn't even utopian!"

Incidentally, this week I had two letters from students, saying, "I don't want to think of your drawings as utopian architecture. I call it dreamed architecture. May I call it that?" I said, "Yes, you're right."

I know the conditions of the time, and I don't think they're going to change. They've been the same throughout my life. They've all sought to geld me in the same way, especially since I was vulnerable compared with Jean, who was a young, forceful man. I was already old, and I'd already been repudiated several times by the profession. The profession has done me a lot of harm, and I haven't tried to patch things up.

JN: We've done it a lot of harm as well.

CP: Yes, you, too . . . But before I'd made so much as a pencil stroke, I had all the guys mocking me, and that didn't help. I muddled along, but it didn't put me in the

position I would have liked to reach one day. I spent all my time fighting against everybody, the ministers and so on. I'd have liked to rest a bit.

But Jean, at least, has never been like that. He's got his own battles to fight. And what's more peculiar, he's never copied or been influenced by the least pencil stroke or building I've made. He's done other things, lived on another plane. I'd never seen his plans for the Philharmonie [de Paris]. He'd never spoken to me about it. It's true, though, that it was a gift to me! I'd already almost died twice, and I think he took pity on me. He played the good apostle. To say before an audience that's come to applaud you, "I did this as an homage to Claude Parent"—to say that before the minister's deputy and all the people present—that was a risk. Yet another risk!

Well, I'd been missing that. Sure, you might be independent, or you might be like me, storming about in your ivory tower—Jean knows this; he's like that, too, in his way—but there comes a point when you'd like to have a little following. It's the same with Azzedine. I've heard things: "He's got a tiny little boutique. He makes two dresses a day."

AA: Yes, it's true.

CP: I've always liked things to move right along. I might have killed myself over a sports car. I'd drive at these speeds because I had a Maserati. And when I'd get above 250 kilometers per hour . . . It was like bullfighting. People would say, "Driving so fast? Are you some kind of loon?" And I'd say, "But I was alone, I had a good car, and there were no other cars on the road." I was struck by the needle. I wanted it to swing, like an architect's compass. It was as stupid as that.

I want to take things further. That's the real question: Why do I search? Why am I always laying down a challenge? So that men will go further, notably in their relation to dwellings.

My whole life, which is now more than ninety years long, I've found it intolerable, inadmissible, that we could lodge, live, or meet in such mundane places. No place satisfies me unless it has the stirrings of the oblique function.

My preacher's role is to urge people to exceed their own limits, because people are terribly limited and afraid. Now that I don't build anymore, I carry on, trying to find people, young people—not to beat them down but to instill a duty to go

further. It's inadmissible to sit on your ass like that, to do your supposed "thinking," to read beautiful books.

JN: I'd like to clarify my position. When I say that I'll always do whatever it takes, I don't mean that I won't take a step beyond. During those early years, I'd lose almost nineteen out of every twenty competitions. My proposal would always verge on the limits of what I could think, not the limits of what I thought would be accepted or acceptable, even if I do believe that being an architect means building.

So I'm always playing the old game, with one foot in the void and the other on the ground. And sometimes that limit doesn't interest me. Most of my peers will say, "How did you get that through!" I explain that I don't "get it through." The work corresponds exactly to what was asked of me. The work is often based on a dialogue. It's a commission.

What's important is that every situation be an adventure, a possibility. Then the situation should be exploited in the most pertinent way, and always in relation to history. My top two criteria for contextuality—and they're not very original—are geography and history. I am geography's son, and there's perhaps nothing unusual in that. A project should know where it is.

When a project comes along, you immediately want to come up with the idea, formalize it, and say, "There it is!" In the end, all the instruction you get at the Beaux-Arts boils down to that. It was an incitement to retire to your studio for a few hours or a couple of days, or three days for the Prix de Rome, to do everything, immediately, and usually off bare-bones specifications.

I think it's important to take into account that every situation opens up unique possibilities through its anomalies. So, idiosyncrasy is an automatic definition tying in to a project. But we're operating on the opposite hypothesis. We have the full evolution of regulations and standards, we arrive in neighborhoods where the volumes are already defined, and we end up with specifications that are already completely defined. What we're asked to produce is a proportion for the facade, a color for the coating. It's terrible! That's what needs blowing up, but most of the time it's mission impossible.

In fact, sometimes it's so impossible that I've invented the notion of "critical archi-tecture." Being a prisoner, I'd have my plans corrected by the government architect of the Bâtiments de France; I'd then take what he'd had me wall up and build it in

stark red, with the rest in brown bricks. That way all the corrections would show. Or else, [for the Anne Frank Junior High School] in Antony, I used a Meccano [toy set]. Of the 750 pieces, I kept the most basic ones—the beam, the post, and the roof—and made the whole school with them.

That's not a position you can extrapolate totally. Sometimes you can show that you're not being fooled, and then you can arrive at aesthetic and cultural attitudes of denunciation, which produce objects that are generally a little more respectful of your discipline. That's the jungle we have to hack our way through; that's the battleground. And conditions have only gotten worse. The development of cities is much more limited now. Growth is much more limited. Twenty-first-century architecture is above all an architecture of integration and modification.

It's much more interesting to start with a material, blow it apart if necessary, and see what to demolish and what to keep, to ingest, to re-create something with respect to what's there, to give meaning to what precedes, to try to extend the influence into the public domain, to initiate dialogues at a remove, even with objects that are vastly distant, and, finally, to come up with a whole series of good reasons to do things this way rather than that, because this exists here and I couldn't do it elsewhere.

It's a philosophy that's firmly anchored and that, in my dialogue with the client, allows me to push through my own desires and convictions. They're added to all the rest. And to make a Philharmonie with a few slightly inclined ascents, and a roof and slope that are just a little odd . . . it's not contradictory. But it's by taking these requests into account, which isn't the response they automatically expect, that you arrive at a result. Because clients and administrators aren't equipped to see beyond situations; they think things are predetermined. I try to escape a form of fatality.

To think we build in a given situation is also to put that situation into perspective with the historical evolution. We build only temporarily. When I speak of modification, I mean at the scale of a city. In other words, we have a given territory, and that territory is marked, until it becomes a ruin or is ingested by something else and disappears. The paradox is that I don't automatically consider architecture to be, above all, the invention of a space. I think it belongs to a space. Architecture is temporary and eternal. Because of its whole domain of interference, because of its irradiance, we should always consider that we build in space and that we modify a part of that space temporarily. This might seem trivial, but philosophically, in our approach, it changes everything.

We have to re-situate ourselves with respect to the vertigo of the evolution of our inhabited territories. We have to consider that these territories are changing, that we take part in that change, and that the more meaningfully we bear witness to this, the more our work will be liked—starting with the first generations. That's what's most important, because in general that's what affords it protection. Later, it bears witness to what we wanted to do at the time. It lays down a furrow from that moment on. But we have to take the historical perspective and consider that a building isn't just a little object that we set down and that lives its life.

CP: I understand and can even agree. But that wasn't the choice I made. Had I been your age, I could have been on board for that kind of experience, that kind of consideration for our role. It's good and well said and rightly analyzed, but I don't want that for me. It would stop me in my tracks. Whereas it doesn't stop you because you invented the thing. You're inside the corpus you're developing, so you're not a victim of it! You're at ease because it's your corpus that's won, your corpus that's getting done.

Philosophically, it's putting yourself in place. I like that you've taken a view on the future, that you've explained how the architect puts his two cents into the corpus and how it'll shake things up—though within reason, not total madness. I can't go along because for me everything's gone to rot. I don't want any of what I'm being offered, anything of what I see, anything I can make out in the desires of my ministers and presidents. And we've seen some developers in our time, all those who fill the cities with creatures you invent . . .

JN: Those are precisely the ones who need convincing.

CP: Yeah, well, they're rotten. They've got the power, which isn't even a power. I despise them. I don't want to hear anything about them, and I don't want them taking part in any way in my inspiration, in the thing I'm trying to draw out of my head and in my means. Not a peep or a sigh or a "Not bad, little one. Keep going!" They'll ruin everything if they're there. And those who'll be in the places we prepare for them—same thing! It sounds desperate, I admit, but I've reached the age of desperation. But you haven't! You're not there yet, and I congratulate you because it's not very captivating to say, "I'm in a pitiful world, a world that doesn't exist and never will, a world where I might do things . . ."

As for knowing the response of the architectural object, they've pestered us with the fact—which you express with much more intelligence and nuance—that a

construction belongs to everybody, to those who are going to be inside it. You've set architecture in a world . . .

JN: It's there, yes!

CP: I remember your statement: architecture is in a world, this world; we didn't build it—ours is not to know it fully but, in a way, to tame it with our work. That is our duty. And that had me dreaming for a while. I thought, "Yes. It'd be good to start with that. There's an opportunity." An opportunity that I've yet to come across. We take steps in that direction. It's resulted in buildings, or responses to the whole of what's given, and to our knowledge of the world, which as of yet is far from vast.

But I think it necessary to say no. It's necessary to say, "No. I have no friends, no enemies. I have no predecessors or successors. I have no inhabitants who will suffer from what I'm going to do. I don't give a damn. I do."

You'll say I haven't done much, but I've done things that can be generalized and that have made an impact. If people don't want it, they don't want it. People of my generation aren't ones to put up with interference in our discourse. You've gotten people to tolerate you and respect you. I can't live with respect. I'm good for abuse only. The only ones who respect me are the young, who don't understand what's happening to them and come to me the way they'd go to the doctor. And I've played the doctor for several years. I don't tell them they're mentally ill. I don't tell them it can be cured. I say, "You're up to your neck in shit. Don't expect anyone to come drag you out of the gutter. You've got to do it yourself. It's not up to me. I'm too old and too tired. What I can tell you, though, is that in spite of it all, you can still get tangible results."

These tangible results, they've come through individuals. There's a gentleman—Mr. Drusch, you know the house—who's infirm now. He tools around in a wheelchair. He's had time to have children, who were young when we were building the house. When we met, he was an engineer. He was living in Chesnay, under a little roof, like this, the kind everyone has. In old brick: horror of horrors. He thought he'd like to build a house, so he calls me and says, "I'm holding a little competition, great prince, and you're in it. Here are my conditions."

I show up with a little sketch. We set to work, and it takes me a year to get him to accept my plans. For a year I go there every week. So often that at one point he says, "Listen, my wife and I have tired you out. You can't go on like this. The house

is shaping up, we see what it is, and we like it. We'd like to furnish it in the same spirit. My wife was in charge of the interior and couldn't get along with you. I was in charge of the exterior and also couldn't get along with you. So we're going to switch. You're going to be discussing the house with my wife, who doesn't know anything about it. And I, who couldn't care less about closets—I'm going to handle the interior." So we build the house.

Point being, this guy invites me over every now and then and tells me about the house. He'll spend an hour telling me about the sunrise, or the sunset, or the spot where I wanted to set a window and Madame Drusch didn't. I'd been right to stick to my guns because that's where the day's final sunbeams come in and so on. He called me again the other day and said, "I feel at home. I don't want to sell. They want to get it registered as a landmark, but I don't want that. I don't want the state sticking its nose into my house!" That's the way he is. He calls me and says, "You've got to come over for dinner or lunch. I've discovered something. Your house, because of its forms—it's acoustical!" He's in it, of course. He's become one of the house's objects, so he knows it better than I do, better than anyone. This goes to prove that you can serve as an example.

It's just one guy, of course. But his grandson is in architecture school, and the son wants to keep the house. It's an example. And this example, like all the houses I've done, had its building permit rejected and three government architects from the department came in to say, "What are you up to now, Parent? Your plans are incomprehensible." I draw up plans to make them incomprehensible. I draw up plans for them not to get it. These three government architects say, "We don't get how you draw up your plans. Make us a model." I made a model. They took away two little oblique rods, which I still regret, even though they served no purpose. And they finally granted my permit.

All this so that you can have an architecture that goes beyond what people might imagine, where you find things you weren't expecting. In other words, as you've said with respect to some of your projects, architecture provides fodder for explanation, and invention. It can inspire dreams in others. But for that it has to be stripped of impurities. Like Mr. Drusch, who was impure at first and later became pure. I can't work any other way.

I break my toys before I play. I want to break this table here before I draw a stroke on it. That's where we're different. It's faulty rearing. I was brought up wrong. I'm cantankerous . . .

JN: In any case, there's one thing I inherited from you, and it's that I still strike fear into some people.

CP: Ah yes, that's true! But otherwise you've got all the qualities . . . You explained your working methods to me one day. They were the opposite of mine, if you were straight with me—

JN: I was straight with you.

CP: I can describe it, then. He gathers the people he likes best at the time, or who are available, and he studies the specs. There are myriad architects great and small at his office. He picks one and gives him the floor. So he gathers information for days on end. Then, once you've gathered as many interesting responses as you can, you go to bed and you sleep if you can. And the ideas suddenly come back to you in fragments. They get mixed up, and he comes out of it with a preview of what he's going to tell his collaborators . . .

JN: It's much more specific than that. I get into bed, put on my mask and my ear-plugs, I don't sleep at all. I let the ideas ramble around the specs. It's meditation, but it's centered on a subject . . .

CP: And these ideas are like masses hanging in the sky. It's very interesting! I think he's the only one who does such stuff.

I need the blank page, and I need to launch into drawing two or three strokes. I draw fewer and fewer. Obviously, then, I'm far from taking care of the little guy who's waiting for his three-bedroom flat.

To wrap things up with our friend, Nouvel. I find there's one terrible thing architects have to put up with: enforced nomadism. You're always on planes, in cars, changing countries. When you would summon an architect in the seventeenth century— when, say, Louis XIV chose a guy—he wouldn't travel ten thousand kilometers. They'd set him up in an apartment or a little palace. There were domestics to take care of him. He was made comfortable. It's shameful what we make architects do. We demolish them! When you want an architect, you pay him and feed him. I want that to change, too. We make them the slaves of politicians who can't even count. It's abominable! So, I wrote an article on nomadism. I believe it's a way to save society. I think we've turned a few people who, by definition, aren't fixed in space, and we're going to open up new worlds for them.

Donatien Grau: You're in favor of nomadism for human beings in general but not for architects.

CP: I wrote a whole piece on it. What we need to give them are paths. They have to build nomadic societies, which will establish relations with non-nomadic societies. That will get us through. I really believe it. The architect will, of course, follow the nomadic path, will be a nomad, but we mustn't put him through the stuff we put him through now. Today you're in Hamburg, tomorrow in Marseille, day after tomorrow in Vladivostok. They kill themselves! It's bad for the heart. You can't think on a plane. That's no place for reflection.

JN: Yes, it's true. On a train you can. On a transatlantic, too. Less on a plane.

CP: Journeys need slowing down. People need to find another way to travel.

DG: Mr. Parent, you're oriented less toward existence in the present than toward human existence in general—and the future of humanity in general—which is another big difference with you, Jean . . .

CP: It's a good thing there are differences, the wretch! If all he had were residues from his old boss . . . At least you're a free man!

JN: I don't know if I'm a free man. When I hear you talk, I find you much freer than I am! When all is said and done, if you've got your paper and you're not bothering with the guy and his boring three-bedroom flat, then you're much more at ease. You might even propose something with a certain "transtemporal" dimension.

I'll say it again: I truly believe that we belong to an era and that architecture bears witness to that era. Let's say that I'm attentive to being able to bear witness to the era. My purpose is often to convince the people who couldn't have imagined what I'm going to propose. In the end, though, when I get to projects of the Lucerne type, for example, I do have the feeling that I've been heard and that I might not have done as well all by myself. I felt a need to act with them, for them, and what ended up getting done there reflects those human encounters. That's my philosophy.

What I retain and learned from you is to have great integrity with respect to the strength of the proposal and to believe in something I'm going to defend to the end. Some time back, five or six years ago, I was winning one out of four or five competitions. People said, "You're going to end up going 'corporate.' You're actually

getting worse! It means everyone accepts what you do." So I got very good again about three years ago. I'm losing a lot of competitions, which means that my intellectual level is going up and that I can still inspire fear. I believe in the importance of bearing cultural witness. We're undergoing a great compression. Which leads us back to the problem of the new city, where grand utopias try to resolve the problems of urban construction, or of establishing a society on spatial and economic norms, and so forth. Well, that's a whole other profession! There have always been utopians. We've seen wonderful plans, taking history as their basis or not. Piranesi and many others . . .

But that's not my profession. My profession is to be an architect, striving fiercely to build something I'm in phase with and that can bear witness to the desires of the moment it happened—bearing witness, if necessary, to antagonisms or difficulties, but such as will enter into architecture's great history in the broad sense, the great history of cities, the book of stone, and so forth. I believe in that sedimentation, and I find it to be contemporary.

If you consider the number of staggering follies we've committed over the past century, in our haste and our ill-regulated urban development, where we vest all the power in companies or the economic domain, I think the architect is now the sole player who can restore a little humanism. An architect's social mission is to safeguard the pleasures and desires of the people who are going to dwell in those spaces. I think that, in the variety of uses a space is put to, the longer that we have dwelled in a space and the more we manage to shape it, the better we can manage, in time, to correct what's there.

In the end, it's evident that throughout history the great representative places—the religious centers, the administrative buildings, the seats of power, and so forth—have been built by several generations of architecture and styles that reinforce one another, that telescope into one another. I don't want to proceed artificially, but I think we take part in phenomena where we're naturally compelled to deal with enduring environs, and where we can then take the elements present and "complexify" and invent. For this reason, too, all notions pertaining to a site—be it urban, natural, or, often, both—and the way in which the site is accounted for on a temporal plane are fundamental to me, in view of the site's eventual modification.

The landscape is also the consistency of time, the relation of the ephemeral to eternity. That's where something can happen, metaphysically. That's where we set up systems linked to fragility, with respect to eternity, with respect to the expression of solidity. Things seem fragile and are not . . . Things that seem more solid are the effect of a patina.

CP: Yes. If I took my demonstration to its logical conclusion, the architect, instead of being their good servant, would be charged by the people who manipulate him with seeking to produce the uninhabitable.

JN: They've already succeeded!

CP: Yes, but they're unaware of it. We'd have to be able to produce the uninhabitable. The oblique function, its secret treasure, is that if you're on a slope, then you're in the moment, dealing with instability. You're so unstable that, as you straighten up, your body becomes a motor, as we say in theory—a motor that allows you to respond to the call of the void. You manufacture a strange being, for whom the principles we ordinarily and unwittingly apply—sitting on a chair, say—no longer have any value because the individual cannot remain there.

It's true that when I take up this posture and look at the slope, the slope attracts me. So the slope is an automatic element. It costs nothing to displace a body. There's no need for fuel, no need for a motor. On a ramp, you move. Vertigo is a motor!

We laud mountain climbing, but we make no progress. We think, "It's good enough for me, nice and comfy on my horizontal plane."

I'd like to see man's curiosity evolve, see him shift the focus of his curiosity. Man's a bit scattershot. He invents pretty much everything. He's set forth on the water, under the water, but he hasn't gotten much out of it. Just leisure and accessories! I'd like man to be an explorer. We've now reached a level of stability where we can just about feed our people. We're not there yet because of politics, but, still, I think we're going to reach stability on the fundamentals. Once there, we'll be able to become true explorers, and not just by being champions.

We're fortunate in our professions. We're enriched, after all. Him with his medi-tations . . . He's even found himself something basic, something I'd never heard expressed so clearly, on your integration. The whole journey where you explain why you do things, why you think them—it's very interesting.

Me, I'm always the same. Once a radical, always a radical. They're not going to change me! For me, things need to shatter. And yet I'm a timid man, afraid of every-thing. That's why I seek to go elsewhere, to go further. So that it'll overmaster me, so that I can conquer the fear!

DG: That's why you want to do away with everything, even the museum.

CP: I used to say the "simple folk" would go to the museum from time to time because they were told to go. And I'd watch these simple folk make four or five rounds through the museum before they were given permission to go home. There were so many visitors, drawn in by the newspapers. I find that appalling.

JN: In all the time I've been making museums, I've had occasion to give the matter some thought. I've got a somewhat critical view of the subject, too. Museums serve an essential function: they preserve and bring to life the remnants of civilizations. It is hard to imagine anything more important. And yet they're usually a bit too similar and not very lively. Why?

First of all, I find it scandalous for artists to work directly for museums. This is one of art's strongest trends right now. Whether we're talking about the scale of the works, or the means of commission, or the art market itself, there's a whole series of artists who live almost entirely off the museum market.

I find it scandalous also that museums, especially in their storage facilities, are now a sort of total racket for everything that goes by, and that to visit a museum's storage facility you have to be able to get up early in the morning, even if you know everybody! It annoys them when you ask to see what's in the drawers. There are tens of thousands of pieces that nobody sees. That, to me, is no museum. A museum is not a building, and it's not just a kind of bank or reserve or library built for researchers.

It has to exist, but the conditions have to be well considered and particularly well spread out, too. This is more of a Greek notion of the museum, the place you go to see things, and talk about things, and talk around things. It's much more of a neighborhood than a building.

What would make Paris and other great cities into world capitals of art? The level of public commissions for public spaces. Art is supposed to belong to life! Today the museum is not a form of life; it's a form of pilgrimage. We've gone from cult to culture. It's an old cliché, but it's true. It would be important today, notably in Paris, for there to be public commissions for works of art either of very large scale or of all scales for educational spaces. The poverty of educational spaces and architecture today is scandalous! The specs are scandalous! The budgets are scandalous! We're giving our dear children the bare minimum. Art's place has really not been established. We might even say that art galleries are much more accessible and closer to

the person on the street than today's museums are. That's a real problem.

CP: For once, Jean, I'm going to provide grist for your mill. At the Tate Gallery in Liverpool, I asked for some drawings in the collection because they'd told me that I'd more or less have my pick. They said no. So I asked, "Why won't you give me a painting that I like and have seen in your collections?" And they replied, "Because, sir, it is being restored. It is currently dormant." What does that mean?

Since museums aren't allowed to sell, they've invented exchanges. It's a way of defending themselves against non-museum people with the means to have themselves a beautiful piece. The museum people have to keep the beautiful pieces. To be able to keep them, they've imposed the need for rehabilitation and the need to put them to sleep. It's like monetary exchange. The pieces must be impeccable. Since they're coming and going and traveling about, they must pass into dormancy. So they keep them, cosset them, spoil them, make them as good as new. And ten years later they put them back on the exchange circuit. They behave as though the works were theirs, and they keep their capital, but since they keep them circulating, things sort themselves out . . .

That's how they've gotten around the ban on making money. And during the exchanges, they do make money! It's a well-organized defense. They're far from stupid, these great museums. They don't want to lose their thing.

When I was a student at the École des Beaux-Arts, I learned nothing at all. When I wanted to learn more about architecture, I bought a teeny little book, a Larousse, called *The Grammar of Styles*. It was truly limited, but at least I knew more than my peers.

It's possible to find inexpensive ways to attract people to art—things that are accessible to the public. They've gotten rid of drawing teachers in high schools. A capital mistake. I owe my artistic competence to three drawing teachers. Drawing classes that already in my time nobody was attending, and now they don't exist at all. Drawing teachers are the ones who opened my mind.

The fundamental question, for you and for me, Jean, is the relationship to art. It remains to be seen how we should reimagine the museum. And I haven't seen the problem grappled with in many places.

V I

There's a vicious circle. The anguish of passing time drives
you to live faster and more intensely. At the same time,
the sense of speed can only double your anguish.
We're going to need to find another solution.

—*Jérôme Batout*

Azzedine Alaïa: What I like about you, Bettina, is that you've made your way through all eras. You've been part of every one of them, from your time with Jacques Fath and Hubert de Givenchy to now.

Bettina: It's other people who set time limits. I know nothing of it. Yesterday's time is the same as tomorrow's and today's. I have no sense of having crossed over from one era to another. Through many memories and much recollection, I might hark back to the past, but I always return to specific moments. Otherwise, time goes by, every day. I have no sense of living through eras. I lived through them a long time ago and have memories of it. The other day something made me think of a certain time in my life. It's always the memory of an event that takes me back.

Donatien Grau: Don't you feel that things have changed?

B: Yes. *I've* changed. We change every day. Once you're born, you start to change. I feel sorry for people whose lives don't change. Some are born with possibilities and choices, of which I've had a lot. Is it destiny? Has it been my choice? Does it come down to the way I live or think? Over the course of my life, I've instinctively taken roads that have almost always led me to good things.

Time has no limits for me. I see far more change in others, through people's children, than I see in myself. A child grows up, becomes a young man. I see time go by like that, but for me it passes harmoniously.

Jérôme Batout: I was born toward the end of the twentieth century, and the twentieth century, in terms of time, was not like the others. The events before my birth, whose memory was still alive and sometimes raw for my parents or grandparents, affected my entry into the world and into time.

I remember that, as a child, I imagined I'd have to eventually become a soldier, like my forefathers. This was an obvious projection, frightening and seductive at the same time. But when I turned ten and the twentieth century came to its symbolic close, in 1989 and the subsequent years, I became aware that we were headed into something different, that I was living on the edge of the most violent continent, which was living through what Robert Cooper has called the "Long Peace." That overturned our relationship to time, which is now marked less by confrontation, struggle, and possible invasion than by invention. And by a sort of separation with the majority of present-day humanity, for whom war and violence are a permanent aspect of life.

B: I lived the life of the people of an occupied country, with all their suffering, which ended up being like a game. Because when you're very young, you'll make a game out of anything, even war and death.

JB: To me, what this temporary distancing from war means—in this small region of the world, it bears emphasizing—is that a break, a discontinuity, has vanished. Because if the main discontinuity of time for our individual existence is death, the main discontinuity for our collective or historical existence is war. War is the break par excellence.

I've realized that I did what I could to handle being brutally torn away from projection into war, and my reaction was to set myself on a path toward discontinuities that the historical era was not going to offer me on a collective level. I think it was an inward form, and that with time I learned to reconcile myself to continuity. Clearly, though, at first I inwardly relived the desire for a break, which comes from the long history of human wars.

B: You have the sense of a new beginning when you live in a postwar period. I started to live because I came to Paris to work right after the Liberation. We had everything to learn, and all the work lay ahead of us. There was a great sense of freedom. We were emerging all of a sudden from a moment when we were saying, "Oh, I'm alive." We got through it, and survived, and learned a whole lot of things. There was a sense of freedom, of survival. People were cheerful and happy. There

wasn't much work to go around, but there weren't a lot of people, either. When you say you were deprived of those years, Jérôme—it's true that when you live through war, you learn to live in a way that makes you much stronger. We came to know many more things through that time because we lived near death.

AA: And afterward, when you entered the world of the good life—

B: It didn't happen right away. I was out of work and had to find a job, and I didn't know anyone in Paris. I remember Sundays, when I'd walk alone through the streets, just to get outside a bit. And then, little by little, things started to happen. You meet one person, then another. I started working at a *maison de couture*, and there I made a few friends who became very protective of me because they were much older. And then I took up lodgings with a Canadian woman who'd been a soldier during the war. Then I rented an apartment. Things happened naturally. The way things just happen naturally is the stuff of life. Everyday events, little events, feed into one another: an apartment, one or two people you meet, and then another, and another.

That's when I had choices to make and roads to take, roads I always took with a sense of curiosity about life, a desire to go further. That led me, by instinct, out of a taste for life, into rather exceptional situations and a rather exceptional life.

The life I've had—always tied in with my life of the heart—has led me to completely different worlds. Every person who has passed through my life opened up a world to me. Hollywood, where I met the most famous actors and directors. Later it was a writer, a publisher. These are the changes of my time.

DG: You accepted that with every new person, you could live a new life.

B: Yes, and I lived life to the utmost. It's not that I was expecting something. I'd live the life of the person I was with completely, which allowed me, unwittingly, to broaden my life to all sorts of people, situations, countries, and travels. And throughout that time I was working. A friend and I did some reporting from Africa, far off. I'd be gone for two months and then come back and do some photos and be in the studios. I could get used to anything. I'd take up my work as if I'd never left. That's a huge advantage because there are people who need to be tied to certain living conditions, with habits and expectations. I expected nothing from anything, but I was alive. It's a great use of time.

DG: Because it gives you more than one life to live . . .

B: Yes. And life is broad and long. I'm still doing things. I still have projects. Even when I was on crutches, two years ago, I went off to see a friend who had a house in the wilds of Haiti. I still do things like that: trips to New Zealand and even to Antarctica.

My profession has been very important to me. I've loved it. After all, I spent ten consecutive years doing photo shoots. That's a long time for a model.

AA: You did a fashion show for Chanel as late as 1969.

B: Yes. That was a great moment. I saw her often. We'd have lunch together. She liked me a lot. I was a client, and then one day she said, "Why don't you join me for the fitting?" So I went down there with her, and she said, "I'm going to do a collection for you." That's how it happened. It was really by chance. I could have said no, but I said yes. But she got horribly jealous when all the journalists applauded me. She was mad with rage that people would applaud me more than the clothes. She went home furious. The journalists were delighted to see me because I was on such good terms with them.

AA: One newspaper headline read "Battle of the Queens." It was Bettina and Suzy Parker.

B: There are plenty of tales. I did fashion shoots with Gary Cooper and Picasso. Picasso was enchanted. Maya wanted me to stay and loaned me her room. She said to me, "I've seen it, you know. My father likes you. Nobody at all likes Jacqueline!" I could have chosen him right then, but I had someone else in view. Gary Cooper was magnificent, with that long, supple body . . .

I did a lot of shoots with long hair and braids, and then one day Jacques Fath, who would often travel to America, came back with the idea of having me cut my hair. He must have been smitten with a boy who had a close crop. The hairdresser wanted no part of it and said, "Oh no! I don't cut hair like that." And then there was Jacques Fath saying, "Shorter! Shorter!" Soon all my long red hair was on the floor, and I was happy! I was a new person.

That was the start of a new look. I was wearing men's clothes at the time, men's shirts and American pants, or wide flannel skirts and ballerina flats. I made the

cover of the first issue of *Express*. A lot can happen in ninety years! There's nothing trivial about it. You can do amazing things. I've lived day to day.

People talk about the 1970s, for example, but for me that doesn't mean anything. I have memories of certain years that fall within the 1970s, but I have no sense of a break. In fashion, though, I find that breaks are deeply felt because certain eras have a particular fashion attached to them. We weren't doing the same things in the 1950s and the 1970s. But in everyday life? I don't know . . .

I live things more than I think them, by instinct. It's not thought out. It's not something I intend. I didn't seek it out. I never thought to myself, "I'd like to do that." It just happened. I think I have good instincts, with antennae and red diodes that light up from time to time. When there's danger there are little flashing lights.

JB: You see your life as a great continuity, without frontiers or breaks between eras. You've lived through poses—that is to say, the moments of immobility for a photo —and you've lived through fashion shows, and therefore mobility. You've lived through seasons, too, because fashion is built on the rhythm of the seasons. It's a singular thing if you think about it: the play of mobility and immobility that makes up the ordinary life of a model.

B: Everyone has a life, a destiny. You can't say, "Hmm, I'd do things that very same way." That's not how things work. You can't copy your life from the lives of others. You are your own whole self. I am my own whole self. Everyone has a life force. Of course, some do more with it than others.

I don't have a family life, no husband or children, but I've lived a full life regardless. If I'd had children, I'd have lived a different life. There, too, I made a choice. I could have had children. My sister had six.

I have a great sense of responsibility. If I'd had children, I'd have lived entirely to make sure they were happy or intelligent or cultivated. I wouldn't have lived my life thinking, "They're going to grab hold of my life. We'll do what we can."

JB: You seemed to be saying earlier that life after the Liberation wasn't all that hard, even if people lacked for everything, because the era had an energy. I wasn't alive at the time, but I can imagine how it could be useful for your own individual life to be carried along by a dense and enthusiastic collective life. I think the absence of such energy in collective life can complicate private success.

It's not the same to write your own little history when you're not included in a some-what larger one—one that you're aware of. Today there's clearly a broad history, but it can take place without our intimate, inner participation. It seems to me it would be good for us to recover our awareness that there's always a collective history, even if it doesn't manifest in a pressing or violent way. Forty years of mass unemployment in a country like France isn't a war, and yet it's a very important historical period. A thing like gay marriage is a historic event—and it's from that perspective, I think, that we should understand the resistance to it. The people against it were at least keenly aware that something historic was happening.

The challenge for the people of the twenty-first century is to accept that the milestones of history don't have to be wars or conflicts. The great question of this century is how we might start living in a collective time again without resorting to violence for the purpose. We're going to have to invent a way.

DG: Bettina, do you think the time of your arrival—the early 1950s, the era of Jacques Fath and Givenchy—was richer in the energy of life, history aside?

B: I think so, but the relationship with fashion was different. There wasn't the same madness that would come later. People showed dresses in a fairly subdued way, in salons. It was more confidential.

AA: There was more design. Today things are more commercial.

DG: The question of beauty was central because people were truly coming to grips with beauty. When you talk about the hairstyle that Jacques Fath gave you, it had a meaning. It was confronting the image: the image people had.

B: It's true, but everyone's always had a sense of beauty, a sense of something, of oneself, of others. I saw it as a job, and I made a good living. I worked a lot, a whole lot. I didn't see it as putting my beauty to use. That didn't occur to me. I knew I was better than many because otherwise I wouldn't have been chosen, but there was something else. I wasn't the most beautiful in an academic sense, but I had something the others didn't. So, what was it? I don't know.

AA: You were photogenic. There are a lot of people in fashion who are photogenic but not particularly beautiful in everyday life. And others who have stupendous bodies that don't show up in the image.

DG: What's your relationship with photography?

B: I liked having good photos in the newspapers, just like everyone else, but once they were done I wouldn't be very attached to them. I've lost a lot of them. Others I've given away. I have some in suitcases. I never look at them.

AA: I'm the one who complained. I said to her, "Listen, Bettina. You're crazy. You can't just set the photos aside." She replied: "Bah. The past is past."

B: Still, there were some amazing people I worked with. I made some lovely photos with Capra, who was otherwise a war photographer. Doisneau did a series with me. Cartier-Bresson asked to work with me the one time he did a fashion shoot. I thought he was great. He made some wonderful photos with the feel of film stills. Irving Penn, he was complicated and difficult. I had to hold the same pose all day long. It was tiring. And if we took a break, afterward I'd have to take up the exact same pose in the same light. Nothing could change. It was meticulous work.

Many of the photographers weren't so set in their ways. It was Penn in particular. He was scary, and cold. He was a magnificent photographer, but he wasn't a warm fellow.

Even today people are always telling me about certain clothes I've had. It's touched people. People used to look closely at dresses. Back then people would buy a pattern and hire a seamstress to make the dress. It was a different time. If you're talking about eras and times: yes, it's something you can sense in that profession.

DG: I think that what lies hidden in what you're saying is the question of elegance. What you have is elegance, and it goes beyond time, whereas elegance is neither the purpose nor the principle of fashion photography.

B: In general, the elegance of a fashion photo lasts only as long as the photo.

AA: There are pictures that make you dream, too. Sometimes the photo surpasses the model, through the woman's physique, her body, the way the photo has been altered . . .

I think about people, what they're going to be like in life, what might help their silhouette, the way a woman should be at her ease. I don't want to produce a fashion that isn't livable. I work with the way a woman can exist in life. My idea is that the clothes should last and that there is no time. When you see what I do, you start with

the 1980s and continue on to today. There's no temporal separation. There's no time. What interests me is that a woman never go out of style.

There are women who have a certain chic, a way they dress. In Harlem, at church on a Sunday, I've met the chicest people in the world, with shined shoes and a white shirt and open sleeves. That's why I love the clothes that people wear on the street. You don't see the era because people dress in sports clothes that don't specify an era.

JB: There's a vicious circle. The anguish of passing time drives you to live faster and more intensely. At the same time, the sense of speed can only double your anguish. We're going to need to find another solution. The current discourse about slow living—with its "slow food" and even "slow sex"—is no better at getting us further along. But at least it calms things down.

B: They teach you to make love more slowly? Why do they teach you that?

JB: To learn about sex today, you start by watching pornographic scenes. You must have noticed that pornography isn't especially an art of slowness!

But there's more than just the "slow" talk. The other talk is about "mindfulness," the will to rediscover yourself through meditation on the present moment. You set aside the past, which you have no control over, as well as the future, which you also have no control over. I'm not convinced that islandlike awareness, this sort of isolation, is the answer. But I'll admit that there are people with a talent for living in the present. Maybe that, too, is being in fashion. Bettina is a woman who's done that masterfully, right up to the present.

B: There exists an outmoded way of life. I've known some easygoing women. More women than men. It's less annoying with men. A woman who's out of style is plain to see. It's in the way she dresses.

AA: And in the way you live in your era. There are so many people who live outside of their era.

B: They live outside of time but in the past. You can be outside of time and create something. If you're outside of time, you can live in the past and create. You can be a painter or a writer. You can be outside of time but inside of your own time. You create your time, your own way of living your time, because you're

creating something. All creators have their own time, which is just as important and full as the time of an agitated person.

DG: Bettina, you've been involved in the domain that has symbolized acceleration—that is, fashion—while still maintaining your own temporalities. You haven't yielded or been afraid.

B: No, not at all. I have no fear. I'm not a fearful person. I'd like to create. Deep down, I've always wanted to draw and paint.

AA: Fashion forces you to be in time. You have to be in time and manage to think through the time before others get around to it. Maybe setting yourself up on the outside is another way to think it through.

VII

The interesting thing about accurately measuring abstract
ideas, such as time, is that it necessarily involves a craftsman.
A lot of the objects that were made to try to record, figure out,
or comprehend time, to make abstract issues tangible, were
beautifully crafted and significant in the history of design,
whether a simple set of dials, a clock, or a watch. . . . To figure
out how you measure time helps you comprehend it.

—Jonathan Ive

Azzedine Alaïa: I am very pleased to begin this conversation. Marc is one of my dearest friends, and so Jony has become one as well. They have both invented forms that change time.

Donatien Grau: You each share a passion for craftsmanship, which seems to be the measure of time for you.

Jonathan Ive: Historically, the interesting thing about accurately measuring abstract ideas, such as time, is that it necessarily involves a craftsman. A lot of the objects that were made to try to record, figure out, or comprehend time, to make abstract issues tangible, were beautifully crafted and significant in the history of design, whether a simple set of dials, a clock, or a watch.

Measuring time concerns both the masses and the individual in different ways. An individual can be intrigued by the issue of time, perplexed by the abstraction of it. That abstraction rises up to the universal. But it's usually been a singular person trying to reconcile the mystery: the dynamic between sensing time, keeping time, and existing. To figure out how you measure time helps you comprehend it.

Marc Newson: Time is empirical. You can measure it. Thinking about the challenge of measuring the abstract more broadly brings to mind Saint-Cloud, not far from where we sit this evening, the place where the idea of the meter and the kilogram were conceived. For a long time, measures depended on the place you got them from. If you tried to convert a measure from Sri Lanka and another from

London, there was no consistency. The calibration is critical, which is why Saint-Cloud is so important.

There's also a connection with the Foucault pendulum in the Arts and Métiers [industrial design museum]: it all comes back to creating universal measures. Yet it is all a construct, which is developed in a specific moment in time. It may eventually become universal but, as the Foucault pendulum and the Saint-Cloud meter were, all these measures were once local and individual before they were adopted universally.

DG: On the one hand you have the individual, and on the other you have the universal experience of time.

JI: I think it is part of the human condition to try and translate something that is hugely powerful and personal into something universal. It is a curious part of the human condition not to be intimidated by a concept that is massive and far reaching—quite the opposite, to try and translate it. This human condition is perfectly relevant when applied to time.

At a certain point in history, the measurement of time became a huge social and political issue. The power of understanding and controlling that technology evolved: you had cities or towns that grew around watchtowers. Time is a key signal of a culture's development. Speaking to those who have studied either the philosophy of time or more pragmatic recordings of it, its impact on cultural issues is evident.

MN: It's interesting to explore the evolution from the scientific idea of recording time to the personal aspect of time. At a certain moment in the seventeenth century, thinking evolved into taking a timekeeping device and wearing it on one's person. It was a profound decision that affected how time became so closely interwoven with an individual's life.

JI: The more powerful that technology has become, the greater the desire to make it personal, most importantly by making it smaller and more accessible.

MN: The idea of miniaturizing technology has always been at the forefront. It's an interesting contradiction that, although we have become so used to the wearing of timepieces on the body, there's now a young generation who are less familiar with the instinct of wearing a watch. They look elsewhere for their information.

JI: It is an odd mixture of the most profound philosophical consideration of time

alongside the most pragmatic. For centuries, individuals worked to make clocks smaller and smaller. The next step was: how does a clock connect to me? For a while, it was on a chain, worn around the neck, later hung from trouser pockets. Thus began the process of miniaturization.

MN: I would argue that the watch was the birth of ergonomics, even more than the chair. It is the original wearable technology, and it predates the concept of furniture as decoration.

JI: There's an interesting story about the origins of timekeeping. The matriarch of a family that lived in Greenwich, in London, would periodically visit the big clock in the town center. She would set her own clock and would travel around the town to sell time. It's a fascinating idea—one of the first iterations of a subscription-like service. The idea was to pay this amount a month, and you would be told the time. The idea of entering an agreement for time ties into the idea of paying for something on faith and trust: "I will give you money because there is a value to this transaction in the future." This woman would be paid every month, and she would visit people in their houses and they would set time from her pocket watch.

MN: And that was time when time was abstract, when it was virtual. It was not absolute. It was not until Foucault shaped the concept of time that we could develop a concept of time that would be scientifically dictated by the celestial things.

The concept of time is relative: my time is relative to me; your time is relative to you. Time and measure go hand in hand; they are relative the one to the other. It was only with Napoleon that the system was united, with decimalized measures and a structured measure of time.

AA: In some places, there is no real measurement of time. There is night and day, and that's it.

JI: Time has always pushed us to try and figure out our place relative to the rest of humanity. There is something very material about that—our place on the planet, relative to the sun. It is physical and simple.

MN: What is time if not the most subjective measure? When we developed the watch, we designed a timepiece, embodied in an object. In fact, the concept of time has little bearing on what we achieve. With the creation of timepieces, we were dealing with a mathematical device, but qualitatively the notion of time does

not denigrate us; it does not improve us or make us less proficient at a task. In a certain way, humanity exists out of time.

AA: For me, time does not exist. Someone once asked me to say something about time. I said, "Tonight, time does not exist for me. It is suspended. We are spending a few hours together; for me, it is just a moment. I prefer to exist in a time that has no limit." The issue of time was for designers. It is a deep problem. The people in the industry have not understood that time does not exist for those who create. And if you bring time into their existence, then you put everything they do at risk.

JI: When I came to your studio, Azzedine, I saw a master craftsman. That is very rare. When you make something, you're not just solving a problem. You create with your hands, a craft that is beyond the borders of time.

MN: For Jony and me, the idea of refamiliarizing a generation with the concept of time is inspiring. The idea that time is an ergonomic construct, that is worn on the body—all that is not a given for a new generation, as it was to the many generations before us.

Without placing these objects on our body, the concept of time certainly would not be the same. Nuclear time exists. The idea of time passing exists.

It's completely instinctual, the notion of wearing a timepiece on the wrist. It has been that way for centuries. Yet I showed my seven-year-old daughter my wrist-watch and it was unfamiliar to her. A watch was a relevant cultural construct at a certain point, and it will be again.

JI: We as human beings are instinctually very practical and very intellectual. What led to the creation of the wristwatch was in fact an aviator who needed to keep track of time. He observed: "I want a clock on my wrist so that I can track time without being distracted from the task of flying." So, what became a culturally significant invention was born of pragmatism.

MN: It's an ergonomic evolution: something is logically placed on a particular part of your body, thus it becomes a physical part of your being. The minute you can wear an object of technology, it changes the whole paradigm of being. The wrist-watch was the first time that you could have a mechanical device on your body; you became part of the universal.

The watch is an inverse concept of the universe: instead of looking out, you look in. It has to do with scale and space. If you put aside some rough measures, time is relative. There are sophisticated cosmological machines in many civilizations. Look at India. They are probably as sophisticated as one that was invented scientifically.

However, ultimately, even if the structure of time is cultural, the most important aspect is personalization. A watch is the first intimate way to deal with personalization, through miniaturization: taking technology, miniaturizing it, and incorporating it onto your body, making it part of your identity.

We need to constantly realize that the watch never left the person. It's all relative to you. The device will be irrelevant if not for your body, then for your own presence in physical space. The concept of fashion in contemporary culture is absolutely relevant; our body is intertwined with the notion of the wristwatch.

It is a bit like a chair: without a person, a chair is useless. There are three fundamental design revolutions: the wheel, the chair, and the watch. A watch is a recognition of the relevance of the human body within the realm of technological advancement. We need a handle on our lives. We need a way to connect ergonomically with technology.

JI: What has been particularly interesting is the liberty to try to develop an object that has a functionality, a utility, one that is new and, at the same time, has a historical, cultural context and is used on the body.

Steve [Jobs] used to speak about how Apple stood at this curious intersection between technology and the liberal arts. From the very beginning, in the 1970s, you had this incredible creativity: a small group of people trying to figure out how to empower many people. They did that in a garage. What drove them was not only to find out something remarkable, but to develop it for all individuals. To find something potent and make it personal and accessible. You can argue whether this is a fundamental part of human nature, but it was what drove Apple. What we have seen is miniaturization and a drive to make technology more accessible to many, in terms of size and cost. It's a highly practical ambition.

To contemplate what that represents from a social point of view, Apple has an important role to play in trying to reconcile powerful technologies with the most personal application, therefore making time for people to exist in their own life.

VIII

I have no fascination for the past, but I'm trying to face down a world that's moving so fast that it seems to leave aside know-how and knowledge and cultures by the ton—things that, it seems to me, are crucial to look into.

—*Ronan Bouroullec*

Didier Krzentowski: It's time to begin.

Azzedine Alaïa: Why so impatient?

DK: When I've got something to do, I have to get in early. You're making me wait for a conversation about time. It's terrible. In my head I've just about already finished. I need to have a thing over and done with to get any peace.

Donatien Grau: Is it the same with you, Ronan?

Ronan Bouroullec: I feel that I'm always short of time. I need sharp focus, and to lead a fairly mechanical and organized life. I spend a lot of time working. I spend my time strolling around the studio, hovering over my assistants. I need reassurance. I need to know. I need to set aside the time to work. It's almost a sanctuary. I have a mechanical need for that space. I hate having appointments. I set up very few of them.

DK: To give you an idea how much time Ronan and his brother, Erwan, need to set aside for work, consider that four years have gone by between their last exhibition at the gallery and the next one.

RB: I don't have a romantic relation to time. It's not the sort of romanticism you get from art school. All that time you spend not doing much of anything—the fantasy of waiting around, in a kind of floating state, where the gestation of a project isn't a

mechanical situation and there's a response you're supposed to supply. That latency seems necessary to me because it establishes a remove.

DG: What's your relationship these days to the time you spend in production?

RB: We work with very few people. We generally refuse the proposals we get. I make sure I'm operating in a context where time is a criterion I can control, so that my method applies. I'm a pragmatic person, of course. I have a sense of reality in some form, but I agree to projects when I think I'll be able to carry them out. A project can be called into question for as long as it's not right, and so temporality doesn't amount to any kind of pressure.

DK: That's exactly what we're after with the gallery [Galerie kreo]. For the designers we work with, there's never a directive. We let them take their thing as far as it'll go to put on an exhibition.

DG: But at what point do you as a designer say, "All right. It's good"? At what point do you know it's done, that a project's time has run out, and why?

RB: I rarely say that. It's a bit like a blue note in jazz. You just sense at a certain moment that the note is right. There's a moment when you stop. You might be greatly disappointed the next day, but you know there's something acceptable, something presentable, at that specific moment.

AA: It never ends. You suffer blocks, but they're temporary.

RB: That's what's terrible. Our anguish.

AA: Why would you want it to stop? There's no right moment for creation. You can create at any time.

RB: But don't you hope to get some relief at some point, Azzedine? I sure do.

AA: I don't want relief from work. But I do want relief from the pressure of that moment. We live in stupid times, when everyone goes along with the acceleration driven by demand. People don't have time to create better anymore. But if you have more time to think and do, creation doesn't come to a halt. It evolves. Sometimes you manage great achievements only at the start of your career. In the beginning you establish yourself and people discover that you've got something.

Then your troubles begin. How do you keep going?

DK: You've got time at a gallery. It's true, though, that there's also a sense of obviousness, a sense of the moment.

RB: We have a special relationship with Didier because I might like the discipline, but it kind of goes against what we can do with him. What I like are objects reproduced in volume.

DG: Not limited editions?

RB: It's a working condition that's become important for me because it has made possible what was once impossible. If you want to make an object that can be reproduced tens of thousands of times, you're dealing with an industrial situation, with strange and complex parameters.

DK: That's what marketing's for. But we want to be like a laboratory. There are certain pieces that were designed at our gallery but have later been produced at other scales, with other materials and procedures, by industrial concerns. If you hadn't made those pieces with us, maybe the manufacturers wouldn't have made them.

RB: It's like directing a film and having to use different actors in certain scenes, with a different setup.

A designer's task is to be right in different contexts, just like an actor. An actor has to make you laugh one day and cry in some other scene. The designer is in precisely the same situation. You're in a variety of contexts and always looking for the right response. You have to find solutions for an object that's reproduced a hundred thousand times, or the right solution for a limited piece. The anguish is the same; the problem is the same. The search itself isn't any different. It's a matter of mustering empathy in different contexts.

For example, right now we're working for Iittala, the extraordinary old Finnish firm that did all of [Alvar] Aalto's vases. The firm is in serious trouble right now, so we're trying to find objects to help get them up and running again, at their scale. They've got a hundred workers, so we need a project with a production run in the thousands. We need to find things that'll work with a specific manufacturing tool: objects we can sell at airports. At the same time, the quality has to be good enough to warrant being acquired by the Museum of Modern Art.

There's no hierarchy of projects. That's why when we were asked to do something for Versailles, I originally said no. I thought we wouldn't have the right response and weren't the right people.

DG: Why did you think that?

RB: Because we've never drawn unique objects—on principle. That doesn't interest me. I actually find it shocking. For me, a good idea needs to be reproduced.

AA: Unique pieces can be reproduced. With certain dresses, on occasion, I'll say, "No, I won't put them in the collections." I know that if I put them in, they could bring in a lot more, but I say no. I put my foot down.

Whenever I see that a garment doesn't generate enough orders, I don't make adjustments. I'd rather save it for the client who comes along and tailor it for her. Then she's all set for the next season. Pieces can be unique when they're made for someone. Later they can turn into produced pieces. But if it's made for the image of someone you have an affinity with, it's good for it to then head out onto the street.

RB: I think there's a mechanical and technical difference between fashion and objects, too—if only in quantity. Overall, we have to do ten objects a year. Five turn out right.

AA: I'd rather do one unique piece and later develop it for the public. The first pieces are sold at designer prices. There might be only twelve, twenty, or even fifty clients in the world who possess a limited edition, but it spreads over time.

RB: I make ten objects a year—that is to say, ten projects. Some are reproduced hundreds of thousands of times.

AA: Yes, but that's not the same thing. Something interesting can be reproduced only a few times. Collectors can have them, and the garment goes on to live its life.

RB: For me, the limitation is more mechanical. It has to do with a context such that certain pieces, certain techniques, certain lines of inquiry receive economic validation. The object lives its life, goes down its path. Azzedine was telling me that he likes to meet the artists. I like to be reached by something. I don't necessarily like to meet the person who's made it or designed it. I like to keep things vague. I like to leave things to the imagination, maintain that distance.

DK: I don't want to get to know the artists behind the works of contemporary art that I collect because I've constructed a dream around them.

DG: That's the problem of art's specificity. By the common presuppositions, design is for everyday life.

RB: Yes, but it's really like fashion. Fashion is for stepping out. It's for living life.

Clémence Krzentowski: It's the question of use. Art doesn't have a use, but design does, and therein lies its power.

RB: And its limit.

DG: The limit of art or design?

RB: Both.

DG: Ronan, you studied at the École des Arts Décoratifs and your brother studied at the Beaux-Arts in Cergy. Haven't you ever considered becoming an artist?

RB: Yes, but for me classification doesn't matter. For me, the important thing is that the thing reaches you—it might be a baguette, or a dress, or a speech that you consider refined and intelligent in a complicated context. It's not so much the box I put each one into. It's more the quality and the interest the thing holds. It's the moment when you're faced with situations or people who seem to be playing a role, occupying a position, or taking on an attitude in the world that seems right to me. The artists are of little consequence. Some of them might reach me . . .

Would I have liked to become an artist? I like thinking that if there's a good idea, it needs to be reproduced and thus shared because, indeed, I think one way to change things is to reproduce something that seems interesting. If our objects can be reproduced in volume, by the thousands, that's a more powerful weapon than the limitation.

DK: I more or less agree. When you put forth a strong project at the gallery, it generates so much talk in the world that many soak it up for their own advancement, industrial or otherwise. Some of the products we've made have become almost iconic and influence the work of young designers or the products of companies. They're known the world over, even though there are few copies in existence.

RB: At the gallery, the finished project matters just as much to me as the project's picture. Since it's not going to be physical, it should be perfect in terms of the iconography, in terms of the image.

DK: Besides, whether or not he's aware of it, he [Ronan] goes to extremes. When we do an exhibition, he hovers over the photographer for two or three days. The photographer can't touch a thing.

RB: That's right. All the pictures of our work have been made by us, and specifically by me, because these days an object's reproduction takes place as much in the image as in reality.

DG: Where do you situate the gallery with respect to that world of an object's reproducibility? Where do you situate that element of experimentation, of isolation, of the limited unit?

DK: What I'm fairly happy with about the projects undertaken at our gallery—because we aren't the ones doing them; it's the designers we work with—is that many are known and renowned the world over. Students all over the world know them. That's our nature, and it moves the story of design forward. Otherwise, the manufacturer these days is often dealing in a kind of remix. There's not much room for freedom of design. Designers enjoy a lot of liberty at our gallery.

If you look at the big movements in design, you realize that the most important objects haven't sold very well. If you look at the lamps made by Memphis, a movement that's left its mark on the history of design, you realize that over the past twenty years, the one that sold the best had a production run of 150 or 200, which is laughable. Everyone knows the name Memphis because it moved design forward.

I remember this one piece that Ronan and Erwan made with a French brand and then with Cappellini that went round the world: Lit Clos. That piece marked the beginning of our story. Cappellini didn't sell a single one, and yet the bed not only inspired young designers but advanced industrial design in another way. Jonathan Ive speaks of Jasper Morrison's pieces as sources of inspiration, but they were in no way best sellers.

Ettore Sottsass has said, "I do industrial projects, but I have no clients." It's the same as with fashion. I suppose there are pieces that are barely wearable but that advance fashion's story.

CK: What I find interesting is the appropriation by the person who makes the purchase. The art object is finished, done. There's no interaction. Whereas the thing I find particularly striking about objects—especially those that are adjustable—is that they're yours. You do with them as you please.

RB: The iconic pieces of the twentieth century have generally been flops. It's the problem of being ahead of your time or your era. That's not the case with everything. The iPhone has been an incredible revolution. It was multiplied tens of millions of times and radically changed the world. It's the extraordinary case of an invention.

CK: Because it's also tied in to a new technology, a new way to navigate.

DK: Very strong technology renders design powerless. In the 1990s, when [Philippe] Starck was working for Thompson televisions, I found certain models to be sublime and couldn't understand why they weren't selling. So I went to a Darty store to find out, and they told me: "The design might be pleasing, but it's a Trinitron." Sony's technology was so far ahead that even with much better design, the Thompson television set was outclassed.

DK: And how about for you, Ronan? Is the question of technology central or secondary with respect to the emotion that an object elicits?

RB: A well-made object is a good blend of fairly opposed parameters: ergonomics, price, comfort, lightness, novelty. What bothers me about technology is that it's often a way to pretend that a project is truly new. It's new in a mechanical way, but being new isn't complicated. Now, being right—that's a whole other matter.

I also really like working with old techniques because it's a real feat to face down the history of something in order to produce something truly new. We recently worked with the millinery kilim technique from Pakistan. Managing to produce something totally different with exactly the same palette, and the same kind of transformation used a thousand years ago, is much more complicated and satisfying.

DG: But is the idea of achieving something new still possible, something to reach for?

RB: Yes, in the sense of difference. I find it interesting only if I manage to produce interesting things. If it's just a matter of putting elements together intelligently, that's not enough.

CK: That's true in all things.

AA: Everyday objects have become art. I'm fascinated by the objects of country folk, and their clothes, which are true creations. They're tools or utilitarian garments, but they're works of art. Vionnet hired someone to draw the drapery at the Louvre as well as in Tunisia and Morocco. The sources of art, like art itself, come from very different domains.

RB: I think a usurping has occurred with the term *art*, in the dichotomy between what is and is not art. An everyday object is not art. It's an everyday object. But if it's extraordinary, it's like an extraordinary person, or an extraordinary dance step, or a dress. That's what counts.

That's what we get with Azzedine: a dress, a dress, a dress. As with me: a chair, a chair, a chair. It's the medium of our expression, whether it's a dress or a chair. I've made plenty of chairs. Some are right, others very bad.

The idea of an absolute in art doesn't seem pertinent. I'm fascinated by Native Americans, by their nomadic tent life, the perfection of their garb and objects, their synthesis of everything that goes into an extraordinary population, with the exacerbated elegance to their stride and the way they lay down little paths. The collective expression of a society or organization that's harmonious and elegant— that reaches me more than any sort of absolute in an artist, as we sometimes speak of it nowadays.

AA: When I was with the Maasai, I was struck by the way they could take goatskin and make clothes with this incredible embroidery. I bought two pieces. I could put a Picasso or a Renaissance masterpiece next to one of those garments. It would have the same density. It's beyond history, beyond era.

RB: I'd like to detail one aspect of my thinking. I have no fascination for the past, but I'm trying to face down a world that's moving so fast that it seems to leave aside know-how and knowledge and cultures by the ton—things that, it seems to me, are crucial to look into. If you take light and the invention of LEDs, that's an extraordinary technology. Light depends on the quality of a lamp or a bulb. We gauge a bulb's quality on its restitution of colors. Incandescent bulbs emit about 95 percent of the colors. LEDs about 70 percent. The technology is extraordinary, but it's meager. It's an impoverishment of sensuality. It's extremely useful because it saves energy, but light and color are impoverished at the same time. The technical,

artisanal, and industrial palettes are very broad. It's idiotic to consider technology as being purely material.

DK: It's true that I get a lot more emotion out of lamps from the 1950s to the 1970s than out of today's versions. But it's also true that there were far fewer industrial constraints at the time.

DG: Maybe that ought to be the project: manage to make something today that uses those artisanal elements but does so industrially.

RB: Yes. It's having a palette of both new and old technologies. It's being in accord and living in a world with an extremely wide field of possibilities. And not falling for the somewhat simplistic faith in novelty. Using a new technology does not guarantee a good project.

It's like the question of painting. Every ten years, there's a recurring discussion about whether it's worthwhile to continue painting. Of course it is. It's like literature; you don't even think about it. You can live a very full life reading only what's been produced until now, but it's in our nature to keep writing and painting.

DG: New technologies are an element of the palette, but not the only one.

RB: That's always been the case. What's new is that we have to keep hammering it home. It's like the coining of a new word or a new phrase. The lamps are interesting in their association with our culture and what we already know. They're interesting not by exclusion but by addition.

DG: Maybe the richness of the present is that it allows for such plurality. There was a belief in new technology that has now been put into perspective . . .

RB: We were speaking of the iPhone. Here is the use of a new technology, an extraordinary invention, with a palette shared by all. Although the competition has the same technologies and shares the same knowledge, there are people who simply arrive at some point and effect a synthesis that's incredibly right. And even as they're accomplishing this synthesis, there are three guys in a forest realizing the power of such-and-such plant and that it's going to save lives or lead in some new direction.

DG: There's a lot of fear in art over the inability to produce new forms, but you,

Ronan, hold yourself apart from that sentiment.

RB: It's the recurrent and ever-present question of whether everything has already been done. Whether we can rewrite. Sure, Dostoyevsky is probably better than Houellebecq, even if it's too facile to think that way.

DK: I think our new way of living, with all the new elements that arise, necessarily produces new things. There will always be creation all over the place.

DG: But there's a certain specificity, which is the public visibility of design today.

RB: It's a matter of communication, of the moment. Like the interest people have these days in chefs. Interests change.

DG: It's not just that. It's also an optimism that's due to an injected energy.

RB: It's interesting to bring up optimism, since I think we're in the most pessimistic society we've ever known.

CK: There's always an element of innovation, meant to make life better. It's in the very nature of what we've perceived as design since the Industrial Revolution. We ascribe positive qualities to it.

RB: There's nevertheless a difference. Take the 1950s, the postwar years, and the fundamental need to get people water and electricity, to organize construction industrially, to foster a general optimism. We had to arrange for access to a more advanced form, on a large scale. Today, Western societies are faced with fewer such necessities, but with more commercial matters. We're in a period that's opening up to new approaches, to a wholly different realm of the imagination. Before it was the realm of necessity—an extraordinary technical realm, but one whose subject was necessity. How do we solve the problem of people with no roof over their heads? How can we produce an interesting shed? Our realm of the imagination is much more complex. Within the context of the gallery, we're addressing extremely rich people whose passion is for new forms.

DG: But do you think there's a modernist idea, a sort of dream of the future, in design's realm of the imagination?

CK: That's what the collector Marcel Brient says. He likes to imagine that part of

what he's looking at are tomorrow's forms, or the proposition that will give birth to them and will pass from the intellectual world to society.

RB: The geographic context, which was fairly narrow and corresponded to fairly defined situations, is breaking wide open. The pieces we design are being used in Japan, by people who live in rural areas and city dwellers alike. At one point the objects were really a pragmatic response to needs. Now we have to incorporate that element into our thinking. When you work in an office environment, the solutions are bound up with the realm of the imagination, but they're pragmatic solutions, linked to the present and to needs. We're not sitting here thinking that whatever we lay out is going to become the norm in fifteen or twenty years. We're just observing the urgency of the situation; we're looking for solutions that seem right.

DG: It seems important to you to be geared toward change.

RB: It's an attitude that seems valid under all circumstances these days, whether you're a painter or a baker. You should act in such a way that things get better. You should try to make things more right.

DG: How do you define this adjective that you're always using: *right?*

RB: My definition of rightness is partial. Rightness is a response to a context. It's something that's merely functional in today's world, with its complexity and violence. What response seems interesting in the face of such complexity, whether it's sensual, sweet, gentle, or violent? For me, rightness is an attitude. It's pragmatic, astonishing; political propositions made in response to a world blown apart.

If we take the question of what makes a good object—it's not an Excel spreadsheet with an X in every cell. It's kind of a strange balance, like an interesting person. It's about charm. Charm is a complex association, a chemistry or alchemy between factors that makes a thing remarkable.

DG: Design overlaps considerably with the problem of how to "live together."

RB: The term *design* has taken on a complicated usage. It's become an adjective. We speak of an object or a chair that's very "design." That's really the worst. It's become a stylistic question, a transparent object made of colored plastic.

DK: In fact, design in the eighteenth century was drawing. It was the idea.

RB: The question of the object writ large is what matters to me. What form or technique predominates, what industrial choice, what artisanal choice. Reflecting on objects is reflecting on our life. So, yes, it really is the question of how we can live together, how we can be open to emotion in our everyday lives. I don't define myself as a designer but as a creator of objects.

CK: Yet you create objects that are more than objects. They're objects in the sense of having a physical existence.

RB: Yes, but in the end, they're objects. It doesn't matter whether they're good, extraordinary, or mediocre. They're still manufactured objects with a price, a cost, a technique, and a thought behind them. Finished objects that emanate principles.

CK: We've cycled back to the hard-to-define idea of politics. In the end, I think we approach things politically. There's a kind of generosity . . .

RB: For me, political engagement depends on how actively we participate in the world. There's something megalomaniacal to thinking that you're going to change things just because you have a good solution. I don't know if that's generous. I think the world is so ugly that there's a lot of work to be done, and at least I'm trying to do something.

DK: What interests me in the gallery is lending a hand to people who think that way, who think to show the way or find new paths. They should change them in a certain way. I start to look at an object of design when I fail to understand. I need something different or new. And so I've had the chance, over almost fifteen years, to have had emotions like that. People who collect have a real desire to glimpse tomorrow. It's wonderful to be caught up in that dynamic, heading toward the future.

RB: It's the sketchbook question. We're all like enormous sketchbooks. There are people tinkering on every corner of every page. When we finally analyze the whole, ten years on, what once seemed right or interesting might now seem old hat, and a few small things will reveal their perspicacity, their intelligence.

IX

Every piece of art is a fight against time.

—*Jean-Claude Carrière*

Azzedine Alaïa: Julian lives every time period intensely, and he is a very dear friend. I wanted to ask him about the issue of time, with Jean-Claude Carrière, whose works are as of the moment as when they were created.

Julian Schnabel: Paintings bring you into their present. You can look at a painting that was made in 1606 and, if you walk up to it today, it's in the present. When we went to the Musée d'Orsay to look at those Artaud and Van Gogh works with Jean-Claude—

Jean-Claude Carrière: Unforgettable.

JS: They were in our present, and they brought us into their present. That's what painting does. That's what art does. Whenever you discover it. If we saw [the 1946 film] *Shoeshine*, by Vittorio De Sica, today for the first time, it would bring us into whatever that reality is. It's not in the past. It's not old. It brings all that up to the now each time you see it.

J-CC: I was working once with a neurologist. He told me about a test: You draw an island. Then you put a boat on the ocean. If you put the boat on the right side of the island, 75 percent of the people say the boat is going away from the island. If you put the boat on the left side, 75 percent say it's going toward the island. Everything—space and time—depends on our habit.

It is impossible to talk about time today without thinking of space. Since Einstein, we live in space-time. It's impossible to separate the two. As you say, making a painting and looking at the painting belong to two different times, but the painting is there to put together different spaces, of course, and times.

For instance, do you know, when you start to paint anything, how long it will take? Do you have an idea?

JS: It depends on the painting. In general, no.

J-CC: When I'm asked to write a book or a screenplay, I have to know more or less how long it will take. If I believe that it will take me four months, I ask for five. If they don't give me the fifth month, I refuse. I can estimate it, but I need a real freedom inside of that.

JS: Somebody asked me recently to write something about Ai Weiwei. I don't know all of his work, but I know one thing: this man is as important as an artist in what he makes as in being a political prisoner. No matter what he does, it's codified by the fact that he is a political prisoner because he lives in a regime that covertly and clearly prevents somebody from doing what they want to do. He does that in the context of being censored, and his work has meaning because of that—more meaning because of that. His limitations open another space for his existence, for his work and everyone who encounters it.

This is a very clear and emblematic vision in the case of Ai Weiwei because it's a state, a country, the government, that is stopping you from making art. If he were to leave that environment, like Cubans who worked inside the Cuban system and then went to the United States, it would be a totally different thing. Like Reinaldo Arenas's experience. They have no reception here anymore, so that's why many stay, so they can work within that system. That's why also, when writers leave, a lot of people abandon their interest in them because their art is not valid anymore. That was Arenas's initial experience. In Ai's case, he has been able to maintain the relevance of his situation and art, which is unique.

Somebody asked me: "You made a movie about Jean-Michel Basquiat, and you live as a successful artist in the middle of the elite intelligentsia of New York City. How could you make a movie about an artist who died young and who lived on the street?" I said to that person that this was one of the stupidest questions I've ever been asked. If I committed suicide after this conversation, would it validate my work?

J-CC: If somebody were to do a film about your suicide, I'd love to write the script for it. That would be really something. It becomes a situation.

JS: There were young artists I knew, particularly the ones who wanted to be great, who always said: "I've got to die by the time I'm thirty." They're still alive. It's sad they didn't die. I'm happy they're alive, but they did not get the kind of myth attached to their ego that they would have gotten had they been dead.

J-CC: I'll tell you a little trick that I do. Time, with a capital T: nobody knows exactly what it is. It is impossible to give a real definition of time. We are almost nothing, how could we have a sense of it all? And yet there is a practical way not to be overwhelmed by time, but to dominate it sometimes.

For instance, what I have been doing for a long time is, every week I take my agenda

and I just draw two lines across two half days, two weeks later. That way, I know that, some time ahead, I won't take any appointments. Some time is waiting for me. It is very comforting. When the day comes, I do whatever I want. I work. I go away.

The idea of not being a prisoner, of not being afraid of time—I couldn't do without that.

JS: There's a line in the movie *Schindler's List*, when a Jewish prisoner in the ghetto, who is a university professor, is standing there, getting some soup, and he says, "You know, today I've had enough time to complete a thought."

When you're writing, first of all you're editing a lot, instead of directly writing the final text. But at the same time, we come to writing through edits. And the fact is that you do it very quickly. You find yourself a situation, you remember something that it connects to, you illuminate that moment, and then you add or subtract or edit something out.

Painting is a compression of things. When they say "a picture's worth a thousand words," that's true because, again, everything's right there. You don't need to wait two hours to see it. You don't have to do anything, you don't have a meeting, you just do this thing. But at the same time it has a very different relationship to electricity, to time, to the public every time you show it. People might not discover it for a very, very long time, even though it took you a shorter time to make it.

If somebody said to me, "How long did it take you to make that painting?" I would say, "62 years and 5 minutes."

J-CC: In a scene from Marcel Ophüls's film *Lola Montès*, the king of Bavaria is visiting an art gallery and the only question he asks about a painting is, "How long did you take to make it?" That's the only question, and it's very difficult to answer.

In terms of writing, I work my own way. Everyone does. I have always been on time with my work. Even in advance. I have never been late in my work. I wouldn't like it.

JS: You would do it anyway.

J-CC: I learned a lot from Buñuel. Luis and I used to work for two months every day, very closely. We had no one with us: no women, no friends. During that time,

we were on our own, just the two of us. After two months of writing, we have the first version of a script.

We proceed: he goes back to Mexico, I go back to Paris. And we forget about the script for three months. Then we get together again. We take the same script; it is not the same.

Things that we used to like, we don't like anymore. Solutions that we were looking for, now here they are. We called this the invisible worker. I suppose it's the same for a painting.

JS: Yes. Many things I'll do, I don't know if they're good or bad. I leave them like that for a while. I come back and I think, "Now it's good." There's a painting that's going to be shown in Fort Lauderdale—I made it twenty-five years ago. It drove me crazy when I made it; I put it away for twenty years. I pulled it out five years ago, and I thought it was good.

A painting, you can put it away for twenty years. It's not like making a movie. It doesn't work always. Sometimes you don't find a solution. My painting is a time lapse.

There's always the admission of death, the admission of being, of not completing something. Putting those white marks in the paint, it's as if somebody else came in and did that. I don't know how people can accept the kind of limitations in what they do. Because it seems that you are supposed to make something that is contained already, and substance contained is dead.

Jean-Claude and I have been working on a script that alludes to the fact that there is something beyond the nuts and bolts of what seems to be apparent. It also points out how people have become distracted and have traded the natural rotations of the sun for computers, technology, and numbers.

J-CC: There is always a moment when time intervenes. It happens when we say: "Now it is finished, this creation, a book, a painting, now it is over." All of a sudden the master enters the room. You can't do anything anymore.

You have been confronting time.

JS: Hopefully what you make reinvents itself every time somebody watches it. If you can conjure up that sensation of limitation, you feel an illusion of eternity or

the illusion of having that sense of, "Well, maybe I don't have to die." Then you can start making art.

Donatien Grau: There is also the sense that you deal with your own work as a material all the time.

JS: I definitely don't want to do the same thing. I try to take everything I learned to a point where I'm not copying myself. It's like throwing a script down. You take everything you did, you know that you don't have to do it again, and then you do something else.

J-CC: It is usual to say that time is experience. My concern about that is the idea that you have knowledge from that experience. Not at all. Experience does not help. Remember that quote by Confucius: "Experience is a lamp that you carry on your back. It gives light only to what's behind." Only the best, not what is good, remains. Experience helps you, of course, but you must forget about it as much as you use it.

JS: Which is the same as Diane Arbus saying it was never like they said it would be. It is always what I have never seen before that I recognize.

J-CC: I don't know about you, but as soon as I feel like I already did a scene, that I have already written it, I don't do it. I don't like to repeat.

JS: If I see something that somebody else does in a movie, I think, "OK, they did it. I don't need to do it." Sometimes people see films as repertoires. They are talented, often business oriented, and they can take something from somebody else without a problem of plagiarism. They just think, "Oh, it is part of the vernacular, and now we get to use it." Are they creating something? If I see something I go, "Well, they did it. I don't want to do that."

Except when you see, say, the balloon sequence in Andrei Tarkovsky's *The Red Balloon*. Then you think, "OK, I want to have a balloon. I have seen Steven Spielberg do it. I have seen Andrei Tarkovsky do it. I want to do it my way."

Andrei Tarkovsky is a guy we need to talk about if we are going to talk about time. He said that art is a representation of life, and in that sense it is different from life, because life contains death. And a representation of life doesn't [contain death] because it is a representation, so it's a denial of death. Therefore, art is optimistic,

no matter if the subject matter is tragic. There can never be pessimistic art. There could be mediocre (bad) art or talented (great) art, but it is always optimistic.

That made a big effect on me. I think I made the movie *The Diving Bell and the Butterfly* so my father wouldn't be scared to die.

J-CC: I am going to give you a secret that, to me, still is a mystery. There is a time specific to movies, to cinema, of course. It is not the same onstage or in a novel. You have to master it to know it.

In any film, you can go from one scene to another scene. You go from one day to another day, to another country, to another time. But you cannot go from one night to another night. If you go from one night to another night, it is the same night.

I don't know what is so difficult with night. Luis and I spent hours, sometimes days, talking about it.

JS: Because the night is infinite and it is darkness. It's a land, a territory, where cinema can't really enter.

J-CC: It's also a practical thing. You just cannot.

Another thing that I learned from an American editor in Hollywood—he was writing westerns and other films—is that the rhythm between days and nights has to be regular. For instance, the famous bivouac scenes in the western. If you have two of them too close to each other, it doesn't work. It breaks the rhythm of the whole film. You have to respect a pace of days and nights. That is international.

JS: That's a very good point. Without rhythm, it doesn't matter how important your story is; if there is no rhythm, there is nothing. It's like music, in a way. All these are governed by intuition. Some people get it, some people don't.

J-CC: Making a film is a dramatic event. The basis is action, the Greek "drama," to find a dramatic interest. It is more important. The rhythm will come. Another issue is harmony. Harmony is not quintessential to filmmaking, but it can provoke questions.

That is what we [Luis and I] felt when we wrote *Belle de Jour*: we were looking for a harmony between reality and unreality, trying to balance the two. That was already in the script, and we wanted to give to what we call reality an aspect of unreality.

What we call unreality—the dreams, for instance—we wanted to turn into a real and deep reality. We knew that from the very beginning.

DG: It ties into the whole issue of style.

JS: We need to draw a line between writing and cinema. Cinema is one thing, writing is something else. Painting is something else. Writing is closer to painting than to cinema. Style has to do with intelligence, attitude.

Marlon Brando once said that anybody can act, but it's very boring to watch some actors. When you look at the cumulative work of somebody, if I look at Jean-Claude's work, I get an idea of his style.

When it happens, it's just an idea. But later, when you start communicating with the person and they tell you things that you didn't know but you feel are wonderful, then it is amazing to see people committing to being curious about your project.

J-CC: I'm not talking about style, as far as I'm concerned. I think nothing ever outdid the phrase by Buffon, who, in the eighteenth century, said: "Style is the man himself." Of course, we cannot avoid the influences of our time, of our neighbors or the writers or painters, but the real style is who you are. You will never be able to completely get your style from the rest of humankind.

Inside these surroundings you have to find yourself, and that is real style. Imagine Proust: writers of the same generation, same age, living in the same surroundings at the turn of the century, but he was himself. He is himself in every word he wrote. To be faithful to oneself is essential. Maybe it won't work, not at the beginning.

JS: Maybe it won't work right away, maybe they've got to get used to your stuff.

J-CC: In the beginning, of course, it was quite difficult for Proust. The book was rejected by publishers.

I used to say that if you want a story to go everywhere, it has to come from some-where, from a precise place. And it must be told by someone or a particular voice. When people tried in the 1960s and 1970s to produce international films, with an Italian actress, German director, French writer, they all flopped. They had no reality. What is difficult for a screenwriter is to write with a direction. You have to work on the same film to say it in the simplest way. It is the most difficult of all, for two persons

or three sometimes, with an actor, to get together and to be on the same narrow line.

DG: The fascinating thing about you, Jean-Claude, is that you have been constantly in dialogue. How do you keep being yourself?

J-CC: I suppose being myself is being with somebody else. That's all. I'm not a lonely person. That's my nature. Working with someone is part of me. Basically, I am a collaborator. The first thing I try to do is to see what exactly is the film the director wants to make and why he likes this film, especially the dialogue. Almost like the work of a psychoanalyst. What interests me is inside.

JS: That's what I tried also to explain to him or show him each time we met. We would go over the script and I would try to make a case, to explain why I want to do this. He would say, "I am here not to agree with you, but to tell you when I see a problem with what you want to do."

As that happens, you start working on the material and then it reminds you of other things. So, I start thinking about the story as a parable that would make sense, and about how that affects a particular character, and all of a sudden the dialogue changes. The story evolves in the desire to make each other understand where you are coming from.

J-CC: Also, when two persons work together—for instance, a director and a screenwriter—it's important not to feel obliged to talk all the time, but to give room for silence. To share a silence is quite important. If you are always in a hurry, you get nowhere. Imagine Luis and I were together, the two of us in my room, and there is a window in a lonely place in Mexico, almost winter, but the window is open and we are in silence, a long silence.

It was raining outside. He was deaf by that time. He looked at me and asked: "Are you listening to the noise of rain?" And I said, "Yes." And he said: "I remember how beautiful it was." It was an unforgettable moment. He was remembering the noise of the rain on the leaves of the trees.

JS: How old was he when he went deaf?

J-CC: Around fifty-five. When I met him he was sixty-three, and he was already deaf. He went deaf because he was shooting amateur rifles and guns. He was shooting in his office. He had a special box made of metal.

JS: Shooting a gun in his own office made him deaf. Like Quasimodo ringing the bell that made him deaf.

There was a moment when, because of what was happening in my life, I was very sad. You and I finally had the meeting we were supposed to have a long time ago. It didn't seem to matter how much time it took. I saw you some years ago. There was a photograph and a film about you, and we met for the first time. I said, "You don't look like this. You looked like the devil in this photograph, and it's just not the right image of you." So I said, "I'll make an image of you." This was five years ago, or ten, maybe. We went upstairs to Toulouse-Lautrec's studio, in your house, and I made the drawing. You liked it. And I said, "It's yours."

You said to me, "I have to do something for you." I said, "You don't have to do anything for me." You said, "No, no, I do." I said, "OK." You said, "I write scripts. So I'll write you a script." So I said: "I've been working on this thing for a while. I'm sure you could help me with it, if you want to." You said, "OK," and I sent him what I was doing.

A lot of things happened with meaningful relationships. You lose something and something fills it up in another way. It was extremely helpful for me.

J-CC: There was a lot of anger.

JS: One day we were talking and Jean-Claude told me a story. You used to go out with Liv Ullmann, who was Bergman's ex-wife, after she broke up with him. You went with her to see Bergman and his wife. You were eating dinner, and Liv said, "Do you still have the house here on the island that you made for me?" "Yes, I do," answered Bergman. She said, "Can we go look at it?"

J-CC: In front of his wife.

JS: "Yes, we can. So, let's go." They all walked over and there's a door. The door has black squares and red hearts painted on it. Liv says to him: "You've kept the door!" Then she said to Jean-Claude: "Every red heart is one day of happiness together. A black square means a bad day together."

J-CC: They are looking at the door and there are lots of red hearts . . . I left them right after that.

JS: It is just amazing that we have the opportunity to know people. Jean-Claude and I have a twenty-year difference and it is a great luck to know him. I feel so privileged that somebody who is older and wiser would feel like it is interesting to spend time with me, and save me, in a way.

If you are an artist, you make art. And if you make art, you have chances that you won't have if you don't.

If you work at a regular job and that's all you've got, it's a much more futile existence. So it is really a privilege to be able to do it. People don't realize that just doing it is the thing, just getting the knowledge, just opening that door and learning how to access that door is the thing.

J-CC: Every piece of art is a fight against time.

JS: And death.

I think all our movies are about the same things.

Time. Life. Loss.

When someone looks at one of my paintings, I want them to feel like there's something else. My friend said that she saw this white shape in a painting I made, and she said it was my shadow.

You can't contain what paintings are in the frame record of film. Basically, everything in the film just alludes to something outside of it, so it keeps self-generating. It keeps alive beyond infinity. It's beyond the frame.

I want my paintings to go beyond the frame. Beyond the materials. So people have a sensation that is outside of that.

J-CC: When the viewer connects with the inanimate object, which is the painting, something else occurs. That something else is really what your movies are about. If I see movies that are just great stories and they're contained somehow by the subject matter, or the story, for me it's not enough.

JS: You think of a movie like *Viridiana* by Luis Buñuel. He's got these people doing all of this stuff that seems very mundane. Many different characters. By the time

you get to the end of the movie, the world has redefined itself in some way. You have a different attitude about your relationship to things that you thought you had a relationship to before.

That's really my goal in making art.

J-CC: One of the great differences between painting and cinema is that you can stay as long as you want in front of a painting. A film is totally different. You have to follow the rhythm of the film itself. It's a totally different approach.

The last time I saw *Viridiana*, I was sitting next to [Pedro] Almodóvar. We hadn't seen the film for at least ten years. We know each other well, but we hadn't seen the film together.

Almodóvar was so taken by the film, so excited. He was jumping on his seat. I was moved at the same time by the film and his response. It was another film.

DG: You are both fascinated with human life, by the intensity of it.

JS: We try to engage with what we are. Either I believe it or not. If I don't believe it, I'm out of it. I have to believe in what is happening. If I don't believe it, nobody's going to believe it. If you're making it and you don't believe it, you're doomed. So you'd better make it as believable to yourself as possible.

DG: You do that through intensifying, bringing it together in a shorter amount of time.

JS: I don't know if I'm intensifying something. Because you really can't tell some-body's whole life in two hours. Whenever somebody says I've done a biopic, I always say it is a portrait. Somebody once asked me, "What's the difference between painting Andy Warhol and directing Javier Bardem?"

J-CC: I used to say that being a painter, for me, was a treat. You are free, you are alone, you do whatever you want. You get paid very well. It's good to be a big and good painter. You don't have to fulfill all the obligations of the producers, of the actors, to listen to the—

JS: Being a painter while making films has given me great freedom because I'm not in their army. I don't care. I don't have to take the job in order to make money. I can say no. That's a great thing, to be able to say no.

J-CC: First rule of liberty is to be able to say no.

JS: I was very interested in film before making any. I never thought I was going to be a movie director, but I watched everything I could. It was my escape as a child from the ordinariness of my life.

So when this guy asked me, "What's the difference between directing Javier and painting Andy," I could say one thing: what the similarity was. It was my job not to let either one of them fall through the cracks.

If somebody's going to give themselves to you, you need to protect them. If you're going to paint them, you need to paint them in a way that's the right way, so you don't let them fall through the crack of your own narcissism or egocentricity. If you're going to direct them in a movie, and they're going to be vulnerable and give you everything they have, you have to get your rug that will catch them. You have to give them a net when they fall down.

You see people who don't care about the actors, and they use them like tubes of paint. Maybe some directors have done a good job like that, but it's not my way.

J-CC: In *The Diving Bell and the Butterfly*, there is a really special way of dealing with time because the main character is motionless. He has no space. He has only time.

JS: When I did *Basquiat*, I tried to make it as if everything happened in a week. That was my attitude. In *The Diving Bell*, when Mathieu Amalric would lie still, people would not notice. When you're lying still, you're furniture. People don't know you're there.

Can you imagine being an actor, you have to be in the body, and not moving. You're staying there, and you really get a sense of how Jean-Dominique Bauby felt like he wasn't there. People didn't notice him because he didn't say anything. He didn't move.

J-CC: Like being an armchair or a bed.

JS: I have claustrophobia, and it always pervades my movies. Think of when Javier Bardem is put in the cage in *Before Night Falls*. Javier doesn't have claustrophobia. I went there and he's sitting in this cell I built, where the ceiling was so low he couldn't stand up, because I thought it would be even more terrifying to make it that way, put the dirt in there. He was sitting there like he was waiting for a bus, and I said, "You know, that's not

the way I would feel if I was in here." He said, "Well, what would you do?"

I said to the assistant director, "Close the door. No matter what I do, don't let anybody open it for the next five minutes." He said, "Anybody who touches the door will get fired."

As soon as they closed the door, I was stuck in there and I went crazy. My eyes were rolling in my head. I was going insane. Javier was sitting there watching and said, "Man, you're a great actor." I said, "I'm not a great actor. I have claustrophobia."

I got out of there, we turned the camera on, and he just, like a sponge, did all of that stuff. It was amazing. One take. Just let the camera run out.

DG: That relates to how life becomes a story, and how the story becomes a myth.

J-CC: Peter Brook and I decided to adapt the *Mahabharata* for stage and then turn it into a film. We knew it was a huge work; it's twelve times the length of the Bible. Finally, one night at three o'clock in the morning, we shook hands and said to each other, "One day, we'll do it."

Peter told me two key phrases. Both of them have to do with time. One was, "We'll do it when we do it. No time limit." And the second, "It will be as long as it will be." I felt already free—a lot of time, the years in front of me to be able to work, to take my time. No hurry. No pressure at all. Right to the point. The great thing about that freedom is that it preserves you from asking the wrong questions: not to ask yourself who you are, just do things.

In the Spanish tradition, we say, "*Lo contrario de la verdad es la razón.*" The opposite of truth is reason.

The world is irrational anyway, so as soon as you start to make it rational, you've made a mistake.

X

Encounters are the most important thing. Every morning I get up and think, "I'm going to meet someone and learn."

—*Azzedine Alaïa*

MICHEL BUTOR & TRISTAN GARCIA
with contributions by Caroline Fabre

Azzedine Alaïa: Meeting you, Mr. Butor, is very important. Encounters are the most important thing. Every morning I get up and think, "I'm going to meet someone and learn." As it happens, I always learn something when I meet people.

Michel Butor: In Lucinges, I meet fewer people, necessarily.

AA: What country has made the greatest impression on you?

MB: Many countries have made an impression on me. I'd like to keep traveling, but it's getting difficult because I'm old. So, I won't be discovering any new countries, that's for certain. But there are two countries that made a great impression. First, Egypt, because it was the first country I lived in outside of France. Then Japan. I made several trips there, and I was lucky enough to be invited by the University of Tokyo to teach a course for three months, during the spring. It rained the whole time, every day, except for three days. We went to Nara, one of Japan's ancient capitals, and there the weather was beautiful. But this was just when the Tiananmen Square affair happened. That cast a shadow . . . Otherwise, it rained and rained and rained. It was great that it did, because that's what allows the marvelous vegetation to grow. The succession of flowers. You see flowers especially at the monasteries. There are monasteries that specialize in wisteria, others in chrysanthemums or cherry trees. The Japanese follow the blooms in the newspaper. They publish blooming maps, with curves like on a weather report. You know that in three days in such-and-such city the cherry trees are going to blossom. It lasts only for a moment because of the rain. The next day or the day after, the petals are on the ground.

Caroline Fabre: That's the essence of Japan: the ephemeral.

MB: Crowds will go to this or that monastery just to see the cherry blossoms or other flowers. You start to taste the flowers, to have the taste of them in your mouth.

AA: I was in Japan for the cherry blossoms. I was with Rei Kawakubo, the creative director for Comme des Garçons, and Carla Sozzani. As we arrived in Tokyo, Rei said to me, "Azzedine, you should look at the cherry blossoms this evening, because today is the day. Tomorrow it won't be the same." The whole street was white. I was thinking, "She must be crazy!" There was a festival where people go to the cemetery. There's a kind of picnic. The next day she asked what I'd thought of the cherry blossoms. I said, "Every time I see cherry blossoms it's beautiful, even when the petals are on the ground, all dead." She laughed and said, "No, no. Yesterday was the truly beautiful day." And I said, "I missed it. Next time I'm going to take the flowers and find out why they bloom in so little time."

Tristan Garcia: I'm fascinated by the number of books you've written. There are few egotistical books in your work.

MB: What do you mean by egotistical?

TG: I don't know. *Portrait of the Artist as a Young Ape* is a more egotistical work. Even in *Matières de rêve*, you're almost addressing yourself. But the texts where you're alone with yourself are fairly rare.

MB: I'm not alone. There's a book written as a conversation that is autobiographical, *Curriculum Vitae*, with André Clavel. I've often spoken of myself but in fragments, in this or that book. I've recalled this or that episode from my life because it was important for me to try to explain why I thought a particular thing. So, Clavel put together a book in which he asked questions.

Donatien Grau: Tristan, you also keep to an intense pace with your writing, and many of your writings are done through friendship. Is that something you think about: the time and pace of your writing? Because it's difficult, as Michel Butor was saying, or for other reasons?

TG: I write a lot, yes, and it isn't easy. I feel that I'm very painstaking. I see myself pretty clearly in Michel Butor. I read your work for the first time as I was coming out of childhood, becoming an adolescent. What I immediately found immensely

pleasing as a preadolescent, as I followed the twists and turns of your bibliography, was your sort of wild desire for the world, your encyclopedic curiosity about all sorts of things, all sorts of clippings and lists and maps. If I've written a lot, it's been out of that sort of childish desire to embrace the whole world, all eras and civilizations.

MB: That's not so childish.

TG: Well, I've always taken it to be a childish desire. It's a residue from childhood.

MB: Baudelaire said that the genius is a child who can at last express himself with the means of an adult. If the child doesn't last, it's over.

TG: Another line of Baudelaire's that your work often calls to mind for me is: "The universe is a match for his hearty appetite." That desire for the world, that childish desire to consume everything that books and globes and encyclopedias promise.

MB: Yes. His poem "The Voyage," when the child falls in love with the map: "Oh, how vast is the world by lamplight! / And how small in memory's eye!" But I must say no to those words. I've traveled a lot, and the world is not small. I've seen only a tiny part. There are many, many things I'd like to see, or see again, because things change extremely fast. The universe is a fair match for my vast appetite—a vast appetite that only expands. Here I say no to Baudelaire.

TG: There's a lovely sentiment diffused throughout your work: the absence of re- sentment. There's never any disappointment. You've dreamed of the world, and the world has never disappointed you. It has never disappointed your childish hope.

MB: No, I've never been disappointed by a trip, ever. I've come across real differences from what I was expecting, but it's been fascinating. If I haven't been disappointed, it's because I've expected disappointment from the start. Since I was wearing a sort of armor, I could keep my eyes open and discover some wholly differ- ent things. I consciously inoculated myself against the exoticism in advertising.

TG: We can sense it with respect to orientalism, when you went to Egypt.

MB: When I went to Egypt, the first thing I thought to myself was, "Watch out. This is in no way the land of cruises." There were cruises at the time. These days

the country is a little hard to get to, but before I thought to myself, "Time to open my eyes. I'm going to end up in a small Egyptian city . . ."

TG: That was on Taha Hussein's invitation?

MB: Yes. Taha Hussein was the Minister of Education. He'd tried to raise French to the same level as English in the secondary-school curriculum. He'd brought in teachers from France with bachelor of arts degrees to teach in Egyptian high schools. I thought, "Well, I'm going to end up in an Egyptian village. It'll look like a small French city in Languedoc."

And when I got to that small city—Minya, which had a population of eighty thousand and lay two hundred kilometers south of Cairo—it did indeed look like a city in Languedoc. Very quickly, though, it proved to be profoundly different. And the longer I was there, the more different it became. It was very hard for me, but it was fascinating. I'd had the sense to shield myself from the media so I could take a completely different view. I could fall back on my picture of pharaonic Egypt because, when we were children, my father liked to take us to the Louvre, especially to the department of Egyptian antiquities. When I went to Egypt, I thought, "I'm going to see that." And, then, I was interested in the Muslim side of Egypt, and the great metropolis of Cairo.

TG: It was a time of great change in Egypt.

MB: It was just before the great change. When I was there it was still under King Farouk, just before the coup d'état. It was the following year that Farouk was expelled and a whole series of troubles began that still haven't been resolved to this day. Even now it's a very inaccessible country.

AA: It's an astonishing country. The people are very kind and very joyful. During my childhood, I knew Egypt through the cinema. I wanted to get to know Egypt. With my grandfather, we'd spend the first Thursday of every month in silence. We had to keep still and listen to Umm Kulthum sing. For Egypt.

MB: She was already well known at the time. She was already playing an important role. I was a little French child making discoveries. I knew nothing of Arabic. I learned a little Egyptian Arabic to get by, but I never learned literary Arabic. I was lost with that, but little by little I made my way into the landscape.

Cairo has changed completely since then; its population has increased tenfold since I was there. After a certain amount of time, I got to know medieval Cairo very well. I'd stroll through it and turned into a sort of photographer. The photographer's art is to remain invisible or turn visible the instant he can make something happen. I'd become invisible. I could wander all over by the end of my stay.

TG: Would you go into, say, Coptic Cairo as well?

MB: Yes. Nobody would take any notice. I was a funny character, but a normal funny character.

DG: What was your view back then of photography, that art of time, and what is it now?

MB: I practiced some photography. When I was in Egypt, I would have liked to send back some pictures of the place. At the time, there weren't any images of Egypt. There were no postcards, and I didn't have a camera. When I got back I immediately decided to take up photography. Back then, photography was still artisanal. You'd work with film, of course, in black and white, and most of the time you'd make your own prints and develop them yourself. You had to have friends who had darkrooms do it for you. So, I took up photography and did it for ten years. I stopped because I'd made some photographer friends. Later, much later, in Japan, during my two- or three-month stay, I took it back up again. At the time, Japan was the land of photography. They made the world's best cameras, and people there were always taking pictures. If you weren't taking pictures, there was something wrong with you. Once you had a camera, especially if you were a foreigner, you had to take pictures. People would ask you to take pictures of them, not so that you'd send them to them later but so that they could be on your roll of film and travel the world that way.

My Japanese friends gave cameras to my wife, who took a lot of pictures. Once we got back, we looked at them all and I said to her, "Some of these aren't bad." So, we blew them up to A4. And we started taking pictures together. My wife would take the pictures, and I'd write the text. We managed to do a fair amount, and the work has been shown; there've been exhibitions. When I retired from the University of Geneva, I thought about taking up photography again, but I haven't had the time.

DG: What's your position on photography with respect to painting?

MB: Photography is a pictorial technique like any other, although with its own specific conditions, but there's no opposition between photography and painting.

TG: Photographers tried to become painters during the pictorialist period. Demachy, for example, tried to move in the direction of Degas, or sometimes the Pre-Raphaelites. And many have tried to imitate the brushstroke.

MB: In the late nineteenth century, photographers took a lot of inspiration from painters. They tried to paint the way painting was done at the time. They did some absolutely magnificent things. Later, photography found other paths, as did painting.

DG: So for you there's no disconnect between painting and photography?

MB: Not at all.

TG: What interests me more is the difference. I'm interested in the limits between any systems of representation. Adorno wrote a beautiful text that I often think of when reading you. It's called "Art and the Arts," and in it he speaks of the fraying of the arts in modernity. He says that painting is going to end up like music, and music like painting, painting like literature, and literature like painting. He predicts a sort of erasure of distinctions by the end of modernity. Now, you've also written a beautiful text, *Les Mots dans la peinture*, and have maintained a system of exchange with other artists, musicians, and painters. You wrote for them and about them, but it's always seemed to me that you don't go as far as to erase all distinctions. In other words, your friendship was based on the idea that there was a barrier, a difference in the forms.

MB: Of course there was a difference. We made the distinctions we were accustomed to from the nineteenth and twentieth centuries. Those distinctions shift. It all shifts. At certain times, people would say, "Painting and literature? Nothing to do with each other! Ugh! A literary painter? What an abomination!" That's over with, fortunately.

That doesn't mean we don't have different competencies in life. It's important to understand how to make bread, but we don't all have to be bakers. The same goes for artistic creation. Not everyone has to be a photographer or a painter. There are painters who are also very good writers, like Delacroix or Van Gogh. There are writers who are also remarkable draftsmen. There are photographers who are good writers, and good writers who are good photographers. And so on. That doesn't mean the attitude can't be different and that, in certain cases,

a collaboration between individuals can't be useful.

DG: When Apollinaire created Cubist poetry, it was important for him that it be a shift. Picasso, Gris, Braque, and the others were the painters, and he was the poet. Even when he moved on to calligrams, he was the poet playing at being a painter, not an artist. We speak of the avant-gardes as a moment when literature and the arts together reached a boiling point, but it was also a moment when everyone was in their pigeonhole and spoke with the other from a very strong position.

MB: Yes, but that doesn't mean there weren't windows opening up.

DG: But those windows opened from relative strongholds.

MB: Yes, they were holding very strong lines. We have trouble these days realizing how closed off everything was. It was only gradually that the window opened up from within those walls. Apollinaire published the first part of his *Calligrammes* with an epigram attributed to Correggio: "*Anch'io sono un pittore.*" So in publishing that book, Apollinaire was saying, "I, too, am a painter." That was absolutely intended. He wanted to open the window between the two that the critics and the journalists wanted to keep closed. He said, "No. We can open this." It took almost a century for the academics to start to understand.

TG: As a reader, when I was an adolescent and then a young adult, what I really couldn't understand was why so many writers of your generation abandoned novelistic form. You wrote a final classical novel, which is my favorite and is, for me, your most successful novelistic work. What happened when you published *Degrees*? Why did that novel, so polished and perfect, end up being the last in the genre for you? Why did you want to set off for other territories in prose and never come back?

MB: It wasn't anything I sought out. In 1960, when *Degrees* came out, I went to the United States for the first time. It was important at the time for a young European to go to the United States, and it was a profound experience. *Mobile* was the result. I left with an idea for a novel in mind. It was supposed to be a novel in letters, a grand epistolary novel. But the American reality threw me for such a loop—with things that I really disliked and things that fascinated me—that I wrote *Mobile*. And *Mobile* caused such a scandal that I was obliged to defend and explain myself. So I continued down that path. Publishers, of course, did everything they could to steer me back toward novels. I tried. I only want to please. I would have liked to please my publishers, but it wasn't possible. I had to do something else. I tried to under-

stand why, but after that, the novel was old hat. Today, people are writing more novels than ever. Some aren't bad.

TG: *Mobile*, which you published in 1962, completely forgoes novelistic narration and time. It's a geographic mise-en-scène of the United States. You can read it as a map, or a musical suite, from a series of cross sections and fragments, with toponyms, quotations, signs seen on the road, quotations from historical texts, advertisements. It's a sort of total portrait of the America of the time. At the heart of the book, there's also a political charge that, to me, seems absent from much of your work. There, though, it seems very strong. I imagine it was the shock of the racism you discovered in the United States.

MB: Yes, there's a very strong political engagement around the question of racism, a problem that still exists. Even in the United States, which has changed a lot, considerable traces remain. The edition you're talking about is a semi-pocket edition that, with my approval, has pages that flip vertically. It's a book where the layout of the text allows the eye to wander a bit freely. It's fairly loose and can therefore tolerate editorial differences. There are two editions: the one you mention and the edition from the complete works, which has a different format. It's taller, which allows for more text. There's a difference, but the text is done in such a way that it works. The books I wrote afterward were composed page by page, whereas here it was sequences. I did everything I could to make it publishable. It was quite a feat at the time.

TG: Do you like Joyce as a model? Or *A Roll of the Dice*?

MB: Yes, except that Mallarmé considered *A Roll of the Dice* to be like a fantasy.

The really important one was Apollinaire. There too, though, most people thought *Calligrammes* was amusing but just another thing. With my book, I was compelled to ask new questions about the whole problem of organizing single pages within a book. It was a kind of revolution. I suffered for it, naturally. Abuse was heaped on me by the cartload, and not just from readers. From journalists as well, saying that I was dead set on destroying the French language, French culture, et cetera. Things have since settled down, and it's become one of the classics of French literature.

TG: You've lived a double life at university, in Switzerland and France. The result of one of those two lives is your work as a theoretician and critic, for the most part in *Répertoire* but elsewhere as well. I've always felt that you were a perfect

pedagogue: extremely clear, especially compared with other intellectual figures of your generation. You've never yielded to the siren song of the great interpretative systems—psychoanalysis, semiology, and so forth—which today are showing their age. You've developed a kind of empathetic structuralism. You've used the tools of the thought of the time, notably structuralism. You've written some subtle articles on parentage in Faulkner, and a few studies that verge on linguistics, in which we can sense that you've read Jakobson. But you're always empathetic, always careful not to abandon the reader's subjectivity, and sentiment, and the subject, although there was a powerful tropism at the time to condemn all that and embrace a hard, rigid, cold structuralism.

MB: Yes, that tendency did exist.

TG: There's something much looser about you. An irenic concern: never a polemic, as with Barthes. No confrontation. A gentle, tranquil character, down to your taste for Romanticism.

MB: Yes. I've always tried to maintain things.

You were speaking of Barthes. There was a period of hard structuralism, and then one of fractured Romanticism. I've always been Romantic and have always said so. I still am. I've never gone through any crisis.

As for genre theory, I've done everything I could to keep a sense of proportion. That's not to say that there are no genres at all, as with the arts. There are, in certain eras, genres that come together because they match up with a certain social function. It's perfectly obvious in the work. Now we're starting to see how it worked. Genres evolve. There's a considerable entropy, such that forms greatly retard what gave birth to them. There are relics.

DG: To get back to the poem—you say we need poems these days. Now that you're living apart, in a different relation to time, what is the outside world's effect on your poems?

MB: Formally, I don't know because I'm now trying to do very simple things, particularly to collaborate with artists on books. I respond to requests from artists I like.

TG: Can we interpret your work as being split between two periods, like roof tiles

that overlap for a few years? First, a period of concern with grand forms, a strong desire for the world, a strong encyclopedic impetus, which is both a desire to discover the world and a novelistic and experimental will to reconstruct it. And, second, a period when that libido is gradually replaced by a pacific ideal of friendship, which comes to fruition in commissioned works, dispatches, and responses; almost all of the books operate through echoes. They respond to the works of your friends, who populate your social existence, or to works in your library, which haunt your intimate life as a reader. You've written a lot about Rabelais, for example. It seems to me that this second half of your work contains the dream of cultivating an ideal: that of a community of artists apart from the world.

MB: In books by artists, there is always a response to some artist or other. The whole enterprise is based on friendship. It's the constitution of a sort of harmonious society within our own, which is not harmonious. It's an ideal right now, and arose after a certain date.

TG: A sort of aesthetic socialism. You've always been fascinated with Fourier's *phalanstères*. Your artist books are *phalanstères* of ink and paper . . .

MB: The artists books—that began in 1962. After the novels, after the trip to the United States, something else took shape. The dialogue with artists became increasingly important. I've done more than a thousand books. It's scary.

DG: There's another criterion that comes into play in the evolution of your work, after *Mobile*, and that's the question of fiction. Because your great methodological and aesthetic contribution to fiction has been the idea that fiction is not necessarily the invention of a story but the arrangement and form. I think that leads down a totally natural slope to poetry. Would you agree with that reading?

MB: Yes, it's possible. In any case, the world we live in is a fiction because we live amid lies. The world we believe we live in is an imaginary world. In the old days, people thought the earth was flat.

Of course, we're a little more aware than our ancestors, but not too much more. There are a lot of things we believe and see that are false, that with every passing year reveal themselves to be more and more false. The way our ancestors imagined China to be obviously makes us laugh now, but imagine what the way we imagine China to be now will be like for the people of the next century.

Literature, science, history gradually strip away those illusions. Literature especially. But it's a very long haul. They are things that develop over millions of years. Fiction is very important in literature because fiction at least says that it's fiction. The novel at least says, "What I'm relating is not actual reality." Whereas the newspapers and history tell us, "We're telling you how it is." Which is false. They're telling us only the way they see reality today.

Huge pockets of reality are completely closed off to us and remain obscure. We still have very little information on half of the world. What did people of the nineteenth century know about China? There were wars; there were very, very distant conquests. People did abominable things, and nobody saw anything unless they were in monied circles. Everything else remained unknown. Half the world was completely unknown to us. Pre-Columbian America existed, but nobody knew it. It took years and years to discover that there had been incredible civilizations.

So, we're living in a semblance of reality, and fiction denounces that semblance. Fiction tells us, "This is not actual reality, but it will help you understand reality such as you live it." Actual reality is like Kant's thing in itself: it's something we construct little by little, century by century, in an extremely different way.

Fiction allows us to speak of what we couldn't speak of before. It's absolutely essential. Not only are there many things we don't know, and that we're perfectly aware we don't know, but there are things we're forbidden to know for all kinds of reasons: for the sake of propriety. We may not say frankly what we think of certain politicians because there are laws that forbid us to say certain things. There's a classic example: Balzac hated Lamartine. He wanted to paint a portrait of the society of his time. He had to speak of the writers and the poets and, in particular, of the poets being spoken of. So he invents a pseudo-Lamartine called Canalis, and then he can speak all the evil he wants.

But Canalis publishes books in Balzac's work, while at the same time Lamartine publishes books in "reality." After a certain time, when Balzac wants to depict a literary salon, he has to include both Canalis and Lamartine, because they've become separate characters. Canalis had become a *personnage à clef*, as they say. As Balzac's own text develops, then, we see descriptions of such soirées with Canalis and Lamartine.

We have a slew of examples today. There's a slew of abominable con artists, liars whom we may not denounce because there are rules of judicial propriety.

TG: I had those problems with *Hate: A Romance*. I naively believed that taking inspiration from reality wouldn't make me write a roman à clef. What ended up being a roman à clef wasn't conceived as such. Yet it's a French specialty. There are some good ones. Simone de Beauvoir's *The Mandarins*, for example. *In Search of Lost Time* ain't bad as a roman à clef, either!

But it seemed obvious to me that novel writing created worlds, that it didn't just produce a double of the existing one.

DG: It's every novelist's victory. But why?

MB: So that we can speak. There are all kinds of things to prevent us from speaking, every day of our lives. The novel allows us to speak of a certain number of things. In particular, it has the role of fashioning around itself a little secret, a discreet society of people who know one another because they've read this or that book. If we speak of Rastignac, there are people who'll understand. That makes for a secret society. The people who've read Balzac, too. This allows us to speak of what we normally cannot speak of. Novelistic fiction enables us to cleanse the customary fiction that we take to be reality.

It's a fundamental theme of literature. Take someone like Molière. He wrote plays to show that the world is a theater. From that moment on, the staged theater denounced all the theater in society. Society is, of course, a theatrical world. People are always playing a role. The theater allows us to unmask it. Until now, the novel has allowed us to speak of things that weren't spoken of; it continues discreetly to play that role. It's not the most innovative form these days, but that doesn't mean it doesn't continue—just as we continue to do theater, even though we now have cinema and television.

TG: I'd like to return to something that's been a real concern for me and my generation, and that's the impression that because we got here later, because we grew up in the 1990s, we're dealing with the legacy of a whole generation of French writers who turned their backs on fiction, as if it had become the height of naivete or an outmoded apparatus. Sure, they acknowledged the value of the genre. The detective novel and science fiction preserved a sort of treasure trove of pure narration, the ludic pleasure of the adventure novel, and so on. But for a genuine writer, that stuff had been exhausted.

It was hard to grow up with the idea that the novel was now behind us. We loved it,

but it had run its course because it was a bourgeois genre, because it was conventional, because we didn't believe in it anymore. We'd lost the coalman's faith in stories. When I was an adolescent, the idea that the writers I most admired had forsaken that ground troubled me enormously.

I had the same tastes as you, the same passion for Jules Verne, the taste of a Schwob or a Mac Orlan for adventure, for Stevenson, a taste for the joy of hearing intelligent stories of the vast world. What happened?

MB: Reality was transformed in such a way that it no longer had the same impact. That said, some other individual might come along and find a new way to make an impact. At the time, though, things had sort of frozen over.

TG: But what did this loss of faith in the novel stem from? It's a rare thing in literary history.

MB: We felt we were doing the same thing over and over. It felt repetitive. Of course, we are doing the same thing today, in a rough sense. But then there are people doing other things, and that takes a lot of courage.

XI

If we're to establish a common basis, we need to thrust ourselves
forward and accelerate. The past, memory, and history are no
longer the place for people to come together.

—Emanuele Coccia

Azzedine Alaïa: My sense is that contemporary design, in all its forms, is undergoing an acceleration—that things are going faster than before, and that the acceleration has an effect on the way people design.

Carla Sozzani: It's true that there's been an acceleration for a long time, yet the real problem isn't acceleration but a lack of creativity. It's a much deeper problem. There aren't many people like you, so we have to seek them out, which is a whole other story. They can create all the time because there is continuity within their work.

Your problem, and the problem of designers like you, is that maybe you don't manage to create as much as you'd like. The head works faster than the legs and the hands. Your creativity is infinite, but then there are practical constraints. The real problem, though, is the lack of fundamental creativity. People copy; they're looking for vintage stuff. It's very hard these days to find true designers with a real point of view—people who want to follow their point of view, who don't follow the rest, who don't work for another house.

If you have no creativity, you can have the whole world before you and never succeed. If you go to the flea market and buy copies, your creativity will never advance. Creativity is a gift from God that we can then cultivate.

Emanuele Coccia: Why do you think there's less creativity now?

CS: There's less creativity because, unfortunately, there are too many brands. If we look back over the history of fashion, there were four or five brands, not ninety. Today we've got ninety official fashion shows.

AA: In the 1950s, Paris was bursting with fashion houses. There were a ton of them. But times have changed. There were only two collections per year. Today it's four, five, six, seven, eight. The acceleration has brought about a decline in creativity. A writer will write one book. He can't write eight books in a year . . .

CS: You can't draw creativity from a stone. If there's nothing in you, you can have all the time you want, years of it, but you'll never produce anything.

EC: There's a lovely Spanish proverb that says: *Hay más tiempo que vida.* "There's more time than life."

We're never short of time. What we're short of is life—and creativity, as Carla says.

I think the reason for the acceleration is historical. We can't count on history anymore. We can't rely on a solid, stratified, stable memory. Even politically, after World War II, after everything that happened in the twentieth century, nation-states, and communities of all kinds in general, can no longer believe in the truth of the past and of history, so they're obliged to take their nourishment from the time of the future. We're accelerating history because things become unusable as soon as they pass into the past. We then need to replace them with new things. Time no longer has the right to solidify into history because all history is immediately false or imbued with a purely fictive character. Most of the time we stand in horror of the past. We cannot tolerate it, morally or politically. Despite our many commemorations and such, we no longer believe in the political value of memory. Memory has been reduced to mere computer data. Hence our need to constantly project ourselves into the future. If we're to establish a common basis, we need to thrust ourselves forward and accelerate. The past, memory, and history are no longer the place for people to come together. Now, it's the future.

But the future is by definition something that escapes us. By definition it cannot stay behind.

CS: The future or the search for the future?

EC: You're right, because the two probably overlap. The future exists only in the search for it. That's why we need to accelerate.

AA: We have to live in our era, such as it is. We cannot live the way we would have lived in a past era. Nevertheless, I don't know if the mind is capable of dealing with such acceleration. If we want to do everything, then time is too short, and we therefore don't have time to live.

CS: The problem isn't rooted in creativity itself. Designers enjoy nothing more than being caught up in their own world. The problem is other people and what they impose on designers.

EC: I think there are two discourses that are simultaneously true and different. Someone who's involved in design isn't operating within time. You design one work at a time, and it takes whatever time it takes. On the other hand, the time of the work's enjoyment is much shorter than the time of its design. So, those who are not designers are always pressing for more works. That's strictly their problem, but it

becomes a problem for designers as well.

AA: Time spent on design is different. Time spent living as well.

EC: I agree that the design world has a time of its own that doesn't coincide with the time of life, and life's time obtrudes on design's time. And maybe the reason for the coincidence lies in the fact that the notion of heritage was forever demolished in 1968. Now, nothing can ever exceed the bounds of a generation. The time of life, the time of a generation, seems to always want to dictate the rhythm of life, and of survival, to design.

That's why today there can no longer be any cultures. Wherever design cannot exceed the temporal bounds of a generation's life, there can be only subcultures, which don't seek to endure for more than five or ten years. It's a fact. Even if we set aside the time of design, the cultural space that once defined the temporality inherent to the life we lived in common has changed. There's nothing left that aspires to last more than five years.

Donatien Grau: That's where the problem of design comes into play because design exists in its own space and lasts however long it lasts.

EC: In any case, design is always a problem. It was a problem even when there was a culture, a temporality. Being a designer always means being a destroyer of the established order. Anyhow, whatever form the world takes, being a designer means being a problem for the world, or being ahead or behind, and therefore out of step. But the world has changed. Social media is made up of communities that have their basis not in memory—because it's impossible to archive that sort of memory—but in trends: in the divination of the future.

Normally a community was composed of people who would come together over a common history because they all descended from a common ancestor, shared a history, et cetera. Today, the ultimate form of a social, political community is the opposite. It's people who come together over their anticipation of future trends. The flip from the past to the future produces what we call acceleration: that is, the taking of nourishment from the future. And the future vanishes the very moment it becomes reality. The acceleration is just the price we pay for producing a community that lives off the future and not off the past.

CS: Designers exist and will always exist. Then there are fake designers who exist

and will always exist. Marketing has become very important. It didn't exist before. Because of digital communication, there is now design in all fields: in law, medicine, writing, hairstyling. They're all using digital. But that's another story. They're not designers. It's another world. It's a world of marketing. People use the means at hand.

My daughter has her private Instagram. There's a whole network of people doing it between them. That's already better, I find. Thirty friends is already huge. I don't have forty friends myself. But it's better if people exchange things. It's a kind of correspondence. Back in the day we wrote letters. So, I understand that it's a network and that it's for exchange. But to use it for publicity? No.

EC: What interests me is that it's written communication that doesn't have the same characteristics as traditional epistolary communication. The exchange of letters allowed you to put together an archive. You'd keep your letters. Instagram is impossible to archive. It's very complicated. With Snapchat you can send an image that vanishes after ten seconds, whereas in the past the image was what remained behind. A medium that was made to last has become ephemeral. In a way, the characteristics of oral communication have been transferred to the visual sphere. There's a "visual orality."

CS: But in China, for example, no one has a computer or a tablet. The Chinese use cellphones exclusively. When you say you're going to build a website, they give you a blank stare. It's obsolete. They signed me up for WeChat so I could understand what was going on. After a second, if you're not careful, you immediately receive dozens of messages. All of Asia is on WeChat. Me, I'm in front of a computer. Everyone else is not. It's a way of erasing life.

DG: Exactly. We're getting closer and closer to the instantaneous. A letter takes time, a computer less, a tablet still less, and a telephone even less.

EC: No, not necessarily. Until recently, most of the universities in America were scanning all their libraries, but then they realized that doesn't work at all because five years after you've scanned the holdings, you have to update all the files. It's too expensive. So they've gone back to paper. It's much cheaper to reprint than to maintain a digital archive.

That calls for a rather precise distinction between what you want to keep and what you don't want to keep. The printed word used to impose an excess of memory. Everything stayed around because all communication passed through heavy, durable mediums. Now we're obliged to choose among the traces, to decide which are going

to stay and which are going to go. The trace, the written word, is no longer what re-
mains behind, what generates memory. It's what happens as well. And it's interesting
that twelve-year-olds have grown accustomed to making that choice—they're used
to thinking of the written word and the trace as things that can vanish, like words
spoken into the air. It's like a conscious choice to live in a totally ephemeral way
and consume experience in the moment it occurs. Even whole populations saying,
"I leave traces, and for precisely that reason nothing will be left behind."

At the end of his life, [Ludwig] Feuerbach said something beautiful: that all
religion is a crystallization of desire. You have to look to a people's religion to see
what people desire the most. For example, if you look at the Christianity that has
defined European culture for centuries, the idea wasn't just immortality—in other
words, that things shouldn't end—but also resurrection: that our body, the vessel
and means of our experience, would endure forever. Experience could never end.
The religion of the people today, we might say, is the opposite: nothing from our
experience should really remain, precisely because it leaves behind traces. It's
troubling, of course, but it's very interesting from an anthropological standpoint.
A generation that more or less wittingly leaves traces that vanish . . .

DG: What strikes me as I listen to you is that you seem to exhibit the two contrary
phenomena. You have a sense of evanescence and at the same time, in a minority view,
an utterly fanatical obsession with history. The two extremes become more extreme.

EC: Yes, you're right. On the one hand, I have a taste for absolute ephemerality
and for Snapchat. The first time I saw it, I found it interesting that people should
have designed a machine that makes the image into the spoken word's equivalent.

CS: People don't talk or write anymore. That's the problem, too.

EC: Yes, but that, too, is interesting. We use images to speak.

CS: You want to tell someone you love them. We used to write it in our way. Now,
people use three hearts. It's too simple. Do you see what's going on here? Before
you'd say, "I miss you." Ten lines, three lines. Today, you use smileys. It's worse
than the movies, which I hated when I was young. It's utter alienation. You laugh
and cry next to someone you have nothing in common with. The movies were
already horrible in the 1960s. Then came television, and now this. People don't
speak anymore. The beauty of talking to each other.

EC: Don't you think it's an intermediary step on the way to something else—a way to find a new language, albeit it very rude and crude? You say we don't talk to one another anymore, but the fact of living in a culture that no longer has a national basis already changes things, so speaking through images or emoticons allows you to speak a language that's not limited by culture or grammar.

CS: On Valentine's Day, I had dinner with Kris Ruhs at 10 Corso Como, and there were only tables for two. There was one table where the couple didn't even look at each other during their whole dinner. They'd reserved a table for two and spent the evening on their phones. Maybe they were writing to each other . . . Maybe we're making a transition back to messenger pigeons.

EC: I really think we're in a transition. We're constructing new languages that are still very crude and imperfect, and that don't intend to stick around too long, because they know they're laboratories and not ends in themselves. Between now and some years in the future, someone will come along who can join the two cultures— that is, the culture of the word and this new culture that seems barbarous to us but is just a desperate yet incredibly vital attempt to construct a totally new language on the basis of a totally different experience.

We're trying to construct an experience that, even politically, is profoundly *imperial*. There's a book by Bing Xu, *Book from the Ground: From Point to Point*—a novel written entirely in emoticons. It's very rudimentary, of course, but it's also very interesting. Can we force the nonlanguage you're talking about to convey content that we usually convey by other means? I think something's happening. The problem is that creators have to take up that kind of writing. It's a very quick means of communication, but it's a language that still needs development and invention and so forth.

CS: It's a new kind of writing.

EC: It's a laboratory.

DG: But the good thing is that this new kind of writing doesn't stand in contradiction to what came before. In fact, it revives what came before.

CS: It abbreviates emotions.

EC: Exactly.

DG: And, at the same time, it makes you want to lengthen them.

CS: What you used to write in four lines—"I've missed you so much. We haven't seen each other in ages"—you now jot down with emoticons.

EC: But it can be more complex. You can send it with an image, a photo. For now, it's still rudimentary.

DG: This new way of communication is intimately related to time. We're accelerating, and using smileys in WeChat, while at the same time, and in the same way, we're writing more and more long books: works of eight volumes at five hundred pages apiece. We're doing this more than we used to.

EC: But the eight volumes probably won't last. The future is in the hands of whoever can find a way to tie together the old writing and the new writing. Consider the Middle Ages. What do we remember from them? Dante, who managed to tie together Virgil and Christian mythology. Two universes that had nothing to do with each other, and suddenly someone manages to combine them. That's what the future genius is going to do. That's what we have to work on: neither absolute dematerialization nor a return to the past. Both tendencies do indeed exist, but neither is interesting in and of itself. True creation, real newness, will come through whoever manages to find a way to bring them together.

DG: Do you have an idea how it might be done?

EC: Ah, no. It's not up to me to do it, but that's certainly the way out.

DG: To get back to the beginning of the conversation, about the figure of the designer. Just as we were talking about two poles—dematerialization on one side, the somewhat vain obsession with materiality on the other—we feel in much the same way that the idea of the timeless, of things that don't last and their contrary, things that do, like monuments, has perhaps become more powerful today.

EC: It's complicated. I think everything you've done, Carla, revolves around that question. There are two tendencies. On the one hand, there's the production of the ephemeral, with the culture tending more and more toward the production of events, such that nothing leaves behind a trace. On the other hand, we've never built more new monuments than we build now.

But there, too, we'd have to invent something that was both an event and a monument—that is, some sort of strange fusion of the two kinds of temporality, which are the absolutely ephemeral: the event, what we consume as it happens, and the monument, which is to say what never takes place and is just there to last. Maybe fashion is precisely the attempt to put those two things together.

I think that you should be the one to respond to the question, Carla, because, in a way, 10 Corso Como itself answers the question. It's a monument, a place, a space that endures but that's also intended to capture every interesting thing that happens in the world. You were telling me that lots of people come in just to find out what's going on in the world. That's interesting. These days, to find out what's going on in the world, you no longer buy a newspaper. You go to a place; you visit a monument. That's why I was telling you that the idea of 10 Corso Como is the ultimate transformation of what a magazine once was: a symbolic machine for capturing the news. Suddenly, the machine's become a space, a place, a monument. To be precise, it's a strange blend of event and monument, of event and a physical space, made of stone.

CS: It's not virtual.

EC: It's a blend of different things. It's beautiful, and peculiar, because Carla has accomplished what we've all been after. Carla, you seek out the latest trends with the sense of security, the relief, of being in a physical place that lasts.

CS: Yes. It's very different from looking at the pages of a newspaper or a book. It's much more complicated, much crueler from an everyday perspective, because there's constant judgment. When you read a book or look through a newspaper, you can set it aside and look at it later. You can throw out a newspaper.

When you go to a place, your judgment is instantaneous. It's much crueler. A place works, or it doesn't. I didn't know that when I started doing what I do. I'd never have thought that doing it would be so lovely for me, because it's the pleasure of giving. But I'd also never have thought the response would be so strong and immediate, whether good or not.

Sometimes I hear people say great things, and sometimes the opposite. "How funny!" "How stupid!" One morning three or four weeks ago I opened up at ten o'clock. The birds were out. There was a mother and child. The child looks at his mother and says, "Mom, this is a sacred place." Because there were birds. There was peace. The judgment is instantaneous. With books or magazines, there's a greater remove.

EC: And magazines especially don't last.

CS: It's like when you go to a restaurant and say, "The service was good or bad." That's a much harsher judgment. It's the hardest thing to deal with. There's nothing after that; it's the final step. Someone on the street walks in and judges. There's no defense. Everyone's right.

EC: 10 Corso Como is a completely paradoxical construction, a museum on the cutting edge. It's like a museum because you go there to see, but what you see isn't the monuments or the ruins of the past. You see what's happening now, tomorrow, or the day after. That child you mentioned is a genius. Yes, it's like a church, but not like medieval churches, where you'd repeat an event that took place in the year 33, when that guy was killed. At *this* church, we don't repeat an event; we anticipate what's going to happen the day after tomorrow. It's precisely the paradoxical blend of the two trends: museumification and the ephemeral. That's why that kind of place meets a fundamental need. It's more and more the case.

CS: I'm sometimes astonished. People will spend all day there taking pictures. Sometimes I can't get in, and I'll think, "What exactly is so special about this place, anyway?" Because it used to be a garage. I think people come in and feel something. Sometimes they push me. You're like an intruder. It means people want to be in a place where they feel good.

DG: I think it also has something to do with belonging to a place that can exist without us.

EC: People feel good there because they know that 10 Corso Como contains the most beautiful things in the *world*. In Greek, world means "ornament." So, it's not just things that are there; they're things that have been brought together to create the most beautiful place possible.

CS: And I think people feel that it's true. It's not pretentious to want to give. It isn't all that simple an idea, but it can be applied in several other areas. Everywhere, in fact, because you can give people a sense of well-being, outside of time.

EC: A world, by definition, is something that has no need of you.

CS: There are people who spend their whole day there. I see them in the morning. I see them in the evening, still there. You think, "Well, they feel good. So much the better." I'm glad. But it's not a matter of thought. Anyone might show up.

EC: It's like a church in the Middle Ages. You'd spend a lot of time there.

If we had to come up with a formula to translate what's happened with 10 Corso Como into our domain of writing, on one side we'd have increasingly heavy books in eight volumes, and on the other blogs that come and go. We'd have to find a similar formula for a monument that manages to capture what's going to happen the day after tomorrow.

CS: With the internet, more and more people are establishing real places. All the very successful sites in the virtual sense are now going offline to make things experiential, providing the online service afterward. Life doesn't exist without the offline. There are great things about being online: you can buy books and do all the research you like, but who's going to give you the pleasure of entering a beautiful bookshop and touching the books? You'll never have that. And now there's a lot online that happens offline.

DG: It's the same with bookshops. There was a period when bookshops were going out of business one after another, and the ones that have survived are the ones that are places.

EC: And that have a very focused selection. Instead of having just the latest releases, they try to provide something specific.

DG: What we're getting at is the question of the human being's position before a world that feels evanescent, that seems to be slipping away. Hence the need to find some *place*, a reference point, as the church once was. A place where you enter and say, "It's all right. We're OK. We're being taken care of. We're protected." Museums do this because they set you in relation to the world's most beautiful things. 10 Corso Como does it as well.

EC: That's absolutely right. Diego Della Valle used to say, "I'll stay, because it brings me peace." In fact, you enter a place of that kind and you're reassured because, in a world where everything changes every two minutes, you know that there you're going to meet with things that truly matter. You're reassured because you know that someone's brought together truly the most interesting and most current things. So, you're reassured of the world's texture. You know what's going to happen from now to the day after tomorrow.

Universities should become places of that kind. The biggest problem with universities is that they've completely gone the way of museums. They pass on the knowledge of a few centuries past, whereas they ought to be places, monuments, that teach, that gather together, the things that are going to happen the day after tomorrow. If universities take that turn, they'll become interesting places again.

CS: The true sense of the university.

EC: Otherwise, it makes no sense, and we can close them down right away. Universities as they exist now in Italy and France and Germany make no sense because they continue to repeat information that no longer has value. They should be overturning the models and becoming the museums of the future, the museums of what's going to happen the day after tomorrow.

DG: Yes, but it's fascinating to see how people in universities fall back on knowledge because they feel that it's slipping away.

EC: Knowledge is always slipping away.

DG: What's much more interesting—and this is where the university model of Corso Como can come into play—is that Corso Como is a model that doesn't change but that, at the same time, changes constantly.

EC: It's the same with great artists: they don't change, but they change all the time. That's the quality we need in our knowledge.

DG: It's the question of timelessness. Timelessness demands an absence of fear and an ability to follow one's own movement. It's the figure of the timeless, fearless creator standing in opposition to all who cannot be creators, who cling to the past, who don't want to move and who need reassurance, maybe a facile reassurance.

CS: Yes, but there aren't thousands of them to go around because you have to be generous, and that's another problem. You need to want to give, but not everyone's capable. There are people who make other choices—who prefer to have villas and other things, rather than hold exhibitions or give books. To attend universities, there needs to be people behind them who decide they want to spend the necessary time. It's not just a matter of creativity; it's a matter of time as well. You need to spend a lot of time. I don't think Azzedine spends the evening at work without that desire to give. Me, in the evening, at midnight, I'm happy to still be there, but you can't have it if you don't give. It's pleasure that offers no reward, or money.

Most people, even the smartest ones, will tell you about their work and their private life. But we have only one life. We don't have a private life on the one hand and work on the other. Our life is our life. There's no division of time. When you talk to people who talk about weekends and parties and vacations, you think to yourself that you'd get nowhere that way. It's another point of view that I respect. It's not my point of view, but I respect it.

XII

With words, you cannot express truth; you can
only point out the path that leads to beauty.

—*Alejandro Jodorowsky*

Azzedine Alaïa: Being with Adonis and Alejandro, I realize that what we have in common is that we're all free and can therefore live. We enjoy total freedom. But freedom is something you have to acquire. That, I think, is what we're going to talk about.

Donatien Grau: That is indeed the subject of our conversation. Alejandro, it's easy to see why it would be important to you that Adonis appear in your film *Endless Poetry*—that he be in it and play himself. You're brought together by the fact that time leaves no room for poetry. And you're here.

Alejandro Jodorowsky: Nothing has an exact definition. Everything we can say is only an approximation of what is. Poetry is not a material object. How can we define or describe it? It's precisely because we cannot define or describe it that it is poetry. Anything that has been defined is not poetry. If you want to try to define poetry, your definition will be just a set of words. With words, you cannot express truth; you can only point out the path that leads to beauty. We cannot define the truth because the truth is not words; speech is not the thing. How can we speak of poetry? We cannot do it with definitions. So, nothing we say is exact.

Adonis: What matters in the film, poetically speaking, is that poetry is an act. So, it's a practice and a way of looking at the world. It doesn't exist only on the theoretical, technical plane: writing a poem. No. It's how you live, too.

AJ: It's how you live, not only how you see.

A: How you live, how you see the world, the role of the other . . .

AJ: What does it mean to live poetically? That phrase of the futurist Marinetti— "Poetry is an act"—changed my life. Poetry can be an act. It's the poetical act. You always have to be searching for the poetical act in filmmaking, not in writing. In writing, it's something else. Adonis knows what poetry is for writing.

Vision is looking, yes, and it's listening as well, because reality encompasses all the senses. It's not just looking. It's how to listen poetically, poetic scent, poetic taste, poetic caresses, poetic insults: anything can be poetic. Poetry is a way of life, I think, unless I'm mistaken.

A: Indeed, we always have to be rethinking poetry because what's unique about poetry, and about love, is that we cannot define it. When we ask what love is—if we had a response, it could end up killing love. It's the same with poetry. That's the essence of the matter for me. It's an act that's always new and never repetitive. Never. As Heraclitus said, "You never cross the same river twice." That's what poetry is. It's like love as well. You can never make love with your beloved—

AJ: If you define her.

The supreme moment of mysticism: when the emperor says to Bodhidharma, who has brought Buddhism from India to China, "I've built a thousand monasteries. What is my merit?" He replies, "No merit." So, the emperor says, "And who are you, earthworm, to tell the emperor of China that he has no merit?" And he replies, "I don't know," and goes off.

The meaning of mysticism is: "I don't know who I am. I cannot define myself."

A: I think you can show the "poeticness" of the human body in cinema, in a film. And that's what we need: the "poeticness" of daily life, of things, of relations, of the time in which we live, here and now. Poetry isn't just discourse and poems. There are a lot of poems that have no poetry at all. That's what we should be after.

AJ: Maître Philippe de Lyon was a mystic in 1900. He said, "Hunting is forbidden, fishing is permitted, and poets are fishermen, not hunters." We know nothing; we receive.

The circulation of blood isn't intentional; blood circulates naturally. We do things out of natural need, not because we seek to produce something. A poet doesn't seek to produce. He does. He is possessed by what he does. He searches, of course. He searches. If I write a three-line poem, I work at it the way you'd make a painting. It's work, but happy work. With the poem, you work to turn the perfect phrase. Sometimes it happens all by itself.

In my case, I'm working a lot right now at what I'm currently doing to make sure there's nothing else: poetry and nothing else. For me, poetry is the essential thing: beauty, with nothing to be added or taken away. As soon as you add something or take something away it's no longer beauty. That's why I admire Adonis. I've read that balance in his poetry. Poetry is a sacred art because it's received. The Kabbalah is what is received.

A: The specificity of poetry is important. When everything else—science, philosophy, the social sciences—can say nothing further about the world, there's always poetry. It can always say something new about the world. When everything else falls silent, we find that poetry is still with us, and it can always say new things about the world and its changes.

We can always love, and always find an answer in love or poetry, whereas philosophy might not have an answer to give, and not science either. On the contrary.

AJ: Reality is a flower. It's continual beauty. A poet sees that. Everything is beautiful, but you have to be able to see it.

A: When you design a dress, you're trying to better your understanding of the body.

AA: Exactly. Every era has its way for us to exist in our body, and you have to understand it every time.

A: And when we create a film or a poem, we're trying to better our understanding of the world and of living beings. I don't write to make propaganda or to explain an ideology. I do it so that I can better understand the world in which I live. Writing poetry helps me, allows me to live better. I think a poem, and artwork in general, is a meeting place, the most beautiful meeting place that human beings have.

AJ: Container marries content. There is no content without a container, and no container without content. When you design a suit, you're trying to show the beauty of the appearance. It completely eliminates the person wearing it, and the suit glides along all by itself. It's an appearance. But the appearance touches the content. It's the beauty of the appearance, and it's a beauty in and of itself. We generally reject appearances because we say that appearances are not truth. But appearances are the "splendor" of truth.

A: Of being!

AJ: Appearance is not being. To seek truth through language is to produce appearance; seeking poetry through language leads to being. Speech is not the thing. Human beings cannot apprehend the truth. Language does not allow us to know the truth, but in becoming poetry, language can know beauty. The deepest aspect of creation is beauty. And the deepest creation is poetry, the sublime art par excellence. It's the summit. In esotericism, beauty is the "splendor" of truth. And after beauty comes divinity.

A: A question: Don't you find that with cinema there are many more possibilities for showing the poeticness of the world than in a proper poem?

AJ: It's true. It's possible.

A: It's possible in film to achieve a synthesis of all the arts. You can listen to music and look at a painting, but there are elements with which you can create poetry in the style of the cinematic language. It's the most complete language. Cinema is a great art. It depends on the creator. There are people who can, like you, Alejandro.

AJ: The problem with cinema is that it's become an industry. It exists only to earn money. It's become a show, like many museums these days. We need to restore cinema's soul. That's what I'm trying to do by giving it back its poetry. I've just committed a revolutionary act. I've given away *The Dance of Reality* as a gift to everyone. I've stopped selling it. I'm allowing anyone on the planet to see my film free of charge. I thought, "Everyone's making films to make money; I'm going to make films to lose it." So, we're going to lose money on that film, even as we prepare to release *Endless Poetry* for an audience that understands that cinema has a soul and is an art.

Cinema should be an experience, too. For example, it's an ontological experience to have my father be played by my son. That a poet be played by a poet, an actual poet, is an experience for the audience because I've eliminated the actor. If you want to make a sculpture, you have to make a real sculpture. When a sculpture represents an event in the news or something of the sort, it's no longer a true sculpture. The form is then in service of profit, of the news. But the form has nothing to do with the news. It's something else.

You can hide beauty, but you can't kill it. The whole exterior might be hiding the beauty, by industrial means, but it doesn't kill it because it shines through at every moment. So what's left in the end? Poetry, the real beauty. And industry crumbles as the years go by. You cannot kill true beauty. Why? Because it's a human need. A civilization vanishes when it loses beauty.

AA: Beauty is a human need. That much is obvious.

AJ: We mustn't separate the beauty of the world from the need for beauty. The world is one. If I have need for beauty, it's because the world has need for beauty.

A: Suppose you asked me, "What country do you come from?" I wouldn't name a

geographic country. I'd name a country where I felt I was completely free. My country is my language. That's where I feel completely free and can express whatever I like. A nation is a prison.

AJ: What is freedom outside of traditions? Everything is free. But if a part is not free, then nothing is. Because freedom is total freedom. If a single thing is not free, we are not free. If a single individual isn't free, I am not free. So, all those people who have folkloric traditions have been poisoned. That's the past. And that past must come to an end because it is the reason that we don't have our freedom. It's impossible. We're headed for the world's destruction.

What is a poet? A free person. You aren't free when you achieve your freedom through speech alone; you're free when you're free to think, love, desire, and act. Being able to destroy the other is not freedom; you're just a prisoner to your animality. To think of your body as being yours and not on loan to you is to be a prisoner to death. A pure being can be pure only when it has no ties.

And love? Love is not a tie; it is a free attraction, like a magnet and steel. There is no tie but a free union. But we're not free as long as we're not totally free. If we cannot be totally free, we can start to be free. We must have intentions: the poet is a creature who is starting to be free, to let out words, to leave behind tradition and the personal, to reach the collective, et cetera. He's embarking upon the great mutation of the human species in the quest for freedom.

A: Such is the case with mystics. They've changed the notion of God. The God of Islam is like the God of Judaism: a force outside of the world that controls the world. But in mysticism, divinity is immanent to reality and to existence. So, there's no separation between God and the world. They've also changed the notion of identity. In Islam and Judaism, identity is passed down. You inherit your identity as you'd inherit a house or a field. Identity is a creation. And a human being creates his identity by creating his body of work.

Mystics have changed the notion of the other. The other as a human being is an element of the self, and the self doesn't exist without the other. That upends everything, changes everything. Even the notion of time. Time is the future, in a total opening up.

AJ: The closer you get to beauty, in poetry, the more of the audience you lose. With that limited audience, however—the smaller it gets, the higher its quality. Because the mass audience is into the show. You go against the audience, so you lose some of it. We don't

aspire to conquer the world with a superhero film or a popular comedy. We cannot.

A: But the audience is an ideological and political notion. It's not an artistic notion. We have readers, not an audience.

AJ: In the film I'm making right now, I want to cross that frontier. That's why I'm offering to show the film free of charge. I'm creating an audience, a mass of readers: not one or a few but thousands, throughout the world. That's what we ought to do. Our struggle is to win over readers, to create an audience, not an individual. Individuals exist, but you have to respect them and consider them as such.

Today's music seeks out a specific audience, created by the political and religious situation. It's an audience fashioned by industry, with feed for pigs. True artists don't seek that. They begin with a few, then add more. They create their audience. They clean out the ears and the eyes of those who go see them.

I'll be doing that, pursuing this same project, until the day I die. I won't be asking the industry to seek people out. No, I'll make my own path. If it amounts to little, so be it. If it grows, it'll get bigger. Breton said something very beautiful: "Some best sellers are like a glass of water cast onto a book. It soaks the book and then evaporates. The true artist is a drop of oil. He sets it onto a bit of straw, and over the years it pervades the whole book."

You should embrace the world not for power but out of love. I love the human race, and I love myself as well. Nothing I do is for power, but it nevertheless has an impact. You set your mind to the work and not to its fruits.

DG: Did you fight to become known?

AJ: On occasion. I'd put out work, and there were so many scandals that, yes, I made headway. I got into cinema, which is the most industrial of the arts. For thirty years, you couldn't show my films. I had to find a solution. I had to wage war to put myself out there, but I did it.

A: What Alejandro is saying leads me to the question of era, the sequence, and the way the world constrains us. That's why in monotheism the notion of progress needs rethinking as well. There is no such thing as progress, theoretically. On the contrary, progress in both Islam and Judaism is a return to the past, a journey to the past. It's advancing toward what you've surpassed, the origin, a trip toward the

origin. That's progress. Whereas in modernity . . .

AJ: The origin exists in the future. The origin is something I carry in my heart. Every beat of my heart is the origin. Why would I seek the origin if I already have it? We are the origin.

What does the origin do? It's the power that sustains the universe. The universe is sustained by a power. An energy sustains us at every moment. There's a beating. When you look at an unhatched chicken, you see in the egg a little red spot that goes *ba-boom, ba-boom*. That's going to be the chicken's heart. The beating comes before the heart. The universe is a beating. Before matter comes a beating. Seeking out the past—that's a fairy tale.

A: One aspect of *Endless Poetry* is the destruction of many old notions: family, the relationship with the father and the mother, the relationship with the other, et cetera. It's a lovely moment of poetry.

AJ: It's a liberation. I've liberated myself from all that, from places. I've liberated myself from Chile.

Poetry is the path. I sincerely believe that. Not a political revolution; a poetic re-evolution. That's what we lack.

Politicians are ugly people. Every one of them wearing a tie and dressed like a robot. They're ugly, ordinary, and idiotic. How can they give us such ugly people to dictate our lives? They have no poetry.

They want to be like everybody else.

The people who are destroying the world are vulgar people. Because they're asleep, they destroy the world. And individuals are reduced to being compulsive buyers and destroying the world and voting for cretins. It's total madness. Where are we at now? A few have a lot, and many have little. And we're here talking, outside of it all. We're in paradise. We can talk. But what does the rest mean?

A single little firefly in the dark can light up the whole of the night. There's no more darkness. Mr. Adonis, then, is a firefly. Because it's wonderful if that exists. You have to have faith. You have to make do and carry on, no matter what. The Tantra is a sexual doctrine in China. At a certain time, it comes to an end; there's only one master

of the Tantra left. Then a young man buys passage on a boat and sails from Japan to China. The master dies, and the young man returns to Japan with the Tantra, and tantric Buddhism invades the world. All the young man did was arrive—that was all—and yet he left a mark on the world. When you look upon the world, you wonder, "What mark has the individual left, for better or worse?" It's individuals who have left their marks on the world; so we must believe. In poetry, you must have faith.

A: Alejandro believes because he knows. Religions deform the human being. Religion imprisons us, reduces us to a space that is not human. The human being is the most beautiful being in our universe, especially when you look at woman. I believe in the human being. It's true that we have a diabolical side, or a diabolical dimension. I shouldn't use the religious term. Religion has no future. The future belongs to the human being, to love, friendship, and creation.

AJ: The human being is a human being within the limits set by culture, family, and society. The human being is a marvel. That's the marvel. Poetry and beauty are part of the human being because the language of reason does not lead to truth. Poetry is the quest for beauty. The human being needs it, even if we don't understand. But when we understand, we understand. There's a wonderful thing within the human being. I was reading a book on Sufism and came across the following phrase: "The light that you perceive is not all, for within you is a light that sees. For the light in which you speak is the light that you yourself have seen." I think every human being has this desire for beauty.

A: The greatest mystic, whom I compare with Rimbaud, is named Al-Niffari. He left us only one book, a manuscript. An orientalist stumbled upon it and published it in 1935. He lived in the tenth century. The manuscript was found by accident, and no one knows it. It's an extraordinary work, telling of a painful life. It's a poetry of life and death. He speaks of God, in an extraordinary chaos. He speaks of everything and of nothing.

AJ: Chile was a country of poets. The young wanted to be poets. Being a poet was a trade. The poet was respected. Sometimes a poet was an ambassador. Chile had poetry, surrealism, battles between old poets. It's a country that lived poetry as a reality.

A: Poetry spills over, surpasses the poem. There are many poems that aren't poetic. In our era, in our modernity, everything has been transformed into a means. Right now, art is a means of making money or practicing politics. As you were saying, Alejandro, maybe the big mistake that poets and poetry movements have made is

to seek out the crowd, to seek out a general audience. You mustn't ever seek out a general audience for poetry because it's contradictive. Whatever is common is also anti-poetical because poetry has to do with dreams, the imagination, the corporeal, and the personal. This doesn't mean that it's isolated from the world. A poem is a meeting place between the poet and the reader. To seek out an audience is to make poetry into a means or a tool.

We can just look back at history. All *poésie engagée* [politically engaged poetry] is terrible. Unlike poets who have been rejected by the public, like Mayakovsky. Now, when we make the comparison, we can easily see that he revolutionized life and our vision of things more than Lenin. And that was rejected, denied, by the Revolution.

Poetry is an inner journey, a quest, a form of beauty, an aesthetic: an ethics that is not moral. Morality is imposition: you must do this or that. Ethics lies behind poetry. Great poetry is never public. It has never been popular, or populist. All the so-called engaged poetry in France—name a single poem that's truly powerful. *Poésie engagée* is a repetition of ideas that say nothing. But commercially it's widespread. The relation between poetry, creation, and the general public has been taken up by publishers and merchants.

AJ: I know what poetry is. I don't have it, but I know. Poetry is something that doesn't correspond to thought, either. There is thought in poetry, but it's sensibility.

A: Thought in poetry should be like the fragrance of a rose. If it's clear and direct, it destroys all that is poetic and turns into something else.

AJ: Poetry is what comes closest to life because life is complex, not direct. Poetry is an organism.

Here, now, me. So, who is me? All the others. Who is here? The whole universe. What is now? All time. So, everything is here. Where would you expect it to be? If not here, it's nowhere.

XIII

I feel as if I'd never been bound to time. To make films, that's precisely what you need—not to be bound to time—because there are all kinds of different times within an account, within a story, inside what we imagine within another time.

—*Charlotte Rampling*

Azzedine Alaïa: Why did I want to have these conversations about time? In observing fashion's various movements, I sensed there was a deeper phenomenon. Time didn't matter to people anymore. There was no more respect for the human being, or design, or work. Now, when I don't have the time to do something, I just don't do it. At the same time, though, it was important to see our era, and the important people of our era, and to talk about their notions of time.

Olivier Saillard: Charlotte and I worked together. I also sat down across from her and wanted to ask her about various subjects that concern us here. I've come up with questions about time but also about cinema, about Charlotte's profession of acting.

There's a similarity between cinema and fashion: namely, the relation to time. In cinema, you make films whose temporality is never today's. You make a film about the past because maybe your story takes place in the eighteenth century, or in the 1960s, or even in the 2000s. It's about yesterday.

You also do it out of sequence. When I was a child I thought people made films from beginning to end, in the same chronology that the spectator sees. And when you start talking about your film, spectators think you're still in it, when in fact you've already moved on to something else.

My first question for you is, what is your experience of all those moments that make up the relationships of a story that takes place in the past, that's written today, and that you belong to at a certain moment and then not at all?

Charlotte Rampling: I started early, young. Your relationship with time at that age is very different. When you're eighteen, you're sort of impelled toward what the future's going to bring. You couldn't care less about the past. You don't have a past. I feel as if I'd never been bound to time. To make films, that's precisely what you need—not to be bound to time—because, as you say, there are all kinds of different times within an account, within a story, inside what we imagine within another time.

I haven't necessarily given the subject much thought before, but I think I've got very little connection to time.

OS: We often talk about an actress in relation to her roles, and then right away we gloss over that time. For example, I'm full of admiration for your role in Visconti's *The Damned*. It takes place during the war. Does the time you spend playing the role count? Or is it just the woman you were embodying?

CR: It becomes a whole. I enter and exit. I come in dressed like someone from another era, another world. And I go out and put on my own things. There's a sort of inner choreography to it. There's no separation. Again, there's no time.

OS: It's a stretch of time that's a costume . . .

CR: You might say that, yes.

OS: In fashion, which is what concerns Azzedine and me, it's always seemed odd that designers, especially today, should have to put out collections as fast as possible, collections that should reflect the future. Designers want nothing to do with the past. For example, aside from a few greats like Azzedine, if you tell designers to take inspiration from a dress from the past, they display a sort of fear, even if they secretly buy a lot of vintage clothes for inspiration. They'll all talk about "vintage," yet they'll disdain the past. Do people talk about the past in cinema? Do you like rewatching the films you've made?

CR: In fashion, you always have to be inventing something very different and very new, even if you look back and go retro. You're always led to make new creations. There's always a frenetic creativity.

AA: It's four to eight times a year nowadays. Before it was twice a year. You had six months to undertake some self-examination, carry out your search, look for fabrics—and live while you were at it. I don't understand why we do so many collections that bring in nothing these days. It's commerce and nothing more.

OS: For this conversation, I added up the number of shows taking place in Paris, London, Milan, and New York in a season. There are four hundred fashion shows. I kept track of the most well-known brands. My assistant counted 14,870 new silhouettes; that comes to millions of garments. A quantity like that almost nullifies the idea of creativity. You cannot create on such a scale. If we set that against the literary world—every week fifteen new books come out, not all of them interesting. Cinema, too, suffers from a kind of overproduction. What do you think of this overproduction? I think it ties in with our era and with time. Does it seem healthy, valuable, virtuous? Some say that there's always sediment, whatever the quantity produced.

CR: More and more people want to create, and why not? All the schools are full of students. What's going to happen to them? They're going to produce. And we're going to dress all those models. It's an effect of overpopulation. There used to be space between people, between moments. But there isn't anymore. There's no silence left. We're jammed together all the time. Wherever you go, you're jammed together with people. You're jammed against them and connected. The people are there, and they're creating things. There might be talents among them.

AA: It's true that there are talents, who often get encouragement from the big corporate groups. At the same time, there's nothing new. People are goaded to buy. At fashion's present moment, we should reflect more on what we're doing, how we're doing it, why we're doing it. Soon, many of the things we're making will cease to exist. A person's creativity will one day vanish, and only the things will be left. When you paint, your works remain; when you act, the images remain.

Sometimes I'll be at work and think, "Hmm. I need more time to make better things." That's why I stop. I'd rather take the time. Fabrics arrive, and if you don't make good use of them right then, all is lost; they can't be used next season.

In cinema—even in the theater—you have time to rehearse. You enter into a character, read, talk it out. Cinema and fashion are truly in concert. At one point we designed a slew of fantastical costumes. We didn't do it lightly. Over time, we fashioned an image of the beauty of women, and of fabulous costumes. It was thanks to time. Today, the stylists arrive and go shopping. If an actress comes to me, I'd rather she do a fitting. If a garment doesn't fit, I'll alter it for her. I now turn actresses away if they come to shop, because a garment should be done in a certain way. I find it sad when an actress wears a dress that's too long. If it doesn't work, I say no. You have to make the garment for such-and-such person, for her character, and for her comfort. It should be made especially for her.

OS: In your relationship to fashion, Charlotte, are there clothes that you've always worn? Fashion, and design as well, have succumbed to the syndrome of novelty.

CR: Yes, but not the wearer. Whoever buys those clothes can wear them for a very long time. Do people really follow fashion?

OS: At the risk of causing shock, I'll say they don't follow it much.

CR: I think it's the magazines that create that effect but not people themselves. No, I don't think people follow fashion.

OS: Do you have clothes that you've worn for years, that you like, that you have affection for?

CR: Yes, absolutely. I love the clothes that I've worn a lot. I love the feel of aged fabric. When it's well cut it's wonderful for a very long time, and it becomes part of your world. You grow with the garment.

OS: It's like having a double, an envelope.

CR: Yes, and it creates an identity. For some it can be fun to change styles all the time; I've never enjoyed it. I have a style that suits me, that calls out to me and is recognizable. A certain silhouette.

OS: One day, when we were rehearsing for the performance *Sur-exposition*, you said something very beautiful to me. You said you liked to look at yourself only in mirrors that you knew. I liked that a lot. I've taken an interest ever since in the relationship between time, the mirror, the reflection, and no doubt the age we see in the mirror. I like the idea that we should see ourselves in the same mirror throughout our lives.

CR: Since it shows you an image you trust, you think, "I'm like that; that's what I look like." In all the various periods of a life, some years you'll have confidence in the evolution of who you are, visually. If you look into other mirrors, it'll be something else. Every mirror will show you something very different, depending on the light. I think, then, that over time it's good to trust in the gaze you cast on yourself. You do your makeup, you dress, you look, and then you never look again for the rest of the day. It's done. There's no need to look again.

OS: I like the idea that we should choose our mirror, because it's quite distasteful to come across an image of yourself out in the wild.

CR: We're very fragile with respect to our own image, so we have to build trust in our image. Otherwise we're lost.

OS: When you look in a mirror, do you look yourself in the eye or look at different points?

CR: I look myself in the eye. It's like talking to yourself for a brief moment of the day. It's a dialogue. I find it's very important, even necessary. Why not talk to yourself? You're going to talk to others later.

OS: I'd like to come back to the position of the actress. Actresses are part of a pantheon, which makes you into goddesses. I continue to buy films on DVD with actresses who, for me, will never die: Bette Davis and Greta Garbo . . . Cinema invented stars, and eternity. When you decided to take up the profession of acting, was the desire not to die at the heart of your decision?

CR: No. I wasn't aware of that at all. But it ends up being a fascinating notion, especially as you age. You see other people who've grown up after you and see you at the age of twenty, while you are now sixty.

OS: It's mysterious. How is it that we can meet you on the street in a given era and still associate you with a film you did at age seventeen, or another you did at forty? There's really no problem for the spectator. You're part of eternity.

CR: Yes. People will run after you and say, "Ah, you're Charlotte Rampling!" They've seen you in a film a long time back, and you're as old as you are, but for them it's the same thing. I'm not going to say, "Ah, you recognize me?" For them, I'm the same person who was young and has now evolved, but who was there when they saw me. They see me in that time as well.

OS: It's a frozen time.

AA: For actresses, age is not age. When an actress is important, the myth is always the same. The admiration doesn't change. They've done something, and we never forget it. Even if the face is very different. I met Garbo and Arletty. I was so fascinated with certain actresses that I didn't see them age. Arletty was always young.

OS: Garbo is certainly the one who made the use of time into a work of art.

CR: She practically made it into an architecture. She brought time to a halt.

AA: One afternoon there was a Garbo retrospective at the Pagode cinema. I didn't know her. I saw the film and was struck by the image, the makeup, the eyes: all very modern. The next day I was at home, on rue de Bellechasse, and Cécile de Rothschild shows up with Garbo. The saleswoman who was with me said, "It's Garbo." I thought she was fooling with me. I go in and see Garbo sitting on the *canapé* with her bangs and her high turtleneck. I said, "Dear God, it's not possible."

That's how I met her. I've always kept that image, even when I saw her older . . . I don't like the word *old*. Age and time are two different things. I thought, "It's crazy. That face is fascinating." I'd seen her in all her beauty the day before on-screen, and I felt the same emotion now. She had the gumption to make a decision: she entered the world of silence.

OS: Didn't Garbo bring time to a halt by deciding to end her career? She evaporated by killing off a professional career. She had so thoroughly vanished that her biological death became secondary. She'd fled. Isn't that the most sublime way to escape the world of mortals?

AA: Garbo, whom I knew very well, wanted to enter into silence. She wouldn't speak. When she dined, she spoke only with her family. In the morning she'd take her tray and go to her room. She was a woman who understood how to retain a place in history.

CR: It was a sacrifice she made, but she was up to it because her personality and character urged her in that direction.

Donatien Grau: Charlotte, what do you think of Garbo's sacrifice? The sacrifice of absenting yourself in order to construct a work of art, for example.

CR: To build a work of art is to make a genuine choice about how to live. It's a big decision, one that you can't help but respect.

OS: Have you considered it at times?

CR: Yes, but I'm doing it dram by dram. For many who take it up, this profession is like death and resurrection. It's a way to bring time to a halt, not to want to be

looked at anymore, or even adulated. To come down from the heights and become a real being again, of flesh and bone, perhaps just ordinary. To live that feeling, so that the desire can return.

OS: What's attracted me about the women I've wanted to work with wasn't any resemblance to Garbo but an attitude cultivated by absence. They're women who, at a certain point, have said no. It's not every three months or every six months . . . And then they work a little on the physical side. I don't mean on their beauty, but on who they are.

What I appreciate about Charlotte is the breadth of her inner life: an actress synonymous with all the photographic fantasies hasn't gone courting photography, hasn't fallen into it, but has instead gone into herself.

CR: For me, the notion of dying and being reborn from the ashes is very powerful. I've done it many times, sometimes painfully. I've looked desperately for time in between, thinking, "I must have time in between. If I don't have time in between, I'm going to die."

OS: My next question is: how do you react, what do you feel, in death? Because there's a strong, dangerous association about you with death. I've spoken of cinema and of a form of eternity that actresses achieve. With you, it's easier to speak of death. I think that, in this respect, you've been dangerous, scorching, and for a very long time.

CR: Scorching but necessary, because if the sensation of death isn't really there, the sensation of being alive can't be absolutely there, either. When you're filming, you're carried along by a sort of continual exaltation, which is more or less good. So what is the exaltation?

Are you in great exaltation when you create, Azzedine?

AA: Yes, but afterward, in the end; you feel you've entered a void and find that you're alone.

CR: But without exaltation, you can't do it. You have to have the time and experience the death as well. All lives are little deaths.

If you're in the kind of exaltation that, for me, is necessary to any creative act—and

for film it's fairly long; you go, and go, and go, and hold out; it's a marathon—you're going to be completely abandoned in the end, naturally. There's no one left. There's only you, and you've got nothing left. This is the moment when, if you've entered the time of death, you can rightly say, "Well, I'm going to live this time until I feel the urge and desire to return." Sometimes the desire has a hard time coming back.

OS: And do you seek out the time of death? Do you know it's coming, or have you managed to tame it? Or has it unsettled you at times?

CR: It's very unsettling, yes. You tame it better with experience, perhaps. You might be less afraid because you know things are going to turn out all right.

AA: In any case, you live and carry on. Life takes up with something else, and you speak no more about it.

CR: Since we're speaking of time, we might say that what people in fashion and creators of all kinds do when going so fast is avoid all that.

OS: That's very true. They flee. Aside from Azzedine, who decided one day to say "Stop," the other couturiers and creators are stuck in an infernal machine to avoid that feeling.

CR: So what happens in their case?

OS: Sometimes it goes nowhere, and sometimes it feeds economic ambitions, but it's dangerous all the same in terms of creations. There aren't too many couturiers left who are plumb lines like Azzedine, or like Balenciaga and Madame Grès were. Fashion has always been a bit morbid in its extreme production, in its flight.

CR: But it's not the designers who seek this out. It's the production.

AA: We don't allow designers to mature. As soon as they've left school, they believe themselves capable of anything. It's not true. There's a know-how to the profession. You have to learn, and they don't have time to learn. They want to put out grand styles right away, but it's not possible. They're given opportunities with these big machines, but it doesn't last. We've reached a point where the *maisons* are changing their head designers every three years. Once the work is done, they take on another.

OS: To get back to your personal relation to time—everyone asks you about it in the

magazines. You've chosen not to modify or Botox your face. You haven't fixed your mouth. You've kept those formidable eyes beneath voluptuously drooping lids. Was it clear to you from the beginning that you wouldn't touch up your face?

CR: I've never thought about it! I've spent too much time thinking about life and death and the desire not to come back!

OS: When you're an actress, and the stages of life go by like clouds, there must be moments, I imagine, when you ask the question—or do you not at all?

CR: No. Well, I've seen pictures where there's been a little aging—just a bit! But my nice little mirror, my magic mirror, has always said to me, "It's OK."

OS: You've been photographed many, many times by great photographers—and, indeed, are still being photographed, notably by Juergen Teller. Do you look at those pictures of yourself? How do you see yourself over time?

CR: When I did the shoot with Juergen, I was sixty-two. I was nude in front of statues. I didn't do it to provoke. It's work that I do regularly with Juergen. It's a work about time. I find it beautiful.

OS: It demands a lot of confidence or abandon.

CR: Yes, but, as I've said, I've gone along with time since the beginning. I don't put up any resistance because it's so much stronger than we are, so much more important. So you go along with it. You can always say no to anything you find intolerable. In my profession I can say no. I can manage my time because I can schedule between film shoots.

OS: At present, whatever the artistic event, at fashion shows or other shows, all people do is photograph themselves, at the risk of missing the event. They're never connected to what's going on because there's always a smartphone to take a picture and serve as an interface. Do you have this habit of constantly taking pictures?

CR: Ah no, not at all. It's yet another proof that we don't want to really think or really see, that we don't want to really hear or really live, because we're always sticking this thing, the screen, in front of us. The screen before what you really see, what you really hear, and so on.

OS: A filter. What's it like for you, this tyranny of the present?

CR: I don't know where it's going to lead because I'm not of that generation, but it holds no interest for me whatsoever.

OS: Wanting to witness the present, we fail to witness it.

CR: Absolutely. For his fortieth birthday, one of my sons threw a great, impromptu party at a pub in London, and the minute the cake arrived everyone took out a phone. I took a photo of everyone else taking a photo of the moment. It was fascinating.

OS: They think they're living the moment as it happens by capturing it, by taking a picture.

CR: There must be some compensation, though. They can relive it the following instant.

OS: When I take a picture at an exhibition, I hope to be able to remember it better. The idea of capturing time is to have a memory of it later. But you soon realize that you never look at the pictures you've taken.

CR: I don't take a lot of pictures. I eliminate the bad ones. What's the advantage?

OS: The ability to preempt reality. We've never before spoken so much about memory. We're all afraid of Alzheimer's. As soon as we forget something, we say that we've lost our memory. Twenty years ago we didn't speak of memory and we didn't manage the memory of computers. Is memory something you're afraid to lose?

CR: I don't have a good memory. I have trouble with names. And, once again, I think, "It's OK." Once again, it's a way not to condemn myself to a state that I might be in later. I might be headed that way, but so what?

OS: When you did a reading of Sylvia Plath's poems, were you afraid you were going to lose your memory at that moment?

CR: No. It takes a certain time to learn lines, but once you've got them, you've got them. It's like a song, and it's great. You might be thinking of something else, and it'll just come gushing out. It's your mechanical memory at work. You work, you force things, you get those lines to penetrate, you've got it, and afterward it's there.

You have it for a long time. I'll play Sylvia Plath from time to time, and it's still there.

OS: What does "take your time" mean to you?

CR: It's a huge thing, of capital importance, to be able to take your time. You have to learn how because no one will teach you. When you're a child and you take your time, when you wander, they'll tell you, "Come on, do it. Go back to work." Taking your time is one of the most delicious things you can do as a human being. The time might be brief. I'm not talking about holidays. I mean taking your time during the day, becoming aware of what's happening, where you are, and what you're thinking.

OS: One day someone called to request something of you, and you replied, "No. I do only one thing at a time." I like that discipline. People focus more when they do one thing at a time. Otherwise they lose sight of the project.

CR: The idea of doing one thing at a time has a lot to do with time. When you're reading, you focus on the book; you're present with your book. You don't answer the telephone; you read. It's so good, if you're attentive.

OS: Do you sometimes feel that certain moments have gone by faster than others?

CR: Yes, of course. Time is always speeding up and slowing down. We push it and drag it and leave it in the void a bit. We manipulate time, and time, in fact, doesn't exist.

DG: If we look back at all the photos you've done, from Helmut Newton to Juergen Teller, it seems that there's no getting at you, that you exist in a sort of exteriority, and therefore outside of time and outside of us. Can you tell us something about that frontier—being outside of time and outside of us—with Newton and Teller?

CR: Those are perhaps projections because, if you think back to Helmut's pictures, from 1972, the nude on the table, and to Teller's, where I'm nude in front of the statues, it's a capacity to preserve yourself from time, to preserve your space.

OS: It's paradoxical because you say you're nude without the slightest fear. As I saw in *Sur-exposition*, you just do it, never wondering whether you're beautiful or not. It's plain to see that there is indeed a sort of almost inaccessible frontier.

CR: A photo should attract. The model is there to draw in the gaze, and the

photographer is there to sublimate the gaze. It's an interesting game. It says, "Come see me; I'm absolutely yours if you like, but you'll never have me."

DG: You have the parallel experience of existing outside of time as a model; of living, speaking, and having a history in cinema; and of living, speaking, and having a life. And your name is Charlotte Rampling. What's your experience of these three lives, each with a temporality by definition different from that of the others: the glazed temporality of the instant, the separated temporality of film, and your own time?

CR: If you are unaware of what you're representing, then everything can happen, and nothing can happen. I've never been aware of what I represent. I don't care. I knew I had to forget what I represent. You forget it all in order to survive and to lead a genuine life. To reconcile those three dimensions, there mustn't be a barrier; I mustn't be aware of any of them. Because if you're unaware of something, you don't see it, but you do feel it. You are that thing; you live it.

OS: There's also a format that I've always associated with time: that of melancholy. You have a form of melancholy. I find that melancholic creatures have a kind of abandon to them. They'll never be completely happy and never completely lost. Are you aware of that melancholy?

CR: It's a state we all have, I think.

DG: I think of melancholy as a way to intensify life minutely. I feel that your intensity is much greater than melancholy. Your strength exceeds melancholy and is on the order of the minute.

CR: I'm not going to show you my melancholy. Melancholy is my intimate friend, but it is also potent.

OS: It can also be a powerful driver.

CR: When we say melancholy, we must immediately think of its opposite, for we are made entirely of contrasts.

AA: You live with it from morning till night, except when you're busy or at work. But when nothing's going on, melancholy takes over. It presents itself. Then you adopt it and say to it, "You won't get to me." And that's it. You keep living your life. You organize your life in some other way. I feel a tenderness for actresses, and for

all women, because at a certain point you really have to take charge and find some other way to live. You have to adopt your melancholy and make it your friend, not let it pervade you. Otherwise you'll be swamped by the past. An actress films and films and then stops. Afterward, when it's all over, all actresses end up alone. That's when you have to say to your melancholy, "You're not going to get me"—not melancholy or the past. Because it's really hard for all human beings, for all actors. You have to be very strong, adopt it like an animal, and take the offensive.

OS: Do either of you think regularly about your past?

AA: I think often in the past I didn't have the time to live and think, "Now, no. I don't accept it anymore." That's why I refuse to do fashion shows at the same time every year. That's the moment you free yourself from all pressure, and from people in general. There comes a time in life when you have to take charge and say, "I'm alive, I've given, and I'm going to enjoy the fruits of my labor."

It interests me to face a client. I want to spend time with her. Today a client orders a garment and tries it on. You have to live that stretch of the life of the woman who has ordered a garment. The only important moment is the fitting. We witnessed a scene with the head of a workshop. A client said, "I love it. I'm comfortable," and sat on the floor. I thought she was going to tear the garment, but not at all. She was almost doing gymnastics in it. Suddenly I thought, "This woman is alive. She thinks she's going to have the most beautiful garment and be the prettiest."

OS: Is the fitting more important for you than the fashion show? Do you like it better?

AA: If I do a fitting, it's for the women. Even when a woman doesn't have the physique of a model, it's my duty to devote time to her and make her happy throughout the fitting. As with wedding dresses, the most beautiful moments are the fittings. Afterward, the wedding takes only a quarter of an hour.

DG: And you, Charlotte? Do you think of your past?

CR: Not much, but I know my past has been recorded because I've made films. And something that pleases me greatly is that I've made films since I was very young. So I have all these images of myself at different ages since I was eighteen. But events? No. I don't think of them. I don't think about my past.

BIOGRAPHIES

ADONIS

Adonis is widely acknowledged to be the world's most prominent poet in the Arabic language. A major voice in the politics and cultures of the Arab world, he is the author of *An Introduction to Arab Poetics* (2003) and *The Songs of Mihyar the Damascene* (2019), and his *Selected Poems* was published by Yale University Press in 2012. A collection of his drawings was exhibited at the Galerie Azzedine Alaïa in Paris in 2015.

AZZEDINE ALAÏA

Azzedine Alaïa (1935–2017) was a grand couturier, a member of the pantheon of fashion history in the league of Frederick Worth, Paul Poiret, Christian Dior, Gabrielle Chanel, and Cristóbal Balenciaga. He entertained the companionship of artists, designers, poets, philosophers, actors, actresses, pop stars, and filmmakers of his time, as well as some of the greatest luminaries and icons of twentieth- and early twenty-first-century fashion and style. The inventor of some of the most influential clothing ever designed, he was a fierce advocate for all creative individuals and for everyone's life, constantly stressing the need for people to take their time and not let themselves be crushed by the demands of industry.

JÉRÔME BATOUT

Jérôme Batout is a philosopher who lives and works in Paris, where he was a close friend of Azzedine Alaïa. Born in 1979, he studied at the London School of Economics. Since 2014 he has served as an editorial adviser to the Paris-based journal *Le Débat*. Over the course of his career, he has held a number of positions for the French government, NGOs, and international corporations.

BETTINA

Bettina (1925–2015) was a legendary model and icon once described as "the most photographed French woman." A muse for Jacques Fath and Hubert de Givenchy, she is today considered to be among the first supermodels in the history of fashion.

RONAN BOUROULLEC

Born in Quimper in 1971, the French designer Ronan Bouroullec has been working with his brother Erwan since 1999. Together, they have explored diverse fields of expression, from industrial design to decorative objects. Their work includes collaborations with the great international design firms of today as well as with artisans schooled in the historic traditions of Europe and Japan. Their research has led to collaborations with preeminent international museums, and their urban public-space projects have been realized in countries throughout the world.

MICHEL BUTOR

Michel Butor (1926–2016) was a twentieth-century avant-garde writer. An inventor of the groundbreaking *nouveau roman* literary movement, he is widely considered to have changed the nature of fiction and nonfiction writing. With *The Modification* (1957) and his three other novels, he contributed to redefining the genre itself. He created books beyond generic codification, starting with *Mobile* in 1962. His collected works over a sixty-year span fill thirteen volumes, each containing more than one thousand pages.

JEAN-CLAUDE CARRIÈRE

Jean-Claude Carrière is an author whose screenwriting career started in 1963 with his collaboration with Pierre Étaix; in 2018 he cowrote the screenplay for *At Eternity's Gate*, Julian Schnabel's film about Vincent van Gogh. Carrière was also a close collaborator of Luis Buñuel, with whom he worked on four films, and has written screenplays for movies directed by Miloš Forman, Jean-Luc Godard, Michael Haneke, Philip Kaufman, Louis Malle, Nagisa Oshima, Volker Schlöndorff, and Andrzej Wajda. Among other distinctions, he has twice received a BAFTA and was nominated three times for an Academy Award; in 2014 he received an Academy Honorary Award for his career in the film industry.

EMANUELE COCCIA

Emanuele Coccia is an associate professor at the École des Hautes Études en Sciences Sociales in Paris. He is the author of *Sensible Life* (2016), *Goods: Advertising, Urban Space, and the Moral Law of the Image* (2018), *The Life of Plants* (2018), and, with Donatien Grau, *The Transitory Museum* (2019). He has written numerous essays on visual artists and served as a scientific adviser to the 2019 exhibition *Nous les arbres*, held at the Fondation Cartier in Paris.

ROSSY DE PALMA

Rossy de Palma is an actress who has appeared in nearly fifty feature films, including seven by Pedro Almodóvar, with whom she closely collaborates. She has worked across a wide range of media, including cinema, dance, music, and fashion. A distinct and outstanding performer, she has also been part of many juries, including the Cannes Film Festival in 2015.

CAROLINE FABRE

Caroline Fabre is Azzedine Alaïa's studio director. After a long-term collaboration with Yohji Yamamoto, she became Alaïa's right hand in 2002, and was appointed to the position of studio director in 2015.

TRISTAN GARCIA

Tristan Garcia is a writer and philosopher. He is the author of such groundbreaking novels as *Hate, a Romance* (2010) and the theoretical works *Form and Object: A Treatise on Things* (2014) and *The Life Intense: A Modern Obsession* (2018). He is an associate professor at the University of Lyon.

DONATIEN GRAU

Donatien Grau is a scholar and writer. He has published extensively on art and artists and is the author and editor of academic studies on literary history, art history, and the political history of the ancient world, both in French and in English. He served as a guest curator at the J. Paul Getty Museum in Los Angeles and is currently the head of contemporary programs at the Musée d'Orsay in Paris. He was the adviser to Azzedine Alaïa for exhibitions and programs at the Galerie Azzedine Alaïa, the couturier's not-for-profit exhibition space, from 2014 until Alaïa's passing on November 18, 2017.

VITTORIO GRIGOLO

The tenor Vittorio Grigolo is one of the world's most celebrated opera singers. Nicknamed "Il Pavarottino" (The Little Pavarotti), he has performed for the past twenty years on the world's preeminent stages, from La Scala in Milan and the Metropolitan Opera in New York to the Royal Opera House in London and the Staatsoper in Vienna, playing roles in such nineteenth-century masterworks as *Tosca*, *La Traviata*, *L'elisir d'amore*, *La Bohème*, and *Werther*.

ISABELLE HUPPERT

Isabelle Huppert is one of the world's most critically acclaimed actresses. For her work across a wide range of films, she has won two best actress awards at the Cannes Film Festival, two Coppe Volpi at the Venice Mostra, one BAFTA, one Silver Bear at the Berlinale, and one Golden Globe.

JONATHAN IVE

Born in London in 1967, Jony Ive is a designer working in San Francisco. As chief design officer at Apple, he is responsible for the look and feel of hardware products, the design of user interface and packaging, and overseeing major architectural projects. The holder of over 5,000 patents, he has been awarded honorary doctorates from the Royal College of Art, Rhode Island School of Design, and Cambridge and Oxford

Universities. In 2013 he was made a Knight Commander of the British Empire "for services to design and enterprise." He was appointed chancellor of London's Royal College of Art in 2017 and, a year later, was awarded the Professor Stephen Hawking Fellowship by the Cambridge Union Society. In 2019 it was announced that Sir Jony will form an independant design company, LoveFrom, which will count Apple among its primary clients.

ALEJANDRO JODOROWSKY

Alejandro Jodorowsky has defined what being an artist has meant for the past sixty years. As a filmmaker, he is the author of the legendary *El Topo* (1970), *Holy Mountain* (1973), the unrealized *Dune*, "the most famous movie never made" (1973–77), and, more recently, *The Dance of Reality* (2013), *Endless Poetry* (2016), and *Psychomagy* (2019). He has been a poet, comics writer, performer, theater director, and thinker. An exhibition devoted to pascALEjandro, his collaborative work with his wife, Pascale Montandon-Jodorowsky, was presented at the Galerie Azzedine Alaïa in spring 2017.

DIDIER KRZENTOWSKI

Didier Krzentowski is a passionate collector of contemporary art and design. In 1999 he established, with his wife, Clémence, Galerie kreo, recognized as one of the most influential design galleries in the world. Located in the Saint-Germain-des-Prés neighborhood on Paris's Left Bank, with a second location in London's Mayfair, the gallery produces, represents, and exhibits original pieces by the greatest contemporary designers; it also presents a selection of exceptional twentieth-century vintage lighting. Krzentowski has written two books on the subject, *The Complete Designers' Lights: 1950–1990* and *The Complete Designers' Lights II*, which have become references in the field.

BLANCA LI

Blanca Li is a choreographer, film director, dancer, and actress whose work explores the encounters between genres and the connections among cultures and disciplines. After moving to Paris from Madrid in 1992, she created an independent company

of contemporary dance. In 2019 she was elected to the Académie des Beaux-Arts, which noted that Li's "reputation and singularity have made her even more impossible to categorize." She has created choreographies for renowned venues (the Paris Opera Ballet; the Metropolitan Opera in New York City) as well as for filmmakers, including Pedro Almodóvar.

MARC NEWSON

Born in Sydney in 1963, Marc Newson spent much of his childhood traveling in Europe and Asia. He started experimenting with furniture design as a student and, with the aid of an Australian Crafts Council grant, staged his first exhibition in 1986; it featured his Lockheed Lounge, a piece that has set four consecutive world records at auction. He has worked across a wide range of disciplines, creating everything from furniture and household objects to bicycles and cars, private and commercial aircraft, yachts, architectural commissions, and signature sculptural pieces. He was a close friend of Azzedine Alaïa and designed the House's shoe store on rue de Moussy in Paris.

JEAN NOUVEL

Jean Nouvel is an architect and 2008 Pritzker Prize laureate. The author of some of the world's most acclaimed buildings, his works include the Institut du Monde Arabe in Paris (1987), the Fondation Cartier in Paris (1994), the Agbar Tower in Barcelona (2005), the Louvre Abu Dhabi (2017), the National Museum of Qatar in Doha (2019), and the extension of the Museum of Modern Art in New York (2019). He is also a designer and stage designer, and, in that capacity, he collaborated with Azzedine Alaïa on *Le Nozze di Figaro* at the Los Angeles Philharmonic in 2013. An exhibition devoted to some of Nouvel's museum projects, as well as those of his mentor Claude Parent, was presented at the Galerie Azzedine Alaïa in Paris in 2016.

CLAUDE PARENT

Known as the inventor of "oblique architecture," Claude Parent (1923–2016) is considered one of the world's most influential architects and architectural theorists. His buildings, such as Sainte-Bernadette in Nevers, rank among the greatest achievements of twentieth-century architecture. In 2012 a retrospective devoted to Parent's work, curated by Jean Nouvel, was presented at the Cité de l'Architecture et du Patrimoine in Paris. A monograph of Parent's oeuvre was published by Rizzoli in 2019. It contains a foreword by Azzedine Alaïa, the couturier's last piece of writing.

ANAËL PIGEAT

Anaël Pigeat is an art critic and editor for radio and print media. After working at the Musée d'Art Moderne de la Ville de Paris, she was the editor of *Art Press* for seven years before joining the French edition of *Art Newspaper* as editor at large.

CHARLOTTE RAMPLING

Over her fifty-year acting career, Charlotte Rampling has played legendary parts in such films as Luchino Visconti's *The Damned*, Liliana Cavani's *The Night Porter*, Patrice Chéreau's *The Flesh of the Orchid*, Woody Allen's *Stardust Memories*, Sidney Lumet's *The Verdict*, and Nagisa Oshima's *Max, Mon Amour*, as well as starring in four of François Ozon's films. She has also maintained long-term collaborations with the fine-art and fashion photographers Helmut Newton and Juergen Teller.

MAËL RENOUARD

Maël Renouard is a writer, philosopher, and translator. He was awarded the Prix Décembre for his novella *La Réforme de l'opéra de Pékin* in 2013 and is the author of *Fragments of an Infinite Memory*, originally published in French in 2016 and published in English in 2020.

OLIVIER SAILLARD

Olivier Saillard is a fashion historian and curator as well as a poet, performer, and editor. Between 2010 and 2017 he served as director of the Palais Galliera, the Musée de la Mode de la Ville de Paris, where he curated Azzedine Alaïa's first Paris retrospective, presented for the museum's reopening in 2013. In 2018, after the designer's passing, he became the curator of exhibitions for the Galerie Azzedine Alaïa in Paris. That same year, he was named artistic director of J. M. Weston.

JULIAN SCHNABEL

Julian Schnabel is a painter and filmmaker. His work is in collections of the world's most prestigious modern and contemporary art museums and has been exhibited in many venues, including the Musée d'Orsay, which presented *Orsay through the Eyes of Julian Schnabel* in 2018–19. He is the author of six feature films, including *Basquiat* (1996), *Before Night Falls* (2000), and *The Diving Bell and the Butterfly* (2007). A close friend of Azzedine Alaïa, he designed the House's New York flagship store in 1986 and the Paris store at rue de Moussy. His 2018 film, *At Eternity's Gate*, is dedicated to Azzedine Alaïa.

ALEXANDRE SINGH

Alexandre Singh is an artist whose work has been presented in numerous exhibitions, including *The School of Objects Criticized* at the Palais de Tokyo in Paris (2011) and *The Pledge* at the Drawing Center in New York (2013). In 2014 his play *The Humans* was performed at BAM in Brooklyn, New York, as well as the Festival d'Avignon, where he was also a guest artist. In 2019, his film *A Gothic Tale* premiered at the Legion of Honor museum in San Francisco.

CARLA SOZZANI

Born in Mantua and raised in Milan, Carla Sozzani spent twenty years in journalism
as a fashion editor for a variety of magazines. In 1990 she opened the Galleria Carla
Sozzani at the location 10 Corso Como in Milan; a year later the gallery and bookshop
were expanded to create 10 Corso Como's "slow shopping" experience. While an editor
for *Elle* and *Vogue* in 1979, Sozzani met Azzedine Alaïa and supported his work. She
began working with him in 1999 on the maison. In 2007 she cofounded the Association
Azzedine Alaïa, with the couturier and his partner, the painter Christoph von Weyhe.
In 2017, after Azzedine Alaïa's passing, she became the foundation's chair.

ROBERT WILSON

Hailed as "a towering figure in the world of experimental theater" by the *New York
Times*, Texas-born Robert Wilson has created singular works in the realms of opera,
performance, video art, glass, architecture, and furniture design since 1963. Prolific
yet exacting in his approach to staging, light, and direction, Wilson has been honored
with awards for excellence, including a Pulitzer Prize nomination, the Golden Lion of
the Venice Biennale, and an Olivier Award. He is founding director of the Watermill
Center, a laboratory for the arts and humanities in Water Mill, New York.

CHRISTOPH VON WEYHE

Christoph von Weyhe is a painter who, for the past forty years, has been painting the
harbor of Hamburg, both in situ and at his Paris studio. His work has been presented in
exhibitions in Frankfurt, Paris, and Berlin and is part of collections of the Musée d'Art
Moderne de la Ville de Paris, the Brant Foundation in Greenwich, Connecticut, the
Städel Museum in Frankfurt, and the Fonds National d'Art Contemporain in Paris. In
2019 his first US exhibition was organized at The Box in Los Angeles, with the author
and artist Pierre Guyotat.

First published in the United States of America in 2020
by Rizzoli Ex Libris, an imprint of
Rizzoli International Publications, Inc.
300 Park Avenue South
New York, NY 10010
www.rizzoliusa.com

Publisher: Charles Miers
Editor: Daniel Melamud
Design: Geoffrey Dunne
Translation: Pedro Rodríguez
Copy editors: Peter Behrman de Sinéty and Mary Ellen Wilson
Proofreader: Kelli Rae Patton
Production: Maria Pia Gramaglia

Library of Congress Control Number: 2019950151
ISBN-13: 978-0-8478-6155-2

2020 2021 2022 2023 / 10 9 8 7 6 5 4 3 2 1
Printed in Italy

Typeset in Baskerville and Gotham,
and printed on Munken Print White 115 gsm paper

Published with the support of the LUMA Foundation

**LUMA
FOUNDATION**